THE PRE-RAPHAELITES

Publisher and Creative Director: Nick Wells
Project Editor and Picture Research: Sara Robson
Art Director: Mike Spender
Digital Design and Production: Chris Herbert
Layout Design: Lucy Robins

Special thanks to: Anna Groves, Victoria Lyle, Geoffrey Meadon, Helen Tovey, Claire Walker and Gemma Walters

FLAME TREE PUBLISHING
Crabtree Hall, Crabtree Lane
Fulham, London SW6 6TY
United Kingdom

www.flametreepublishing.com

First published 2007

11 10

5 7 9 10 8 6 4

Flame Tree is part of The Foundry Creative Media Company Limited

THE PRE-RAPHAELITES

Author: Michael Robinson Foreword: Yvonna Januszewska

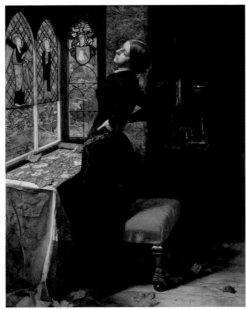

Sir John Everett Millais, *Mariana*

FLAME TREE
PUBLISHING

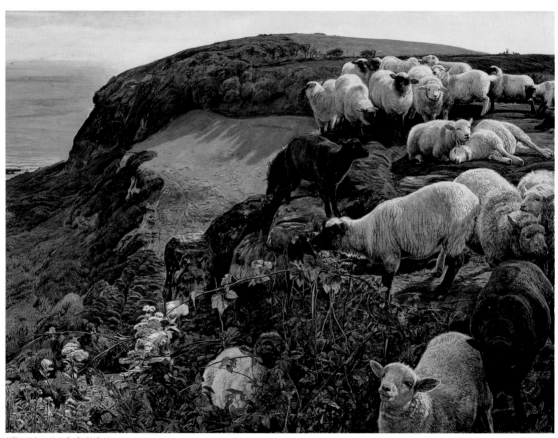

William Holman Hunt, *Our English Coasts*

Contents

Dante Gabriel Rossetti, *The Girlhood of Mary Virgin*; Sir John Everett Millais, *The Vale of Rest*; Sir Edward Coley Burne-Jones, *The Mill* (detail)

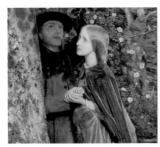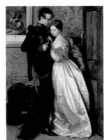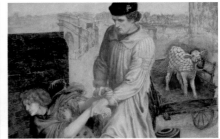

Arthur Hughes, *The Long Engagement* (detail); Sir John Everett Millais, *The Black Brunswicker* (detail); Dante Gabriel Rossetti, *Found* (detail)

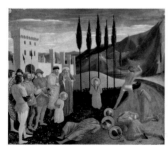

William Holman Hunt, *The Scapegoat;* Frederic George Stephens, *The Proposal (The Marquis and Griselda)* (detail); Ford Madox Brown, *The Hayfield*

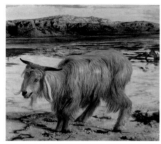 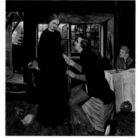 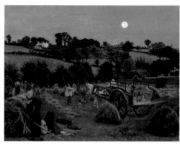

Fra Angelico, *The Martyrdom of St Cosmas and St Damian;* Sir Joshua Reynolds, *Self Portrait* (detail); Odilon Redon, *The Black Pegasus*

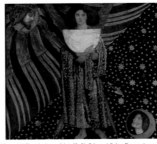

Sir John Everett Millais, *The Boyhood of Raleigh*; Dante Gabriel Rossetti, *Dantis Amor* (detail); Sir Edward Coley Burne-Jones,
Sidonia von Bork, 1560 (detail)

How To Use This Book

The reader is encouraged to use this book in a variety of ways, each of which caters for a range of interests, knowledge and uses.

- The book is organized into five sections: **Movement Overview, Society, Places, Influences** and **Styles & Techniques**.
- **Movement Overview** provides a snapshot of the whole of the movement, starting with some of the earliest works by Pre-Raphaelite Brotherhood members right through to much later pieces by many of the movement's greatest practitioners.
- **Society** explores how the art of the Pre-Raphaelites reflected the times in which they lived, and how events in the world around them were a source of inspiration to them.
- **Places** looks at the work they created in the different places they lived and travelled, and what impact these places had on their work.
- **Influences** delves into the lives of those artists whose work was of great significance to the Pre-Raphaelites, and in turn touches on their influence on future generations of artists.
- **Styles & Techniques** takes a look at the various styles that characterized the different periods of their careers, and examines the various techniques used to create their pieces.

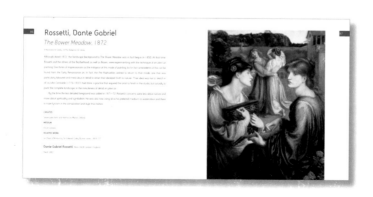

2. Name of artist, by surname then forename

1. Title of work

3. Date of work (if known)

9. Picture credit

4. Information about the work and the context in which it was created

8. Location in which the work was created (if known)

7. Medium in which the work was created (if known)

5. Biographical information about the featured artist: name, date and place of birth and date of death

6. Similar work(s), either from the same or other artists, with similar styles, techniques or subject matter

Foreword

The Pre-Raphaelite Brotherhood (PRB) has shadowed me throughout my life, a fact unknown to me until I embarked on my postgraduate studies. Living in Worcester Park, Surrey, you would probably never realize that you were living in the area where the Pre-Raphaelites found both solitude and inspiration. It was this discovery, which, while I was conducting research on the town where I live, directed me toward further study of the artists and their works. Throughout my life, I have always known I live next to the Hogsmill River and that one can walk down to it via St John the Baptist Church, passing by Worcester Park Manor House. Until my research, however, I was unaware that the manor house and church were the key areas for two of the most compelling Pre-Raphaelite paintings ever executed – *Ophelia*, painted by Sir John Everett Millais (1829–96) in 1852, and *The Light of the World*, painted by William Holman Hunt (1827–1910) in 1853.

In his depiction of Ophelia, Millais sought to portray every part of nature as it is seen in life. This Pre-Raphaelite obsession for detail truly came alive when I was fortunate enough to be shown the exact spot where Millais painted his muse, Elizabeth Siddal, beside the Hogsmill River. Over 150 years on, one can unmistakably see the reclining tree, which adds movement and draws one's eye along the painting. The setting is unchanged – the river still with the same delicate wild orchids growing along its banks, the flow of the water which draws Ophelia's dress down along the canvas and the murky colour of the water, all as Millais captured in such intricate detail.

Drawing inspiration from the Bible, and possibly reaffirming his friendship with the Reverend Stapleton (the Vicar of St John the Baptist Church), Hunt painted *The Light of the World*. It is believed he struggled with the elements of this painting, and it was his good friend Millais who, when walking through a market, saw a young Italian man who fitted the image of Jesus that Hunt needed to portray. In pulling the other elements of the painting together, it is thought that Hunt used a trip to Venice to capture the vivid and sumptuous blue sky which engulfs Jesus, pushing him out of

the painting towards the viewer. It is undoubtedly one of the doors into St John's Church that is used as the key feature of the painting. It is this fact that brings me to contemplate how many more of the Pre-Raphaelite paintings draw imagery from the area in which they lived or visited?

Most of the Pre-Raphaelite paintings are a vision of the world around them, capturing the values of nineteenth-century society. The Pre-Raphaelites endeavoured to depict the places where they were living, and returned to art as the representation of the object. They drew on past influences, and whilst using established techniques, they openly experimented with new styles.

In starting their very own artistic revolution and endeavouring to rectify the vision and teachings of British Art, the PRB struggled to achieve the acclamation they deserved, although many people since have praised Pre-Raphaelite art. From the opening of London's Grosvenor Gallery in 1877, where they sought to show modern art of the time, to the opening of the Christopher Wood Gallery in 1979, Pre-Raphaelite art had a relatively small following. It was, in fact, at the sale of part of Christopher Wood's collection, *Christopher Wood a Very Victorian Eye*, where my path crossed with the Pre-Raphaelites yet again. In 2007, Christie's auction house sold this collection, and I had the privilege of seeing these pieces as I walked through the viewing rooms in my daily work – reaffirming my admiration for these artists.

My latest link to these artists has been through my contribution to this comprehensive book, which eloquently covers the detail of the paintings of the Pre-Raphaelite Movement, and how they relate to their society. The author, like myself, has a continuing passion for British art, and in particular the Pre-Raphaelites and their work. I hope that having read this book you too will share that same passion.

Yvonna Januszewska, *2007*

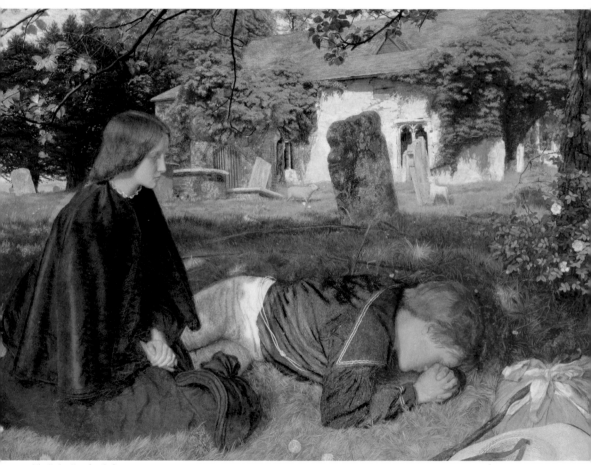

Arthur Hughes, *Home from the Sea*

Introduction

It seems, judging by the success of recent exhibitions on the subject, that our fascination with Pre-Raphaelitism has not waned since the founding of the Pre-Raphaelite Brotherhood (PRB) over 150 years ago, despite the best efforts of the modernists in the twentieth century who eschewed all things Victorian. The fact that Pre-Raphaelitism suffers from the epithet of 'Victorianism' is rather unfortunate, given that it was in its time highly innovative and not a pointless product of Victorian sentimentalism that early modernists such as Roger Fry were so critical of.

It is perhaps poignant that the PRB was formed in the same year as the so-called 'Year of Revolutions' in 1848, when much of Europe was gripped by political turmoil as countries sought changes to their respective governments. In Britain meanwhile, where there was relative stability under a constitutional and popular monarch, a quieter revolution took place, in art. The PRB held its first meeting in September of that year, at the family home of John Everett Millais (1829–96), when he, Dante Gabriel Rossetti (1828–82) and William Holman Hunt (1827–1910) discussed how English art had, in their opinions, deteriorated. According to them this was a result of training at the Royal Academy Schools (at which they had recently been students), based on conventions that had stultified creative painting in favour of 'slosh' (a pejorative term used by the PRB suggestive of the prevailing laxity in painting). Instead they wanted a new mode of expression that had something of the freshness found in *Quattrocento* (fourteenth century) painting prior to Raphael (hence Pre-Raphaelitism).

By the end of 1848, they were working in a new style and the Brotherhood had been enlarged to seven to include the painters Frederic George Stephens (1828–1907) and James Collinson (1825–81), the writer and brother of Dante Gabriel, William Michael Rossetti (1829–1919), and the sculptor Thomas Woolner (1825–92). Although not members of the Brotherhood, Ford Madox Brown (1821–93) and Walter Howell Deverell (1827–54) were associates with strong links to the circle and adherents to the new mode. Despite being critical of the prevalent academic convention, the Brotherhood felt that acceptance of the new style must be made at the annual Royal Academy Exhibition, since all battles for recognition were won and lost there. The core members, Rossetti, Millais and Hunt, agreed to submit their work to the next Royal Academy Exhibition in 1849, with the initials PRB appended to their signatures. In the event, Rossetti got cold feet and submitted his work to the 'Free Exhibition', but Millais exhibited

Isabella and Hunt showed *Rienzi Vowing to Obtain Justice for the Death of his Younger Brother, slain in a Skirmish between the Colonna and Orsini factions*. Although not hostile, the press were lukewarm to the pictures, but recognized, particularly in *Isabella*, a new mode based on *Quattrocento* antecedents. The following year brought considerably heavier criticism as the artists began to develop their 'style'. A prime example being Millais, who was castigated for his *Christ in the House of His Parents* by the writer Charles Dickens (1812–70), who was critical of the lack of reverence due to this subject and the democratization of the Holy Family. By the time of the 1851 exhibition, the pictures showed a diversity of subject matter that included religious narratives, literary texts, history painting and legend. The pictures continued to attract negative publicity since, ironically, they were seen as non-progressive, as 'primitive'.

The PRB and its associates were familiar with the writings of John Ruskin (1819–1900), prior to his critical intervention on their behalf in a letter to *The Times* in May 1851. Ruskin was an established and respected art critic, who had already written two volumes of *Modern Painters*. The first, published in 1843, was an analytical but passionate admiration for the artist Joseph Mallord William Turner (1775–1851) and his work, whereas the second volume dated 1846 was broader in content, Ruskin having travelled over much of Europe in the intervening period, gaining a comprehensive knowledge of medieval painting and architecture. In his writings he made connections between the aesthetic and the spiritual concerns of painting. For him great art was, and should continue to be, an expression of both, since to separate them would lead to art's trivialization, a malaise that he felt had beset English painting. He suggested that the reason for Turner's greatness as an artist was his adherence to this notion and also his quest for a 'truth to nature', a reverence for the natural world manifest in his painting. Ruskin's subsequent support for the Pre-Raphaelites was based on their devotion to that same creed and the belief that they were also seeking to reverse the malaise by adopting certain principles in their work. One of those principles was a return to the spiritual values of the medieval period, which for Ruskin was the high point in man's civilizing quest that had been tainted by the High Renaissance.

Having gained the support of Ruskin, who urged artists to 'go to nature, rejecting nothing, selecting nothing and scorning nothing', the Pre-Raphaelite artists sought a new painting language that was more naturalistic, often using brilliant colours painted on a white ground with meticulous detailing, giving a brilliant, all-over effect. Much of the work was now being painted out of doors in order to capture the full effects of natural light. The most notable early examples of this 'style' are Millais' *Ophelia* and Hunt's *Our English Coasts*, both completed in 1852. Clearly they were entirely

detail
aesth + spirit:
truth to nat
spirt val medeuvl pd

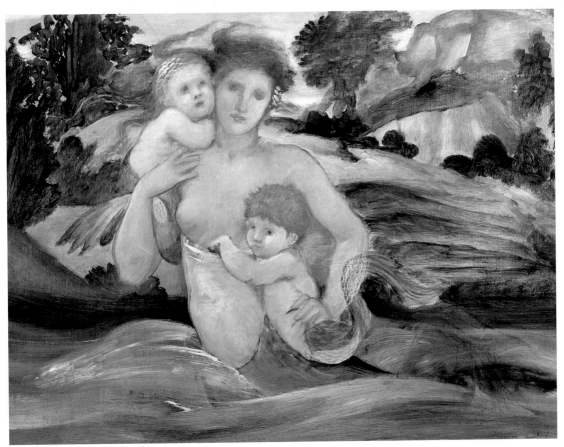

Sir Edward Coley Burne-Jones, *Mermaid with her Offspring*

different subjects to paint and showed the diversity of subject matter that continued to be employed by the Pre-Raphaelite artists, although shortly after a new motif was added to their repertoire – the social-conscience picture used to comment on Victorian society, its mores, social taboos and moral issues. The most notable example of this motif is Hunt's *The Awakening Conscience*, painted between 1853 and 1854.

The initial period of collaborative co-existence in the Brotherhood was all but over by 1854, when Hunt left for the Holy Land to paint, and Millais was elected an Associate of the Royal Academy. Writing at this time to his sister Christina, Rossetti used an Arthurian metaphor to express his feelings 'so now the whole Round Table is dissolved'. Millais, often seen as the early leader of the Brotherhood, pursued his career as a Realist painter of historical (often imagined) narratives, modern allegories and as a portraitist, seeking an essence in his pictures of a 'beauty without subject'. Hunt continued to make trips to the Holy Land in search of geographical and ethnic authenticity for his paintings of religious subjects.

This left Rossetti, who in 1856 had met William Morris (1834–96) and Edward Coley Burne-Jones (1833–98), two Oxford undergraduates who aspired to be artists. Their subsequent collaboration on the commission to decorate

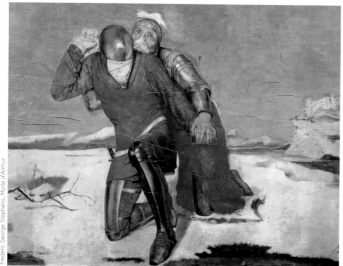

Frederic George Stephens, *Morte d'Arthur*

the library walls of the new Oxford Union, based on Arthurian legend, marked a second phase in Pre-Raphaelitism that saw Rossetti emerging as their new leader. The capricious medievalism of the commission was, however, short-lived and gave way to a deeper seriousness in the work of Rossetti and Burne-Jones. Although they retained much of the Pre-Raphaelite agenda for freshness, the pronounced naturalism was superseded by symbolism, the realism became idealism and worldly concerns gave way to ethereal subjects. Rossetti became

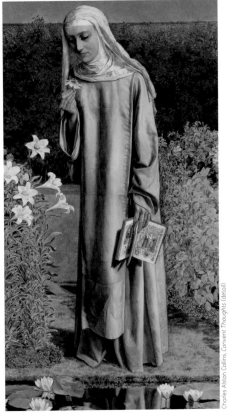

interested in the beauty of a woman's soul, her inner rather than her physical beauty. He became obsessed with the 'courtly love' of Dante and Beatrice, and the depiction of single female figures, often voluptuous, always sensual and sometimes mildly erotic. However, as his work became more repetitive and he became more reclusive, Burne-Jones emerged as the leader of Pre-Raphaelitism.

Burne-Jones's ascendancy coincided with the opening in 1877 of the new Grosvenor Gallery in London, a private dealership that exhibited the new modern art of the period. It was an alternative to the rather staid Academy and enjoyed the patronage of the burgeoning upper middle-class *nouveau riche*. The gallery also showed the work of other 'modern' artists, particularly those associated with Aestheticism, such as Frederic Leighton (1830–96) and Lawrence Alma-Tadema (1836–1912). They, like Burne-Jones, were more interested in the decorative aspects of a painting than its actual subject matter, often using the symbolism of myth and legend rather than a specific narrative. The dream-like imagery of Burne-Jones had a significant impact on European symbolism at the end of the nineteenth century, after it was shown at two Paris *Expositions*, creating an international arena for Pre-Raphaelitism and its legacy.

Charles Alston Collins, *Convent Thoughts* (detail)

Burne-Jones and the earlier Pre-Raphaelites sought to change British art forever, by looking at a motif in a new and refreshing way, and depicting it in a manner devoid of academic convention. Pre-Raphaelitism was not a style but a new manner of painting, one that continued to endure. In the twentieth century, and despite Modernism's best efforts to suppress its importance, artists as diverse as Salvador Dali (1904–89) and Stanley Spencer (1891–1951) were its legatees. Today, in an era that all too often shuns painting in the visual arts, it is worth considering the didactic qualities of art and the Pre-Raphaelites' ability to deliver. This is their legacy, one that still attracts record crowds to its exhibitions.

The Pre-Raphaelites

Movement Overview

Hunt, William Holman

The Eve of St Agnes, 1848

William Holman Hunt began this painting after sitting up all night reading *Modern Painters* by John Ruskin (1819–1900), loaned to him by a fellow student at the Royal Academy School. The artist later recalled that he felt Ruskin had written it expressly with him in mind. Although Ruskin was not an expressed supporter of the Pre-Raphaelites until after 1851, it is clear from this picture that they shared common agendas. The painting was a marked departure from Hunt's previous work in the adoption of what was to become a Pre-Raphaelite mode, that of pictorial honesty rather than an academic concoction of the same.

The painting is a depiction from a poem by John Keats (1795–1821), in which two lovers Madeleine and Porphyro escape from her father's house having eluded the drunken porter. Hunt has however embellished the original scene by including other drunken revellers. One of the preoccupations for Romantic artists of this period was the tension between youthful idealism and family loyalty, so eloquently described by Keats in his poem and faithfully portrayed by Hunt in his painting.

CREATED

London

MEDIUM

Oil on canvas

RELATED WORK

The Eve of St Agnes by Arthur Hughes, 1856

William Holman Hunt *Born* 1827 London, England

Died 1910

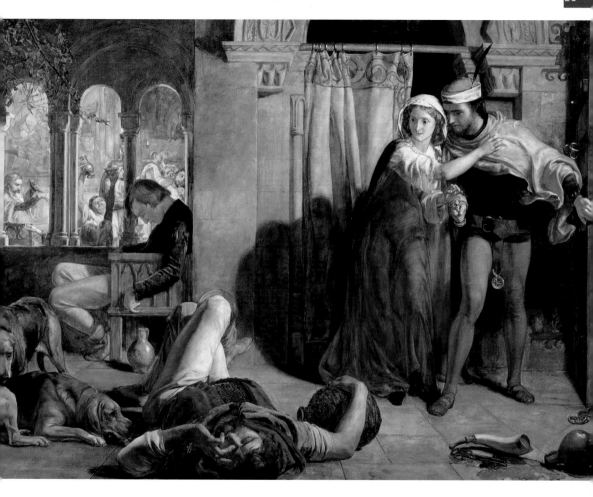

Millais, Sir John Everett

Isabella, 1849

John Everett Millais and Hunt, both students at the Royal Academy Schools, became firm friends after their first meeting in 1843. Millais had already been at the School for three years, having gained entry when he was only 10 years old, such was his precocious talent. Aside from helping the hitherto often-rejected Hunt to gain entry to the School in 1844, Millais and his parents acted as tutors of social skills to the poorly educated artist. It was this friendship that led to the formation of the Pre-Raphaelite Brotherhood (PRB) in September 1848.

Isabella is one of the first paintings executed by Millais after the formation of the Brotherhood. It is a marked departure from his *Cymon and Iphigenia* painted and admitted to the Royal Academy Exhibition the previous year, an example of Classical academic tradition. *Isabella*, which has more in common with *Quattrocento* pictures, is the first of Millais' paintings to include the letters PRB after his signature, denoting his membership of the Brotherhood. Since it was a semi-secret society, there was much subsequent speculation during its exhibition at the 1849 Royal Academy Exhibition.

CREATED

London

MEDIUM

Oil on canvas

RELATED WORK

The Last Supper by Cosimo Rosselli, *c.* 1481

Sir John Everett Millais *Born* 1829 Southampton, England

Died 1896

Hunt, William Holman

Rienzi, 1849

After the birth of the PRB, its early adherents including Hunt sought to fuse literary and pictorial elements in their work. The full title of this picture is *Rienzi Vowing to Obtain Justice for the Death of his Young Brother, Slain in a Skirmish Between the Colonna and Orsini Factions*. When it was exhibited at the Royal Academy in 1849, the artist annotated the work by referring to the inspiration of the work, namely Lord Lytton's novel *Rienzi, the Last of the Tribunes*. This popular novel, adapted by Wagner for the opera *Rienzi* and premiered in 1842, tells the story of the liberator of fourteenth-century Rome from the nobles. The theme for the work must have appealed to Dante Gabriel Rossetti (1828–82) (himself the son of an Italian refugee), a fellow Brother, who with Millais acted as models for the work.

After failing to sell the work at the Academy, Hunt was penniless and ignominiously evicted from his flat for non-payment of rent. The eviction was short-lived, however, as a fellow artist Augustus Egg helped him to sell the work privately for over £100. Now solvent again, Hunt immediately left the city in pursuit of the nature that Ruskin had so eloquently referred to in his writings, a nature so influential to the artist's future works.

CREATED

London

MEDIUM

Oil on canvas

RELATED WORK

The Oath of the Horatii by Jacques-Louis David, 1785

William Holman Hunt *Born* 1827 London, England

Died 1910

Rossetti, Dante Gabriel

The Girlhood of Mary Virgin, 1848–49

Remarkably this is the first-ever oil painting that Rossetti actually completed. It is remarkable not only because the artist was only 20 years old, but also because it anticipated the symbolism of his later work. In this work he cast his mother and sister Christina, themselves very pious Christians, in the roles of St Anne and The Virgin Mary. Although completed at the same time as Millais' *Reinzi* and Hunt's *Eve of St Agnes*, unlike them it was not exhibited at the 1849 Royal Academy Exhibition, despite Rossetti's oath to participate as part of the newly formed PRB.

This exhibition was to be the first time that the letters PRB would be added to their respective signatures on the paintings, but Rossetti got cold feet at the prospect of rejection, preferring instead to send the work to the 'Free Exhibition' which opened a week earlier. Despite Millais feeling hurt and betrayed by Rossetti's apparent disloyalty, the Brotherhood, which was still of course in its infancy, remained intact and continued to meet regularly. Ironically, Rossetti's painting was, unlike his fellow Brothers' pictures, reviewed favourably.

CREATED

London

MEDIUM

Oil on canvas

RELATED WORK

The Annunciation by Fra Angelico, 1438–45

Dante Gabriel Rossetti *Born* 1828 London, England

Died 1882

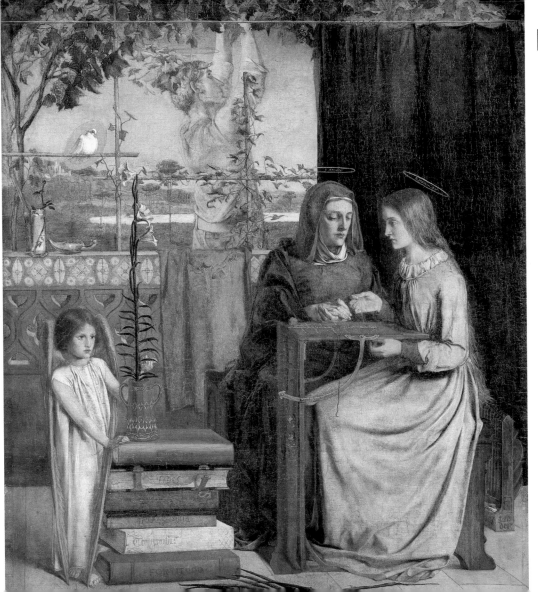

Collinson, James

Answering the Emigrant's Letter, 1850

© Manchester Art Gallery, UK/The Bridgeman Art Library

James Collinson, although one of the original members of the PRB, is one of the least well known. Slightly older than his fellow Brothers, he was recommended for membership by Rossetti along with three others to make the membership of the Brotherhood seven. Prior to the formation of the PRB, Collinson, along with Millais, Rossetti and Hunt, had formed the Cyclographic Society, so named because of the circulation of one artist's drawings to other members for critique and criticism. This was to be the basis for future collaboration of the Brotherhood, Collinson himself stating that he had '... always tried to paint conscientiously'. Equally conscientious was Millais, who through Pre-Raphaelitism aspired to '... heightening the profession as one of unworldly usefulness to mankind, our great object in painting'.

By the time this picture was painted, Collinson had left the Brotherhood (the first to leave), stating that for him its aims were contradictory to his fervent Catholicism.

Collinson's painting reflects on a mid-nineteenth-century phenomenon that saw some nine million people leave Europe between 1846 and 1875, the majority heading for the United States of America.

CREATED

London

MEDIUM

Oil on canvas

RELATED WORK

The Last of England by Ford Madox Brown, 1852–55

James Collinson *Born* 1825 Nottingham, England

Died 1881

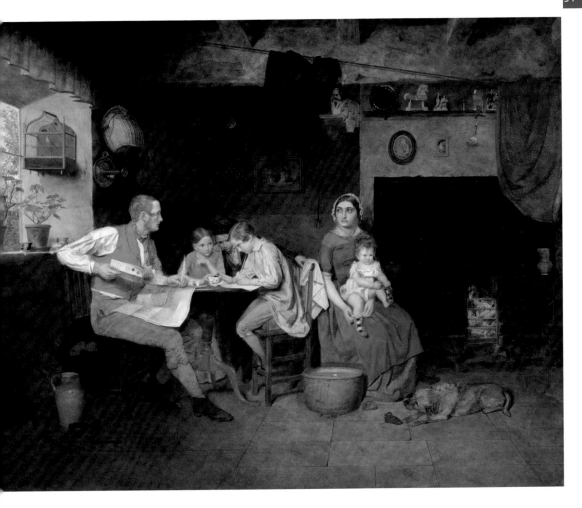

Millais, Sir John Everett

Ferdinand Lured by Ariel, 1849

In the early pictures by members of the Brotherhood, the artists most often used each other as models. In the case of *Ferdinand Lured by Ariel*, Millais used Frederic George Stephens (1828–1907), another founder member, who had left the Royal Academy Schools before the completion of his studies and had not hitherto even completed a painting. Stephens, more a writer than a painter, was also included in Millais' *Isabella*, as were Rossetti and Millais' own father, the latter modelling for Isabella's father in the picture.

Millais and the other Pre-Raphaelites used Shakespearean texts for inspiration in many of their pictures. In this work from *The Tempest* Millais depicts Ariel the magic sprite being carried by strange spirits, leading the shipwrecked Ferdinand to his master Prospero, and ultimately to a meeting with Prospero's daughter Miranda, with whom he falls in love. This Shakespearean romance serves well the early Pre-Raphaelite agenda for literary depictions. The use of mythical creatures by them is also an antecedent to the later Victorian predilection for goblins and fairies so enamoured by artists such as Richard Doyle (1824–83).

CREATED

London

MEDIUM

Oil on panel

RELATED WORK

Twelfth Night by Walter Howell Deverell, 1849–50

Sir John Everett Millais *Born* 1829 Southampton, England

Died 1896

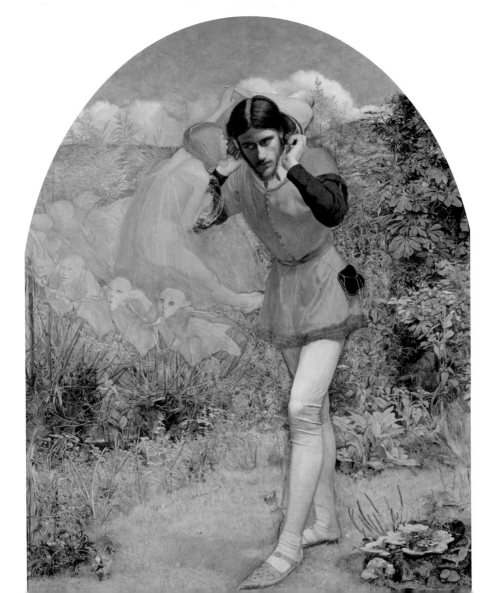

Deverell, Walter Howell
Twelfth Night, 1850

Walter Howell Deverell was not a member of the original PRB, but joined their ranks in 1850 in time for the publication of their journal *The Germ*, which included an illustration of this picture. Deverell was joined by Christina Rossetti (1830–94), sister of Dante Gabriel and William Michael (1829–1919), and others who contributed poetry to the journal. This was a development of the ancient idea that poetry and painting are related art forms, a notion that was effectively exploited by Dante Gabriel, an exponent of both. It should be noted that Christina's poems were not acknowledged in *The Germ* at the time, making the journal an entirely male preserve. *The Germ* served the purpose of revealing the true meaning of the letters PRB used on the first paintings exhibited by the Brotherhood at the 1849 Royal Academy Exhibition. Until then, it had remained something of an enigma to the critics and the public, unaware of the Brotherhood's existence.

The model for Viola in this painting is Elizabeth Siddal, who appeared in several Pre-Raphaelite paintings, particularly those of Rossetti, while the model for her suitor Orsino, is the artist himself.

CREATED

London

MEDIUM

Oil on canvas

RELATED WORK

Valentine Rescuing Sylvia from Proteus by William Holman Hunt, 1851

Walter Howell Deverell *Born* 1827 Virginia, USA

Died 1854

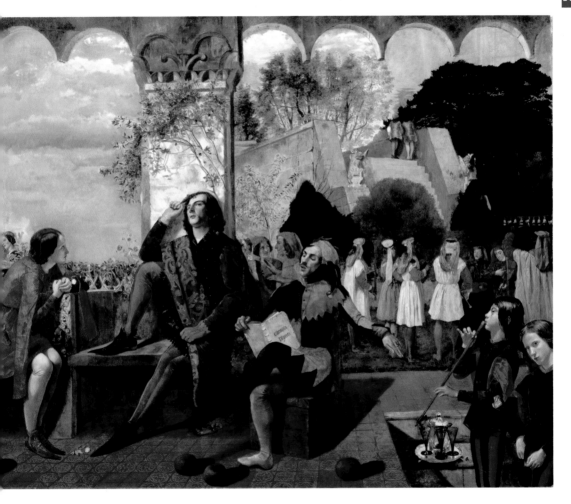

Collins, Charles Alston

Convent Thoughts, 1850–51

Another Pre-Raphaelite artist who is less well known and not a member of the original Brotherhood was Charles Alston Collins, the brother of Wilkie Collins (1824–89) the writer. Collins' early work was significant to the Movement because it highlighted two preoccupations of Pre-Raphaelitism. Firstly a 'truth to nature' in painting that Ruskin had called for and would continue to espouse, and secondly the use of Christian religiosity, a reflection of the importance that faith had in Victorian society. The nun considers the symbolism of a passionflower, while around her various plants are abundant with lusciously coloured flowers, and the goldfish are almost luminous in their realism – a true testament to God's Creation.

Much of the early Pre-Raphaelite work had an 'archaic' feel to it, referring to the *Quattrocento*'s primitivism, emphasized by the use of the arched top to the picture. The nun holds an illuminated missal, the pages of which are open, showing the viewer 'primitive' depictions of the Annunciation and the Crucifixion. The art historian Elizabeth Prettejohn has suggested that, Collins' painting can be read as symbolic of the artistic shift from archaism to naturalism by the Pre-Raphaelites.

CREATED

London

MEDIUM

Oil on canvas

RELATED WORK

Baptism of Christ by Piero della Francesca, 1445

Charles Alston Collins *Born* 1828 London, England

Died 1873

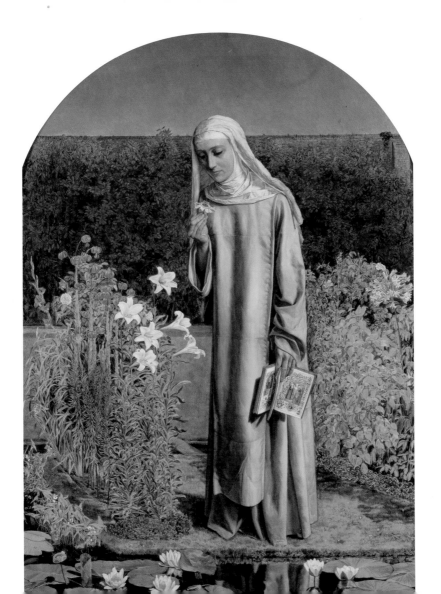

Stephens, Frederic George
Morte d'Arthur, c. 1850–55

A founder member of the PRB, Stephens is perhaps better known as the figure of Rienzi in Hunt's picture than for his own, rarely seen work. It was in fact Hunt who had proposed Stephens for membership of the Brotherhood, an artist who, like Collinson, had not completed his education at the Royal Academy School. His career did not progress as a painter and he turned instead to art criticism working for the important and influential journal *The Athenaeum* from 1860 to 1900, where he continued to support the work of Pre-Raphaelitism.

In the second edition of *The Germ*, published in February 1850, Stephens contributed an article called *The Purpose and Tendency of Early Italian Art*, in which the writer draws the reader's attention to the revival of this art form, in which 'We shall find a greater pleasure in proportion to our closer communion with nature, and by a more exact adherence to her details'. These remarks echo the thoughts of Ruskin, who in the following year was to show his support for the Pre-Raphaelite mode.

CREATED

London

MEDIUM

Oil on wood

RELATED WORK

Sir Galahad at the Ruined Chapel by Dante Gabriel Rossetti, 1859

Frederic George Stephens *Born* 1828 London, England
Died 1907

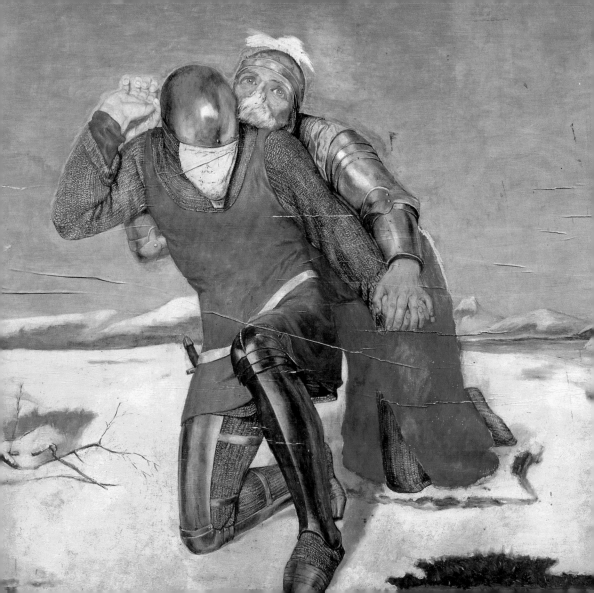

Hunt, William Holman

Valentine Rescuing Sylvia from Proteus (detail), 1851

This scene depicts a scene from Shakespeare's *Two Gentlemen of Verona*, in which two close friends are separated by their love for the same woman. This painting was exhibited at the Royal Academy the same year it was painted alongside Collins' *Convent Thoughts*. The exhibited pictures and the Brotherhood received negative reviews bordering on hostility from the press, something that they had endured since their first exhibition in 1849.

It was Ruskin, however, who took up their cause, and in so doing changed English painting, by writing two defending letters to the editor of *The Times* in 1851. The press had been guilty of condemning the work as retrogressive, a charge that Ruskin refuted. 'The Pre-Raphaelites intend to return to early days in one point only, that they will draw only what they *see* or what they suppose might have been the *actual* facts of the scene they desire to represent.'

Later in 1851, Ruskin issued a pamphlet called *Pre-Raphaelitism* in which he further espoused the notion of 'truth to nature'. Hunt and Millais responded by travelling to the countryside, capturing the landscape for use in future pictures.

CREATED

Sevenoaks, Kent and London

MEDIUM

Oil on canvas

RELATED WORK

Ferdinand Lured by Ariel by Sir John Everett Millais, 1849

William Holman Hunt *Born* 1827 London, England

Died 1910

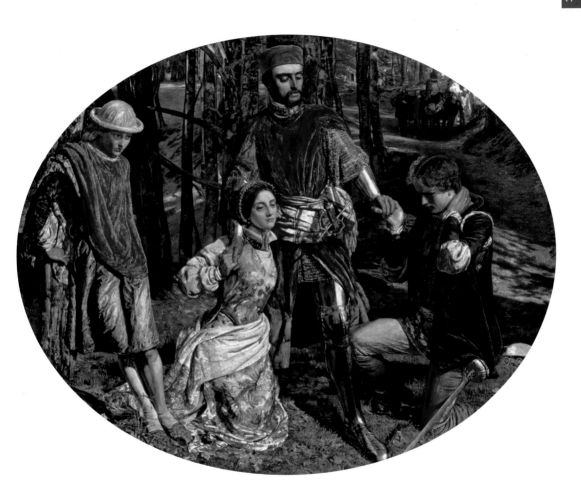

Woolner, Thomas

Portrait Medallion of Alfred, Lord Tennyson, c. 1852

Thomas Woolner was the only sculptor of the original PRB, introduced to the group by Rossetti. He had little success in the early years and emigrated to Australia to 'seek his fortune' in gold-prospecting in 1852, only to return two years later, no wealthier but with an enhanced reputation as a sculptor.

Woolner's reputation was made producing reliefs of well-known contemporaries such as the poet Alfred Tennyson (1809–92), the Prime Minister William Gladstone and the writer Thomas Carlyle (1795–1881). In this work, the artist received a less-than-complimentary review from the *Cornhill Magazine* that read 'Tennyson's hair looks so hard that one might take it for strong nicely curled candlewicks steeped in oil'. Such ridicule and philistinism was to be expected at this time from an unenlightened public and press. However the *Cornhill* also recognized that it was a new style of realism devoid of 'smoothing over or idealizing'. Although faint praise, there is a genuine recognition that these reliefs, based on *Quattrocento* antecedents, were enjoying a revival.

Like Rossetti, Woolner was also a poet who contributed *My Beautiful Lady*, a chivalric poem, to the first issue of *The Germ*.

CREATED

London

MEDIUM

Bronze

RELATED WORK

The Expulsion from Paradise by Jacopo della Quercia, *c.* 1430

Thomas Woolner *Born* 1825 Hadleigh, England

Died 1892

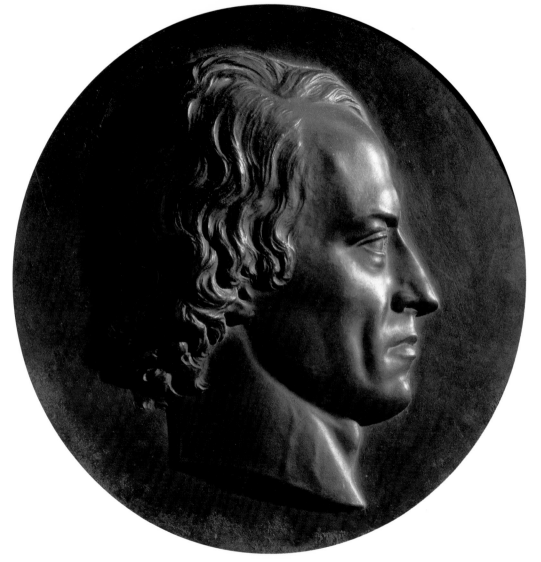

Millais, Sir John Everett

Ophelia, 1851–52

Millais exemplifies the execution of Ruskin's dictum of a 'truth to nature' in this painting. It was intended by Ruskin that the smallest detail should enjoy its own identity just as each person had his or her own. It was not enough to show the species, each plant had to have its own individual identity, a statement of God's manifest Creation in all its diversity and wonder. According to Ruskin, writing in his pamphlet *Pre-Raphaelitism*, '(Artists) should go to nature in all singleness of heart ... rejecting nothing, selecting nothing and scorning nothing'. Such was the importance of the natural elements that the figure of Ophelia was added into the painting only after the background had been completed.

The model for this scene from Shakespeare's *Hamlet* is Elizabeth Siddal playing the part of the tragic heroine who drowns herself following a period of madness. Siddal posed for the painting by lying in a bath from which she caught a chill.

The role was somewhat prophetic in that Siddal later married Rossetti but, on learning of his infidelity, took her own life by swallowing laudanum.

CREATED

London and its environs

MEDIUM

Oil on canvas

RELATED WORK

Chatterton by Henry Wallis, 1855–56

Sir John Everett Millais *Born* 1829 Southampton, England

Died 1896

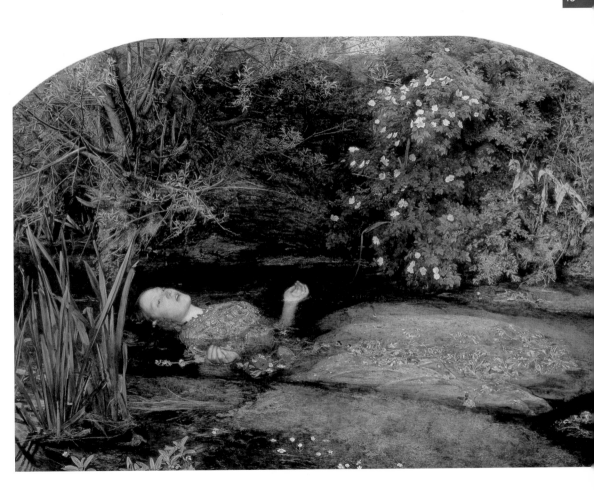

Brown, Ford Madox
The Pretty Baa-Lambs, 1852

© Birmingham Museums and Art Gallery/The Bridgeman Art Library

A close associate rather than a Brother, Ford Madox Brown was influential as a teacher of Pre-Raphaelitism as much as an artist in his own right. Rossetti, after leaving the Royal Academy School, sought out Brown as his tutor before the Brotherhood was formed. He had seen Brown's contemporary work such as *Wycliffe reading his Translation of the Bible to John of Gaunt*, a painting based on his contact with the so-called Nazarene artists, an important precursor to Pre-Raphaelitism in its primitive archaism.

After coming into contact with the Brotherhood and Ruskin, Brown changed his style to one that embraced a 'truth to nature'. This painting was the first that Brown attempted to paint actually in front of the motif outdoors in full sunlight, hence the intensity of light that pervades the scene. Every natural element is executed with precision, and the figures are imbued with the same strong sunlight as the landscape.

This work was exhibited at the Royal Academy Exhibition of 1852 alongside Hunt's *The Hireling Shepherd*, but received heavy criticism due to its overall brightness.

CREATED

Clapham Common, London

MEDIUM

Oil on panel

RELATED WORK

The Hireling Shepherd by William Holman Hunt, 1852

Ford Madox Brown *Born* 1821 Calais, France

Died 1893

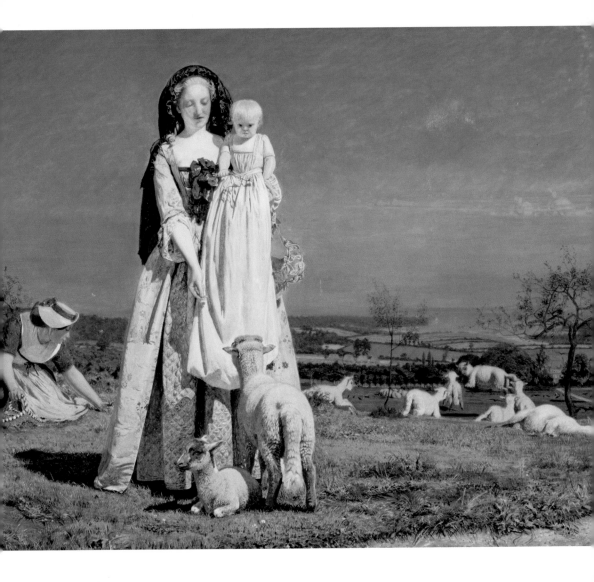

Millais, Sir John Everett

The Order of Release, 1746 (detail), 1853

This painting, which was exhibited alongside his other painting entitled *The Proscribed Royalist* at the 1853 Royal Academy Exhibition, demonstrates Millais' thoughts about social issues of his time. Although essentially a history painting about the Jacobite Rebellion, there is a sense in *The Order of Release, 1746* of the futility in revolution and the importance of one's family. Millais, like all of the Pre-Raphaelites after the initial period of archaism in their paintings, began to address contemporary issues in Victorian society such as inequality and poverty, developing a charitable social conscience. The painting was well received at the Academy and was possibly instrumental in securing Millais' future when he was elected an Associate the following year. Indeed the Exhibition was a turning point for the Brotherhood, acknowledged by Rossetti as 'emerging from reckless abuse to a position of general and high recognition'.

This was in no small part due to Ruskin's intervention. Ironically, the model for the woman was Ruskin's wife Euphemia (Effie), who was later to become Millais' wife after her scandalous separation from the writer.

CREATED

London

MEDIUM

Oil on canvas

RELATED WORK

The Proscribed Royalist by Sir John Everett Millais, 1853

Sir John Everett Millais *Born* 1829 Southampton, England

Died 1896

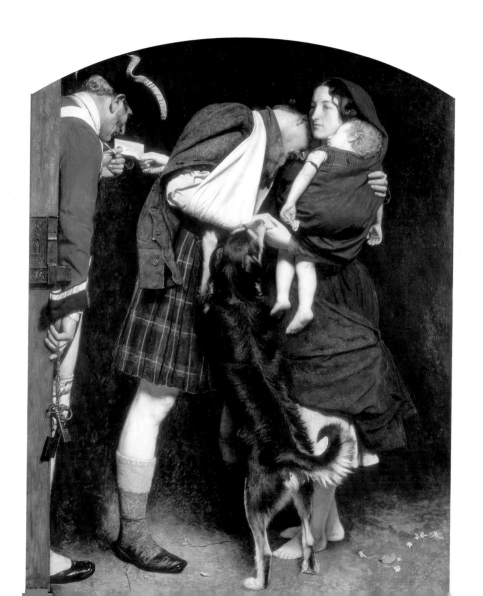

Rossetti, Dante Gabriel

Dante Drawing an Angel, 1853

The full title of this work is *Dante Drawing an Angel on the First Anniversary of the Death of Beatrice*. Dante (Alighieri) (1265–1821) was a fourteenth-century Florentine writer and poet, who fell in love with Beatrice Portinari without actually having spoken to her and thereafter only knowing her slightly. This formed the basis for Dante's literary texts in which he expressed 'courtly love', a medieval notion of love that is both passionate and at the same time self-disciplined and contained. This notion was the influence for Dante's *Vita Nuova*, a book of verse written in about 1293, which features Beatrice. She also appears in Dante's best-known work *The Divine Comedy*. After Beatrice's death in 1290 aged only 24, Dante, even though he had married another woman in 1285, continued to write poetry dedicated to her.

Rossetti was actually christened Gabriel Charles Dante, showing his father's obsession with the writer. The artist himself followed that obsession and even changed the order of his names to signify that same respect. Prior to the formation of the Brotherhood, Rossetti was to be found in the British Library translating the works of Dante, including *Vita Nuova*, Beatrice becoming a continuing influence in his own work.

CREATED

Probably London

MEDIUM

Oil on canvas

RELATED WORK

The Eve of St Agnes by William Holman Hunt, 1848

Dante Gabriel Rossetti *Born* 1828 London, England

Died 1882

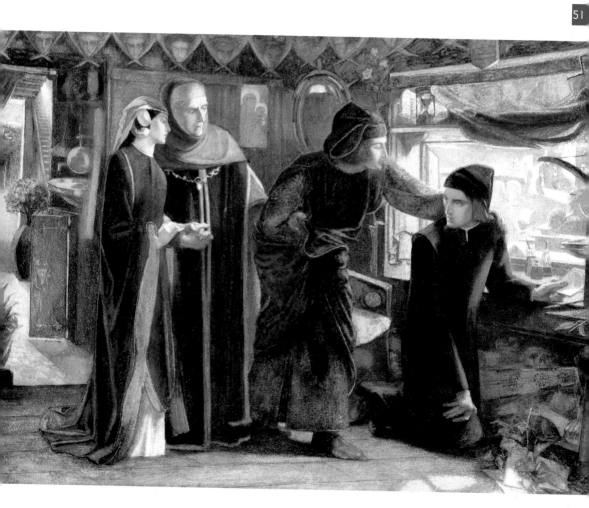

Hunt, William Holman

The Finding of the Saviour in the Temple, 1854–60

It was with some trepidation that Hunt left England on a journey to the Holy Land in January 1854, having decided that his next picture should be *The Finding of the Saviour in the Temple*. He had recently completed his picture *The Light of the World*, and had been criticized even prior to its Royal Academy viewing later that year, leaving Hunt to consider whether it actually expressed Pre-Raphaelite aims of realism in its execution. Coincidentally, Hunt, not previously a particularly pious man, had been introduced to the Oxford Movement and its ideals and had approached the painting with religious fervour.

In the event, Hunt was vindicated for his decision to travel, since later that year his *The Light of the World* was castigated as 'mere papistical fantasy' by, among others, the writer Carlyle, an influential Calvanistic-Romantic thinker of the High-Victorian period.

Once in the Holy Land, Hunt resolved to paint the exact events of the Bible in their correct geographic location, in his endeavour for artistic realism, taking Pre-Raphaelitism to its extreme.

CREATED

The Holy Land

MEDIUM

Oil on canvas

RELATED WORK

The Light of the World by William Holman Hunt, 1854

William Holman Hunt *Born* 1827 London, England

Died 1910

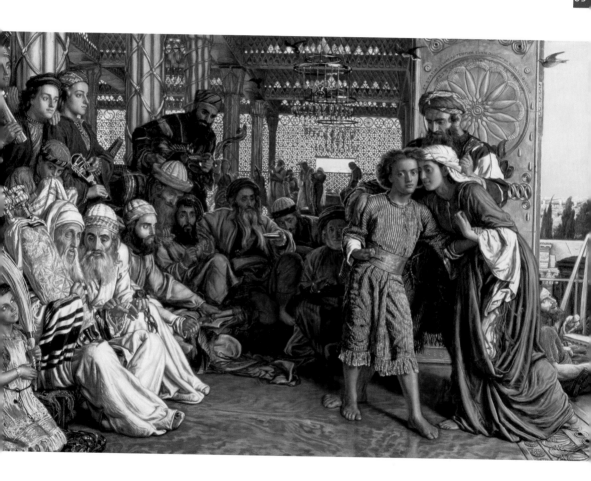

Millais, Sir John Everett

The Rescue, 1855

© National Gallery of Victoria, Melbourne, Australia/The Bridgeman Art Library

Such was the quest for 'truth' that the Pre-Raphaelites went to extraordinary lengths to find realism for their paintings. This is Millais' first painting based on contemporary life but is in effect a take on the medieval chivalric rescue. It depicts the selfless courage of a fireman rescuing three children from a burning house, an incident Millais had witnessed earlier that year. In Millais' opinion, firemen were as heroic as any soldiers or sailors, the subjects of his earlier paintings. Millais travelled all over London watching actual fires whenever they occurred and burned planks of wood in his studio to study the effects of smoke on the light. The reddened highlights in the picture were achieved by placing coloured glass over the window of his studio to illuminate his sitter.

Millais exhibited this painting at the Royal Academy in 1855 finding favour with Ruskin who in *Academy Notes*, first published in that year, called it 'the only great picture exhibited this year'. This is praise indeed coming from the writer whose wife had recently left him to marry Millais that same year!

CREATED

London

MEDIUM

Oil on canvas

RELATED WORK

Eastward Ho! by Henry Nelson O'Neill, 1857

Sir John Everett Millais *Born* 1829 Southampton, England

Died 1896

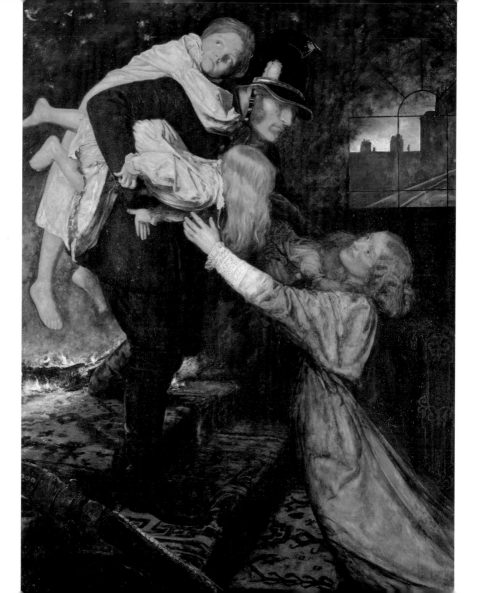

Hughes, Arthur

April Love, 1855–56

Arthur Hughes was only 23 when he painted this work, the first of the Pre-Raphaelite adherents from outside of the social circle of the Brotherhood to paint such a picture. The artist, who was not particularly innovative, was a superb draughtsman and very quick to absorb and implement the new artistic style in his work. *April Love* has retained its appeal since it was first exhibited in 1856 at the Royal Academy, and is the artist's best-known work. When the painting went on display, it was accompanied by a text from Tennyson's poem 'The Miller's Daughter', which tells of love's frailty. Like many subsequent Pre-Raphaelite paintings, the work is full of symbolism, the ivy representing the eternal while the fallen petals suggest love's transience, highlighted by the model's glance toward them. In fact the model was Hughes' own wife, Tryphena Foord, whom he had recently married.

The painting was very well received by the critics, particularly Ruskin who sought to purchase it. It had in any event already been purchased by William Morris (1834–96).

CREATED

Probably Maidstone, Kent

MEDIUM

Oil on canvas

RELATED WORK

Marianna by Sir John Everett Millais, 1851

Arthur Hughes *Born* 1832 London, England

Died 1915

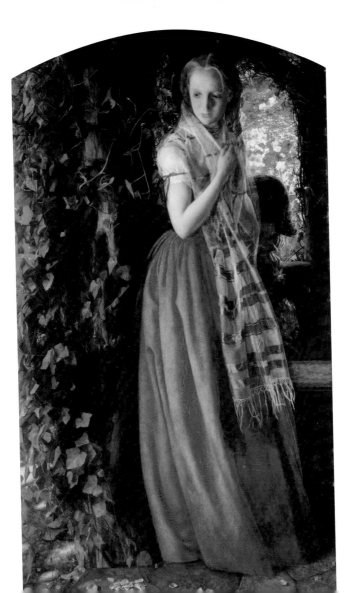

Rossetti, Dante Gabriel

Arthur's Tomb, 1854

Rossetti was fascinated by medieval and early Renaissance literature, none more so than Sir Thomas Malory's (c. 1405–71) fifteenth-century account of Arthurian legend written as *Morte d'Arthur*, which was one of the first books to be printed using Caxton's press. Rossetti's scene is taken from the end of the book when Guenevere meets Sir Lancelot for the last time in an apple orchard. Guenevere had become a nun following her adulterous affair with the knight. Lancelot approaches and begs to be embraced for one last time '... Madame I praye you kysse me once and never more'. As usual the Pre-Raphaelite painter embellishes the story by including Arthur's tomb in the scene, with Lancelot making his beseeching speech across the effigy of Arthur, the victim of Guenevere's infidelity. This compressed composition of the three figures is a ruse to highlight the suggested discomfort for all three protagonists in this affair. Rossetti has also used the tomb's sides to depict other aspects of Arthurian legend. The obvious naivety of the painting suggests a stained-glass window design.

CREATED

London

MEDIUM

Watercolour

RELATED WORK

Sir Galahad by Sir Edward Burne-Jones, 1858

Dante Gabriel Rossetti *Born* 1828 London, England

Died 1882

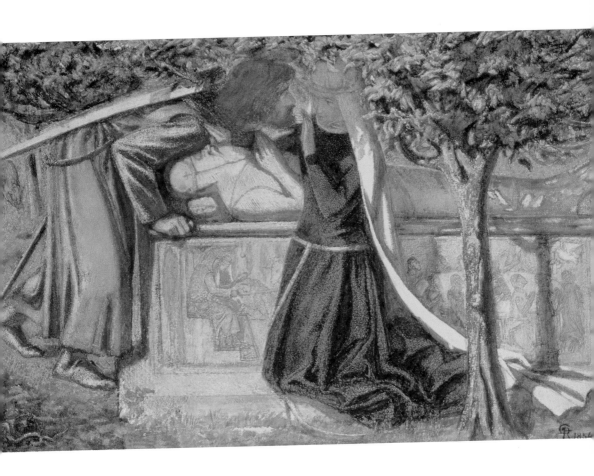

Siddal, Elizabeth Eleanor

Sir Patrick Spens (detail), 1856

© Tate, London 2007

Siddal is better known in her role as model and muse for the Pre-Raphaelite painters, particularly Rossetti whom she married in 1860, rather than as a painter and writer. Nevertheless this work from 1855 is a testament to her abilities as an artist. As with so many Pre-Raphaelite pictures, this one takes its influence from a medieval source, in this case a Scottish ballad in which the King has asked Sir Patrick Spens, a notable sailor, to fetch his daughter from across the North Sea. Needless to say there is a great storm and the ship and all on board perish leaving a grieving king and his court. The central figure in the composition, possibly a self-portrait, is one of a group of these courtiers vainly looking out to sea for the ship.

Siddal was one of a small number of Pre-Raphaelite women artists who benefited from not being taught at the Royal Academy School, inasmuch as they had nothing to 'unlearn'. However, despite members of the Brotherhood such as William Michael Rossetti championing their work, they were largely ignored as 'serious' artists in this period.

CREATED

Probably London

MEDIUM

Watercolour on paper

RELATED WORK

To Those Lost at Sea by Louis Adolphe Demerest, late nineteenth century

Elizabeth Eleanor Siddal *Born* 1829 London, England

Died 1862

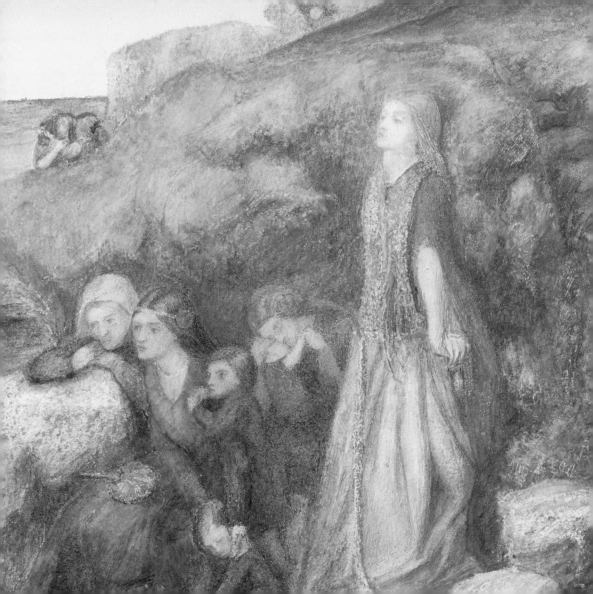

Brown, Ford Madox
Stages of Cruelty, 1856–90

By the time Brown had commenced this painting in 1856, he had already completed his *Jesus Washing Peter's Feet*, which he had been working on for five years. Brown often spent a long time on his highly detailed paintings, but *Stages of Cruelty* seems to have been the longest. Since it is not very large or complex by Pre-Raphaelite standards, there may well have been other reasons.

Brown's preoccupations seem to have been, like many of his artistic contemporaries, the various social concerns of the Victorian period. *The Four Stages of Cruelty* may well have been borrowed from Hogarth's plates of the same name made in the 1750s and published as engravings in 1822. In Hogarth's explicit and spiteful work, the artist explores animal cruelty by small boys and later by male adults. Brown seems to have brought the scenario up to date with a girl attacking the animal and the young woman rebuffing the advances of a male suitor and appearing nonchalant to his torment. The length of the painting's execution may well have been Brown's longer consideration of human cruelty during his adult life.

CREATED

London

MEDIUM

Oil on canvas

RELATED WORK

The Four Stages of Cruelty by William Hogarth, c. 1750 (published 1822)

Ford Madox Brown *Born* 1821 Calais, France

Died 1893

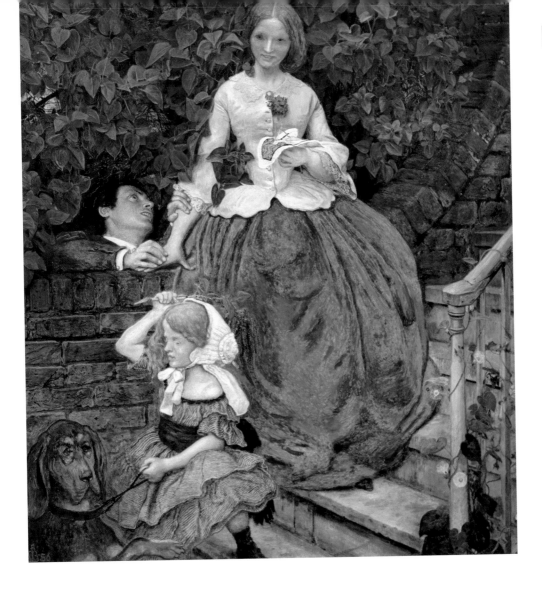

Rossetti, Dante Gabriel

The Tune of the Seven Towers, 1857

© Tate, London 2007

The origins of this work are unclear except that Rossetti in partnership with Morris composed a poem in the following year to enhance the work.

By the nineteenth century, much of the ancient-Roman writer Horace's ideas of *ut pictura poesis*, 'as is painting, so is poetry', had lost most of its vigour. However, Ruskin revitalized this idea in the third volume of *Modern Painters* stating that, 'Painting is properly to be opposed to speaking or writing, but not to poetry', thus restoring the notion that there is an analogy between the verbal and visual arts, one that should be exploited. Since literature was considered at this time to be a nobler art form than painting, Ruskin was trying to elevate the public perception of the visual arts by this analogy. What Ruskin sought was the involvement of the visual arts in creating awareness of social concerns as a way of improving the lot of the ordinary man; in much the same way as the literature of his near contemporary Charles Dickens (1812–70) was beginning to do at this time.

CREATED

London

MEDIUM

Watercolour on paper

RELATED WORK

Le Chant d'Amour by Sir Edward Burne-Jones, 1865

Dante Gabriel Rossetti *Born* 1828 London, England

Died 1882

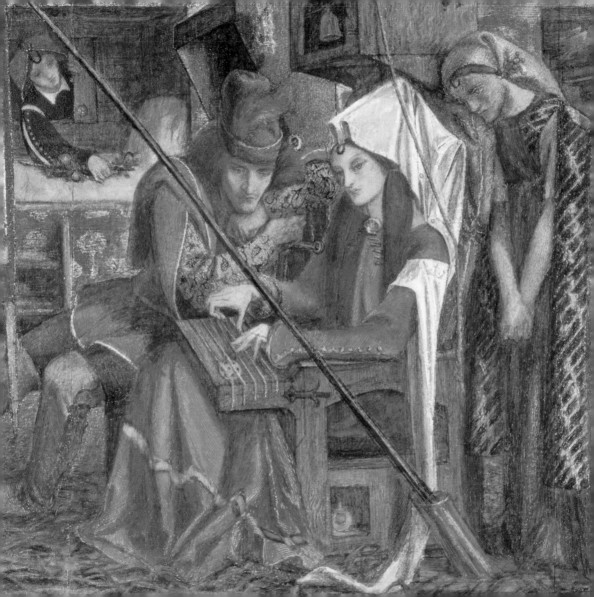

Hughes, Arthur

The Annunciation, 1858

The Annunciation was one of the most popular motifs in the *Quattrocento*, a period so influential to the Pre-Raphaelites. The scene depicts the Virgin Mary being visited by the angel Gabriel to foretell the Immaculate Conception.

The subject was unusual for Hughes, who was generally more concerned with myths and legends and earthly pursuits such as love and romance in his paintings. Hughes, who was more of a follower than an innovator, usually copied a motif that had already been executed by a fellow Pre-Raphaelite. Prime examples include *Ophelia*, *The Eve of St Agnes* and of course Rossetti's own Annunciation picture *Ecce Ancilla Domini* of 1849–50. Although Rossetti's picture is a little less orthodox than its *Quattrocento* forebears, the artist has still used the traditional male and female models in their respective roles. In Hughes' version, the angel appears with a more feminine quality and there is less evidence of the spirituality and divinity of Rossetti's work. Hughes' painting contains none of the usual aura expected in this scene, demonstrating perhaps that he was better equipped to deal with more secular subjects.

CREATED

London

MEDIUM

Oil on canvas

RELATED WORK

Ecce Ancilla Domini by Dante Gabriel Rossetti, 1849–50

Arthur Hughes *Born* 1832 London, England

Died 1915

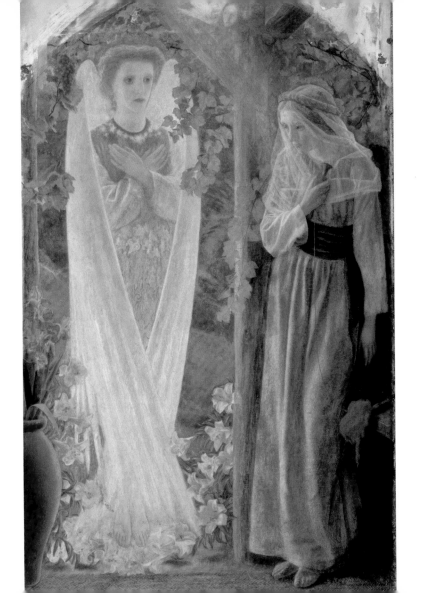

Millais, Sir John Everett

The Vale of Rest, 1858–59

At the time *The Vale of Rest* was painted, Millais was moving away from Pre-Raphaelitism. He left behind the mythical and historical narratives of his earlier pictures in favour of a new 'truth', within contemporary life. Millais still retains a 'truth to nature' in that the figures are accurately painted with close attention to detail and the viewer can discern that the trees depicted are poplars and oaks.

However, the brightness of his earlier pictures with their implied sense of hope and spiritual elevation is missing. In its place is one of mortality and finality. The composition of the picture with the two nuns in the foreground draws the viewer not only into the scene, but also actually into the grave itself, reminding us of our own ultimate fate. This is emphasized by the seated nun looking toward the viewer, a skull hanging from her rosary in plain sight, and two funeral wreaths by her side.

The silhouetted bell tower, suggesting the ringing of a death toll, serves only to enhance the morbidity of the picture, which received a poor press when it was exhibited.

CREATED

Scotland

MEDIUM

Oil on canvas

RELATED WORK

The Churchyard at Beews-y-Coed by Benjamin Leader, 1863

Sir John Everett Millais *Born* 1829 Southampton, England

Died 1896

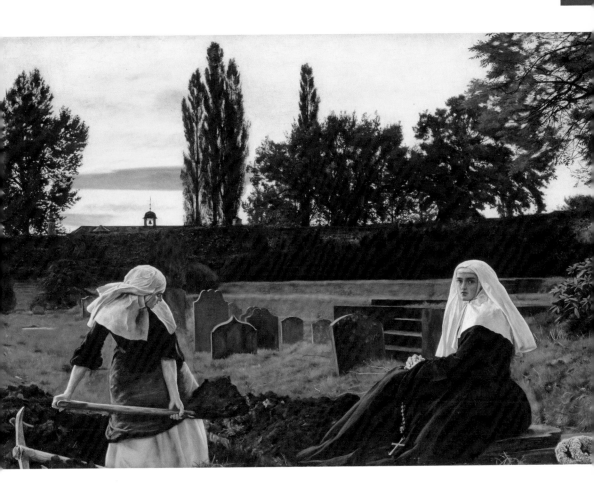

Burne-Jones, Sir Edward Coley

Clara von Bork, 1560, 1860

This very large watercolour is one of a pair that Edward Burne-Jones executed in 1860 – portraits of two characters from Wilhelm Meinhold's gothic story *Sidonia the Sorceress*. This picture is of the virtuous Clara, who meets a gruesome death at the hands of the evil Sidonia.

At the time of this picture, the original Pre-Raphaelite group had all but disbanded with each member pursuing his own agenda. Burne-Jones was perhaps the leading exponent of the next generation of Pre-Raphaelite painters, in which artists returned to many of the key themes of the original group such as Arthurian and other legends as well as Classical mythology. Their work can be seen as contributing both to the later Aesthetic Movement and to international Symbolism in the late nineteenth century.

His route into Pre-Raphaelitism was not through the Royal Academy Schools but as an undergraduate at Oxford University, where he met Morris. Together they were introduced to Ruskin and his ideas on art and social change, and through him they came into contact with the PRB at the Academy Exhibition of 1854.

CREATED

Bexley, Kent

MEDIUM

Watercolour and gouache on paper

RELATED WORK

The Return of the Dove to the Ark by Sir John Everett Millais, 1851

Sir Edward Coley Burne-Jones *Born* 1833 Birmingham, England

Died 1898

Sandys, Anthony Frederick

Morgan le Fay (Queen of Avalon), 1864

Anthony Frederick Sandys came to prominence in 1857 after parodying Millais' painting *A Dream of the past – Sir Isumbras Crossing the Ford* in a cartoon which he entitled *A Nightmare*. Sandys' parody was in response to Ruskin's criticism of the painting that it represented a 'reversal of principle' in Pre-Raphaelitism. This was the beginning of the end for Millais' Pre-Raphaelite period and Millias now pursued a realist agenda of his own.

By the 1860s, Sandys had joined the ranks of the Pre-Raphaelites now under the guiding light of Rossetti who was pursuing an agenda of less worldly concerns such as mythology, legend and spirituality. Sandys, who lived with Rossetti in Chelsea for a while during the 1860s, was a disciple and became something of a Bohemian, a lifestyle that was to be adopted by those of the later Aesthetic Movement around James McNeill Whistler (1834–1903) and Oscar Wilde (1854–1900).

In this work, Sandys, a superb draughtsman and something of a stickler for accuracy, has portrayed Morgan le Fay, the half-sister of King Arthur, who takes the dead king to his resting place in Avalon, a mythical British isle renowned for its apples.

CREATED

London

MEDIUM

Oil on panel

RELATED WORK

St George and Princess Sabra by Dante Gabriel Rossetti, 1862

Anthony Frederick Sandys *Born* 1829 Norwich, England

Died 1904

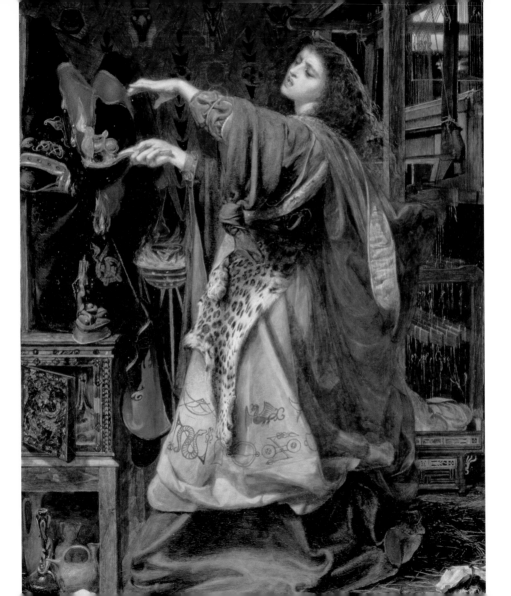

Solomon, Simeon
Bacchus (detail), 1867

Another of Rossetti's 'disciples' was the Jewish painter Simeon Solomon, who used the Old Testament stories as inspiration for many of his paintings. However, for this picture, Solomon has referenced a character from mythology, Bacchus the god of wine and fertility.

During the 1860s, and under Rossetti's guidance, the new generation of Pre-Raphaelite artists embarked on a move away from Ruskinian naturalism and from precise historical context towards more spiritual and symbolic representations. There was also less emphasis on Giotto (*c.* 1266–1337) and more on Mantegna (*c.* 1831–1506) or even Michelangelo (1475–1564). Equally, the narrative of a particular scene was replaced by the close-up sensuousness of the figure. In Rossetti's case it was the sensuous women such as *Bocca Baciata*. For the homosexual Solomon, it was the boyish good looks of *Bacchus*.

In 1873, Solomon was arrested and punished for his homosexual activities, for which he was vilified by the public and shunned by his family. After this he was never able to sell his paintings and became an alcoholic, dying on a London street as a vagrant.

CREATED

London

MEDIUM

Oil on paper laid down on canvas

RELATED WORK

Bocca Baciata by Dante Gabriel Rossetti, 1859

Simeon Solomon *Born* 1840 London, England

Died 1905

Brown, Ford Madox

Romeo and Juliet, 1868–71

Like many of the younger generation of Pre-Raphaelites, the older Brown also fell under the charismatic spell of Rossetti during the 1860s, even though he was at one time his early mentor. Brown returned to literary and legendary sources for inspiration, having enjoyed critical success with his social narratives such as *Work* in the previous decade.

Romeo and Juliet still retains many elements of the 'truth to nature' found in his earlier work (the Italianate city in the background), but is now imbued with the symbolism of faith, hope and charity. The first is shown in the white ostrich feather on Juliet's right shoulder, the crow in the shrub at bottom left suggests the second, and charity is personified as love in the embrace of the two protagonists.

The painting is one of four slight variants, one of which was exhibited at the *Exposition Universalle* in 1889 attracting the favourable attention of French critics. It is quite probable that the French symbolist painter Puvis de Chavannes (1824–98) saw the work there, repeating the motif in his own work in 1892.

CREATED

Probably London

MEDIUM

Watercolour and bodycolour with gum arabic

RELATED WORK

Romeo and Juliet by Puvis de Chavannes, 1892

Ford Madox Brown *Born* 1821 Calais, France

Died 1893

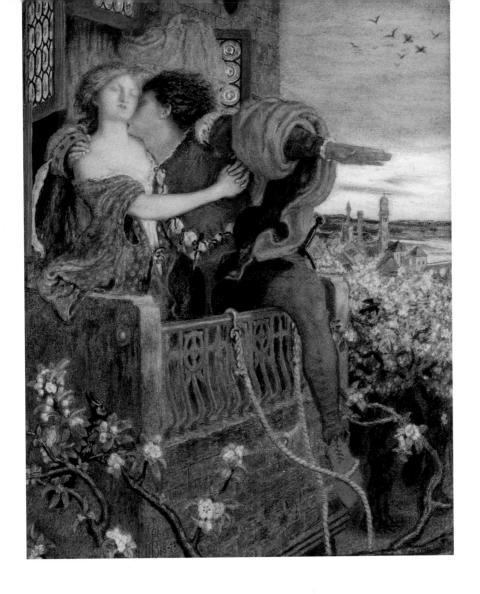

Rossetti, Dante Gabriel

Pandora (detail), 1869

© Faringdon Collection, Buscot, Oxon, UK/The Bridgeman Art Library

This painting clearly demonstrates the affinity that Rossetti had with both poetry and the visual arts, the frame of the painting suitably inscribed with lines from the sonnet he had written about *Pandora*. The model for the painting was Jane, the wife of his friend Morris with whom Rossetti had been working since 1860. Apart from designs for furniture and stained glass for the newly formed Morris, Marshall Faulkner and Co., Rossetti (and Burne-Jones) had also helped Morris decorate his newly built *Red House* with scenes from medieval legend. After this, Rossetti returned to painting with a new agenda, symbolism.

According to Greek mythology, Pandora was the first mortal woman who was sent by Zeus as a punishment to man because of Prometheus's indiscretion of stealing fire from him and giving away its secret to mortals. Pandora possessed a box containing all the evils which, when opened, released them all to be absorbed by men. Only hope was retained in the box once closed. The Pre-Raphaelites thus had a new motif – the *femme fatale*, one that was taken up by many of its painters.

CREATED

Probably London

MEDIUM

Chalk on paper

RELATED WORK

Medea by Anthony Frederick Sandys, 1866–68

Dante Gabriel Rossetti *Born* 1828 London, England

Died 1882

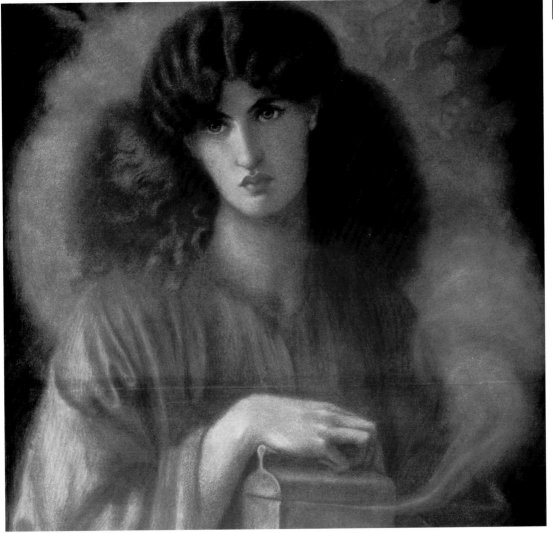

Inchbold, John William

In Early Spring (A Study in March), c. 1855

Not all of the Pre-Raphaelite painters were inspired by portrayals of figures, whether real or mythological. Although in the minority, one such artist was John William Inchbold, who rarely painted anything other than landscapes, his solitary, unsociable and often brusque manner possibly contributing to this tendency.

Inchbold changed his style to one that encapsulated the Ruskinian notions of 'truth to nature' as demonstrated by *In Early Spring*, after seeing the Pre-Raphaelites' work, particularly that of Millais and Hunt. The embracing of this style was, however, short-lived, possibly a reaction to the disputatious Ruskin with whom he travelled in 1858. After 1860 he returned to a much looser style of painting, more akin to the watercolours of Joseph Mallord William Turner (1775–1851).

In Early Spring takes its influence from Wordsworth's *Excursion*, which tells of the season's arrival. In the painting, Inchbold presents us with an image of a sheep and her lambs as well as primroses in the foreground telling the viewer unequivocally that spring has arrived. The landscape style is repeated by a number of newcomers to Pre-Raphaelitism in this period such as John Brett (1831–1902).

CREATED

Probably Lancashire

MEDIUM

Oil on canvas

RELATED WORK

Val d'Aosta by John Brett, 1858

John William Inchbold *Born* 1830 Leeds, England

Died 1888

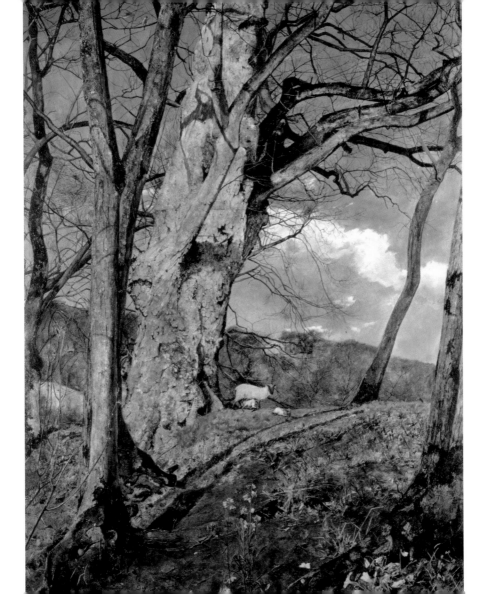

Burne-Jones, Sir Edward Coley

The Mill (detail), 1870–82

The long gestation period of this painting reflects significant changes in the artistic ethos and personal character of Burne-Jones at the time. Despite being largely self-taught, the draughtsmanship of Burne-Jones's drawing and painting was of a very high calibre. This attention to detail had been achieved working with Morris on stained-glass designs in the 1860s, and looking more closely at early Italian painting on visits to Venice and Padua he had made with Ruskin in 1862.

Nevertheless, by the late 1860s, he felt unable to compete at the highest level with artists such as Frederic, Lord Leighton (1830–96). He had also quarrelled with Ruskin over Michelangelo, for whom Burne-Jones had a very deep respect and held in the same regard as Giotto and others of the *Quattrocento*. Thus he began the 1870s with a newfound mode of expression, which needed to be explored more fully. *The Mill* explored those ideas of a more 'mannered' expression of depiction, which he would have seen in Italy and from his exposure to Northern-Renaissance artists such as Hans Memling (c. 1433–94). Such explorations for Burne-Jones were, however, never copies or imitations but innovations.

CREATED

Unknown

MEDIUM

Oil on canvas

RELATED WORK

The Adoration of the Magi by Hans Memling, 1470–72

Sir Edward Coley Burne-Jones *Born* 1833 Birmingham, England

Died 1898

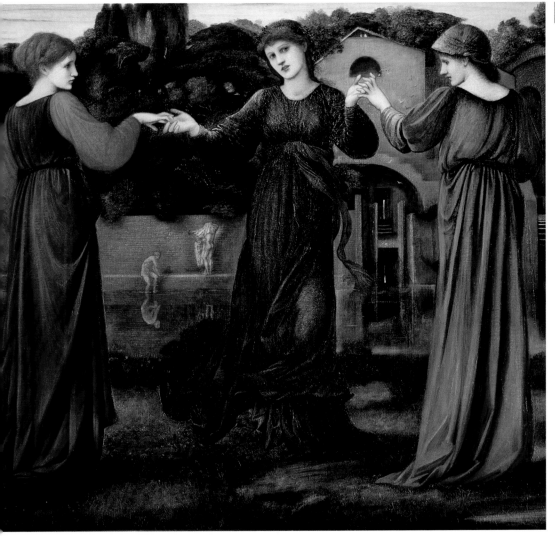

Rossetti, Dante Gabriel

Dante's Dream, 1871

After his earlier work on the depiction of Dante and Beatrice, Rossetti continued the theme in this one, *Dante's Dream* commissioned in 1869 by William Graham, a Scottish MP, and completed in 1871. The work is considerably more ambitious and on a larger scale than previous incarnations. On this occasion, the work is in oil instead of watercolour and, at over two metres (6 ft 6 in) wide, is on the same scale as a major history painting. Rossetti once remarked that, 'a big picture is glorious work, really rousing to every faculty one has'. Unlike many of Rossetti's smaller works, this painting is highly finished as befitting a large-scale narrative work such as this.

Jane Morris modelled for the departed Beatrice, who in this scene is being kissed by Love leading Dante by the hand towards her, while a group of angels at the top of the picture are taking her soul.

At the time of this painting, Rossetti had begun an affair with Jane, finding in her as muse and lover a deep devotion that was manifest in many of his subsequent paintings – a consummate female beauty.

CREATED

Probably Kelmscott Manor, Oxford

MEDIUM

Oil on canvas

RELATED WORK

The Siesta by John Frederick Lewis, 1876

Dante Gabriel Rossetti *Born* 1828 London, England

Died 1882

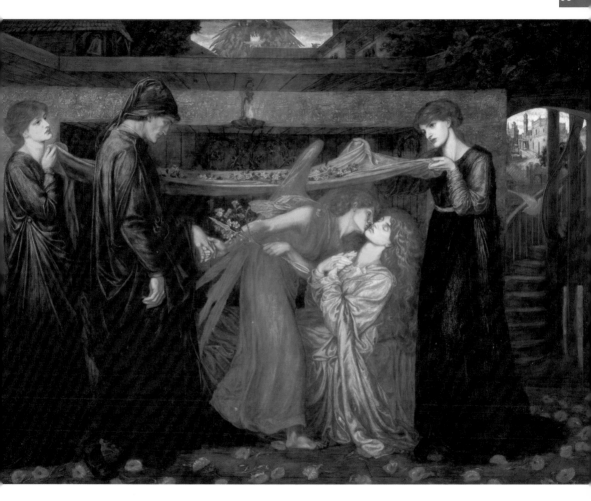

Rossetti, Dante Gabriel
The Bower Meadow, 1872

Although dated 1872, the landscape background to *The Bower Meadow* was in fact begun in 1850. At that time, Rossetti and the others of the Brotherhood, as well as Brown, were experimenting with the technique of *en plein air* painting. One thinks of Impressionism as the instigator of this mode of painting, but in fact antecedents of this can be found from the Early Renaissance on. In fact, the Pre-Raphaelites wished to return to that mode, one that was particularly laboured and meticulous in detail to attain their idealized 'truth to nature'. Their ideal was not to 'sketch in oil' as John Constable (1776–1837) had done, a practice that required the artist to finish in the studio, but actually to paint the complete landscape, in the minuteness of detail, *en plein air*.

By the time the less detailed foreground was added in 1871–72, Rossetti's concerns were less about nature and more about spirituality and symbolism. He was also now using oil as his preferred medium to watercolour and there is more lyricism in the composition and style than before.

CREATED

Sevenoaks Kent and Kelmscott Manor, Oxford

MEDIUM

Oil on canvas

RELATED WORK

Le Chant d'Amour by Sir Edward Coley Burne-Jones, 1869–77

Dante Gabriel Rossetti *Born* 1828 London, England
Died 1882

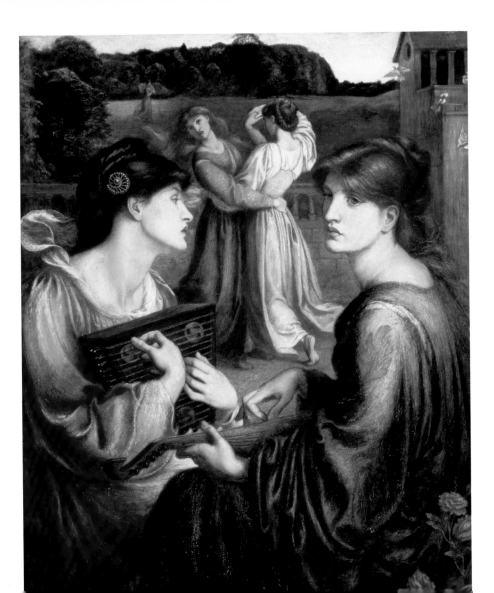

Hughes, Arthur

Jack O'Lantern (detail), 1872

Today we think of Jack O'Lantern in terms of the large pumpkins that are hollowed out and lit from the inside by candles, used on Hallowe'en. The tradition dates back to ancient times when turnips were used for the same purpose, namely the celebration of the evening of All Souls' Day, when the boundaries between the spiritual and material worlds become blurred. Jack O'Lantern was in fact a mythical impish creature that continued to outwit the devil, and thus serves Hallowe'en's purpose, but was also the nickname given to a night watchman of the period.

In this departure from his usual paintings of romantic narrative, Hughes has portrayed a piece of folklore popular in Victorian times. In the last quarter or so of the nineteenth century there was a growing market for fairy and folklore paintings, and Hughes, one of the most commercially minded of the Pre-Raphaelite painters, capitalized on this. The style for the picture is redolent of the Romantic eighteenth-century artist Joseph Wright of Derby, who used light and shadow to such dramatic effect.

CREATED

Unknown

MEDIUM

Oil on canvas

RELATED WORK

A Cottage on Fire by Joseph Wright of Derby, 1787

Arthur Hughes *Born* 1832 London, England

Died 1915

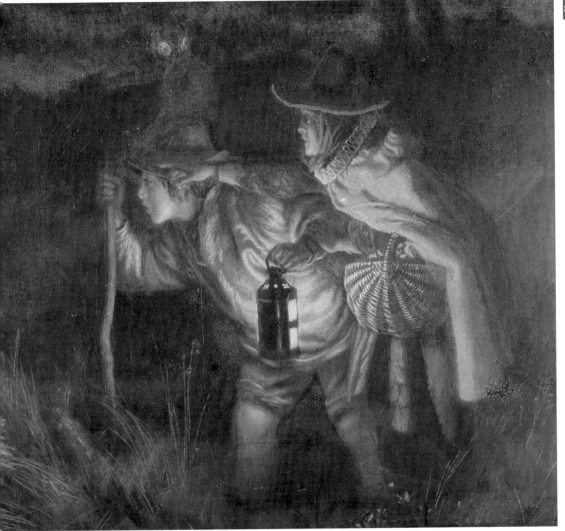

Burne-Jones, Sir Edward Coley
The Doom Fulfilled, c. 1875–77

Burne-Jones had been able to absorb much of Rossetti's influence and, without copying or imitating, develop his own innovative style that had its own language, Symbolism. The curved forms used in the design also anticipate Art Nouveau by at least 20 years.

The nakedness of the female in this painting (the full title of which is *The Doom Fulfilled (Perseus Slaying the Sea Serpent)*) is unusual for the time, in that the nude had become unfashionable in mid-Victorian society, following the prolonged mourning by the Queen of her consort Albert. Burne-Jones has not idealized Andromeda's body, but presented her as 'truth to nature'. Her human skin tones act as a foil to the clothed Perseus who is similarly coloured to and entwined with the sea serpent, symbolizing perhaps that the artist views the beauty of male and female very differently.

The painting is one of a series of 'Perseus' themed pictures commissioned by Arthur Balfour, the politician. In this work, Perseus is killing the sea monster, Ceto, in order that he can free Andromeda who has been chained to a rock by her father King Cepheus as a sacrifice, to appease the god Poseidon.

CREATED

London

MEDIUM

Gouache on paper

RELATED WORK

The Love of Souls by Jean Delville, 1900

Sir Edward Coley Burne-Jones *Born* 1833 Birmingham, England

Died 1898

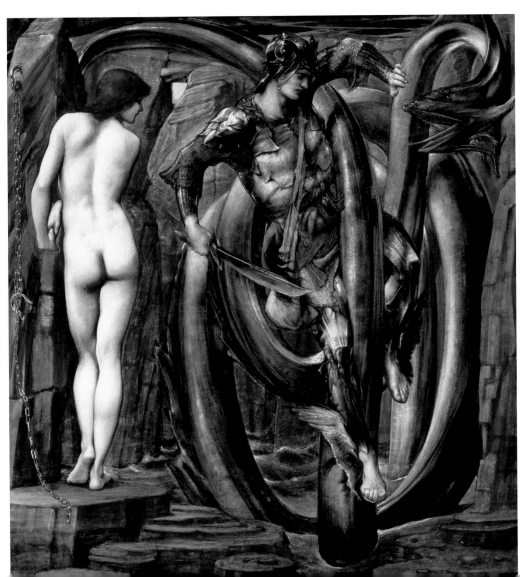

Burne-Jones, Sir Edward Coley
The Baleful Head (detail), *c.* 1876

This is another of the 'Perseus' series of paintings based on Greek legend commissioned by but not completed for Balfour. In the legend, Medusa, a beautiful nymph, has intercourse with Poseidon inside the temple of Athena. The goddess takes her revenge by turning Medusa's head with its beautiful hair into a gorgon with venomous serpents in place of the hair. Anyone who looks at Medusa is turned into stone. Perseus is sent by King Polydectes to kill the gorgon, which he does by beheading her while she is sleeping, avoiding being turned into stone by looking at her reflection in a mirror.

Numerous painters and sculptors of the Renaissance, such as Cellini (1500–71), Caravaggio (1571–1610) and Leonardo da Vinci (1452–1519), undertook the portrayal of Perseus with the head of Medusa. In Burne-Jones's picture there is a departure from the normal narrative, as Perseus and Andromeda look at the head of Medusa as a reflection in the water of a birdbath, and the real Medusa reveals herself in the apple tree next to them. There is considerable symbolism in the apple tree and its fallen fruit, in both Christianity and Classical mythology.

CREATED

London

MEDIUM

Gouache on paper

RELATED WORK

The Sphinx by Gustav Moreau, 1886

Sir Edward Coley Burne-Jones Born 1833 Birmingham, England

Died 1898

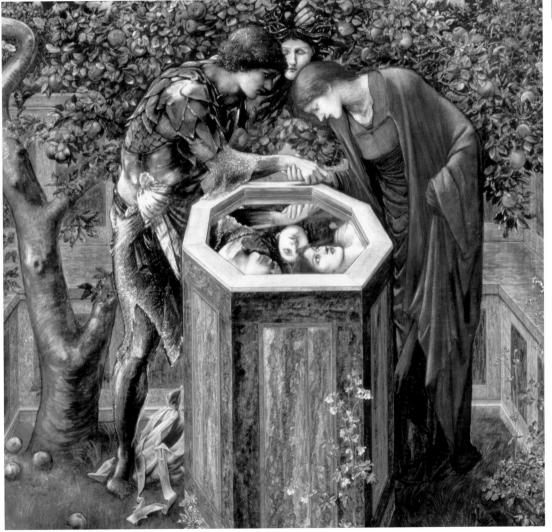

Burne-Jones, Sir Edward Coley

The Golden Stairs, 1871–80

During his trips to Italy in the early 1870s, Burne-Jones recorded in meticulous detail many of the things that he saw, filling sketchbooks with endless references. He was striving for the ideal balance of recording what he actually saw with the spiritual essence of the motif. This attention to detail meant that his finished paintings often took years to complete, as he would be working and adjusting several canvases at one time.

The Golden Stairs was begun just prior to visiting Italy for the first time in 1871 and it was not completed until 1880. It was shown at the Grosvenor Gallery the same year and was well received, although then, as now, there was much debate as to its meaning. Although it has an overall solemnity, its protagonists are not sad, the young ladies at the top of the stairs appearing more frivolous than the more considered group at the bottom, suggesting perhaps an allegory of youth — the woman at the door glancing backwards for one last time before entering womanhood. Alternatively it may just be a well-executed and decoratively designed painting.

CREATED

London

MEDIUM

Oil on canvas

RELATED WORK

Nausicaa by Frederic, Lord Leighton, 1878

Sir Edward Coley Burne-Jones *Born* 1833 Birmingham, England

Died 1898

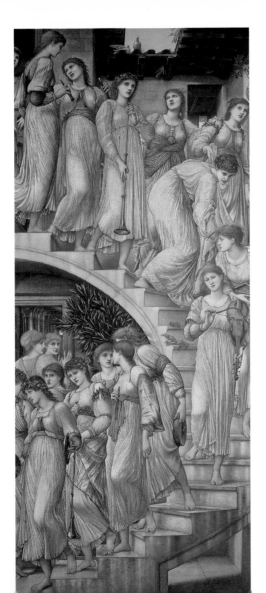

Rossetti, Dante Gabriel

Proserpine (detail), 1882

In 1871 Rossetti moved into Kelmscott Manor in Oxfordshire, a large house that he jointly leased with Morris. With Morris away much of the time, Rossetti was left alone with his wife Jane who became his favourite model. It seems likely that they became lovers, since the Morris's marriage had been in difficulties due to William's work commitments and general indifference. However, it appears to have been more platonic than lustful, a love that was more akin to that which his hero Dante had for Beatrice, although Jane and Rossetti were also soul mates.

Rossetti painted several different versions of *Proserpine* using Jane as the model. Proserpine was Queen of the Underworld, forced to live there by her abductor, Pluto, King of the Dead. Zeus objected to this cruelty and persuaded Pluto to let her go. However, he made her eat a pomegranate (shown in the painting) thus ensuring that she could only live on Earth for part of the year, before returning once again to the Underworld. The story has a resonance of course with Jane's own marriage to Morris.

CREATED

Probably Kelmscott Manor, Oxford

MEDIUM

Oil on canvas

RELATED WORK

King Cophetua and the Beggar Maid by Sir Edward Coley Burne-Jones, 1880–84

Dante Gabriel Rossetti *Born* 1828 London, England

Died 1882

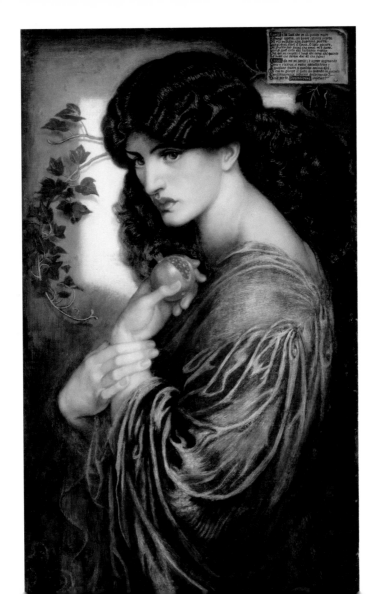

Burne-Jones, Sir Edward Coley

The Prioress's Tale, 1865–98

The design for this painting was originally executed in oil on a wardrobe panel for Morris's house in 1859. Burne-Jones had a life-long friendship with Morris after they met in Oxford as undergraduates, both originally wishing to study theology. The design shown here was executed in gouache on paper and demonstrates how far his draughtsmanship and eye for detail had improved over the course of his career. It was begun in 1865 but not completed until the year of his death in 1898, just two years after Morris's. Apart from the quality of detail, the most noticeable difference is the inclusion of an Italianate city in the background, missing from the original, reflecting the knowledge gained from his trips to Italy.

The narrative for this picture is taken from Chaucer's *Canterbury Tales*, an essentially anti-Semitic story of a seven-year-old Jewish boy who reveres the Virgin Mary, only to be murdered by his Jewish community, who in turn are executed in the most barbarous manner. In this picture the visiting Virgin offers communion to the prayerful boy.

CREATED

London

MEDIUM

Gouache on paper

RELATED WORK

Elijah in the Wilderness by Frederic, Lord Leighton 1877–78

Sir Edward Coley Burne-Jones *Born* 1833 Birmingham, England

Died 1898

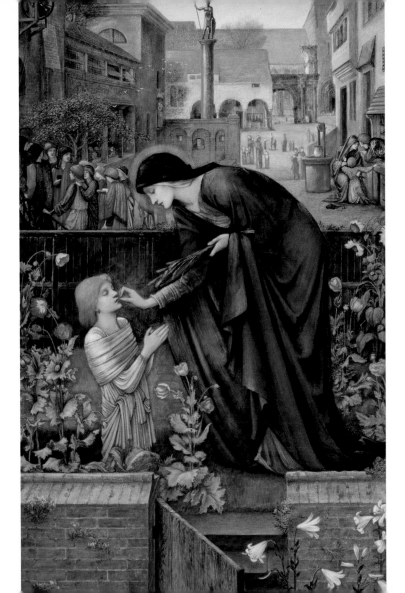

The Pre-Raphaelites

Society

Millais, Sir John Everett

The Woodman's Daughter, 1851

Having provoked outrage at the submission of paintings such as *Christ in the House of His Parents* at the Royal Academy, John Everett Millais retreated to less controversial subjects in his next two paintings including this one, *The Woodman's Daughter*. Millais felt at this early stage in his career that he could not afford to upset the Establishment too much, since for him the Academy was where the critical battles were fought. His election as an Associate of the Academy in 1854 would appear to have vindicated that decision. This painting, together with another less contentious one *The Return of the Dove to the Ark*, was exhibited at the Academy in 1851. This year marked a turning point for Millais and other Pre-Raphaelite painters, since they now enjoyed the support of John Ruskin (1819–1900), the leading art critic of this period, who had been responsible for defending and explaining the art of Joseph Mallord William Turner (1775–1851). His book *Modern Painters*, a work of five volumes dating from 1843, not only defended Turner, but also acted as a bible for young artists seeking a new idiom.

CREATED

Oxford

MEDIUM

Oil on canvas

RELATED WORK

The Hireling Shepherd by William Holman Hunt, 1851

Sir John Everett Millais *Born* 1829 Southampton, England

Died 1896

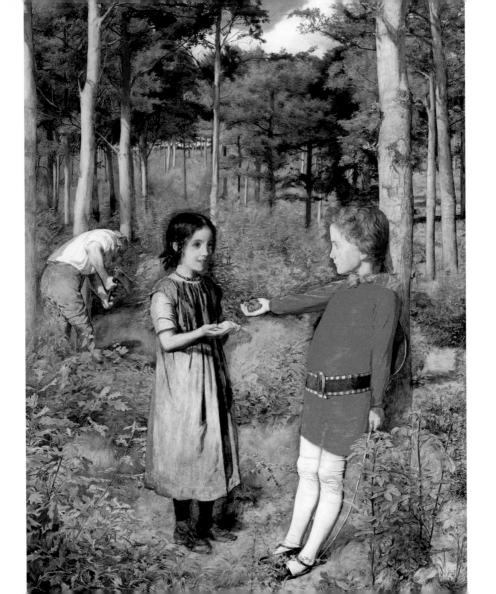

Millais, Sir John Everett

The Huguenot (detail), 1852

The romanticized Huguenot was a very powerful image for the Pre-Raphaelites, representing a hero who had fought against Catholicism in the Northern-European Reformation during the sixteenth century.

The Huguenots were in fact Protestant reformers who had sought a Calvanistic approach to religion in France that decried Catholic ritual and ceremony. As in England at the same time, this led to civil war with Huguenots being persecuted as iconoclasts. Many thousands died, most famously in Paris in 1572 in what became known as the St Bartholomew's Day Massacre. Such persecution led to a mass emigration of Huguenots from France at the end of the sixteenth and beginning of the seventeenth centuries, with some 50,000 of them coming to England.

By the time of Millais' picture, the Huguenots had integrated into Protestant England and many of them had become very prosperous, particularly in the precious metals and textiles trades. Millais has depicted this Huguenot wearing sixteenth-century costume complete with the Huguenot 'Cross' around his neck. In fact the full title for the picture was *A Huguenot, on St Bartholomew's Day refusing to shield himself from danger by wearing a Roman Catholic badge.*

CREATED

Worcester Park Manor House, Surrey

MEDIUM

Oil on canvas

RELATED WORK

The Black Brunswicker by Sir John Everett Millais, 1859–60

Sir John Everett Millais *Born* 1829 Southampton, England

Died 1896

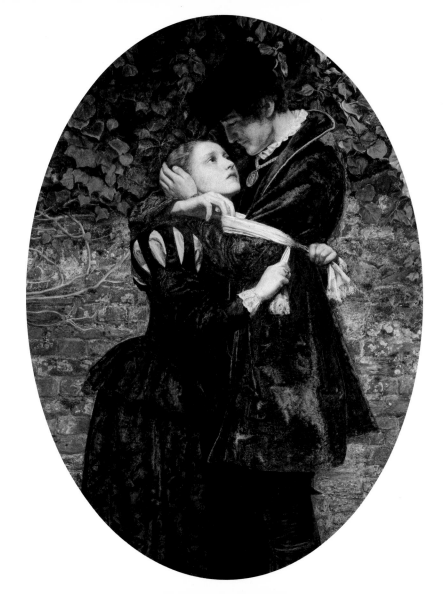

Millais, Sir John Everett

L'Enfant du Regiment (The Random Shot), 1855

The period from 1853 marked a transition from Millais the innovator and pioneer of Pre-Raphaelitism to a more populist mode in his oeuvre. In *L'Enfant du Regiment (The Random Shot)* Millais has used an imaginary scene, apparently inspired by a Donizetti opera, of a young boy asleep on an effigy of a medieval knight. In the background is some sort of military engagement, which may well be a contemporary scene from the Crimean War. The uniform jacket on top of the boy is probably from this period. Millais has cleverly combined this contemporaneous scene with aspects of medievalism, so appealing to Ruskin and the Pre-Raphaelites, including the gothic detailing of the tomb so painstakingly meticulous. As the art historian Paul Barlow points out, he has translated 'the Ruskinian Picturesque into a form in which it could be read both visually and as a narrative'.

The picture can also be seen as an allegory of the vulnerability of children at this time, not just in warfare but also in everyday life. For example at the time of this picture, 16 per cent of infants were likely to die prior to reaching their first birthday.

CREATED

Winchelsea, Sussex

MEDIUM

Oil on paper laid down on board

RELATED WORK

In Memoriam by Sir Joseph Noel Patton, 1858

Sir John Everett Millais *Born* 1829 Southampton, England

Died 1896

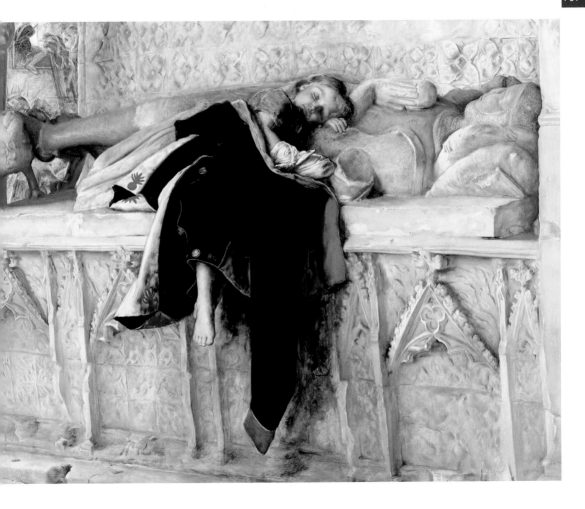

Millais, Sir John Everett
The Blind Girl, 1854–56

The Blind Girl is one of the first paintings completed after the artist's marriage to Effie Gray, the former wife of Ruskin. Millais' choice of more populist images shows his move to less time-consuming and more easily saleable pictures in order to support his new family, and is a reflection of his election to Associate Academician in 1854. There is evidence to suggest that Effie was instrumental in helping Millais select the motifs for his paintings. The brushwork in the picture has more bravura than his previous work, rendering a less highly finished background to the figures. It may also have been a deliberate act of wilfulness against the Ruskinian dogma of 'truth to nature'. Nevertheless the figures are still very detailed and the picture is full of symbolism, the crows in the middle ground, for example, suggesting hope.

The painting, like the ones of his Pre-Raphaelite Brother William Holman Hunt (1827–1910) at this time, is one of social commentary on depravation and vagrancy so rampant in Victorian England. It was exhibited at the 1856 Royal Academy Exhibition, reminding its bourgeois visitors of their social responsibility to the disadvantaged.

CREATED

Winchelsea, Sussex

MEDIUM

Oil on canvas

RELATED WORK

The Stonebreaker by John Brett, 1858

Sir John Everett Millais *Born* 1829 Southampton, England

Died 1896

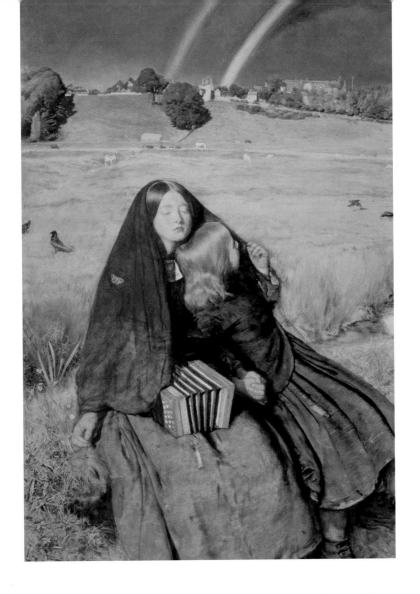

Millais, Sir John Everett
Peace Concluded (detail), 1856

The Crimean War was fought between Britain, France and Turkey on one side and the Russian Imperialists on the other, between 1854 and 1856. For the first time in modern history, Britain and France were on the same side and the war can be seen as the first using modern tactics and equipment. The war began as a result of territorial disputes concerning the Middle East, in particular the so-called 'Holy Places'. Beginning with the siege of Sebastopol by the Allies, it ended with the protracted peace discussions that culminated in the Treaty of Paris in 1856. Although victorious, Britain was heavily criticized for its monumental defeats at Balaclava, particularly the infamous Charge of the Light Brigade.

The resultant 17,000 soldiers killed or wounded in the Crimean War led to the resignation of the Prime Minister and his replacement by Lord Palmerston.

Significantly, through the new technology of telegraph, *The Times* newspaper was able to report the war 'live', a fact recorded by Millais in this painting, a work that is imbued with a palpable sense of relief.

CREATED

Probably London

MEDIUM

Oil on canvas

RELATED WORK

The Charge of the British Troops on the Road to Windlesham by George Baxter, 1854

Sir John Everett Millais *Born* 1829 Southampton, England
Died 1896

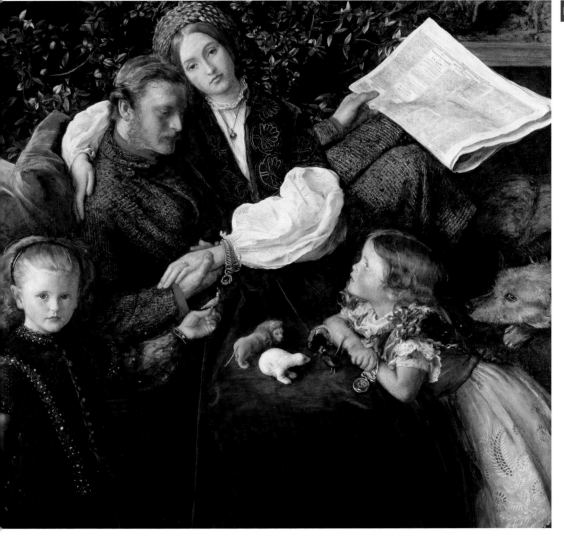

Millais, Sir John Everett
The Black Brunswicker, 1860

Although eschewing most of the *Discourses*, written in 1771 as a pronouncement of the first President of the Royal Academy Joshua Reynolds (1723–92), Millais was at least able to latch on to one – his espousal of history painting which required an artist to paint 'an eminent instance of heroic action or suffering ... which powerfully strikes upon the public sympathy'.

Millais has used an imagined scene of a Black Brunswicker soldier departing from his English lover before the battle of Waterloo. The Black Brunswickers were an elite troop of cavalrymen, renowned for their extreme bravery, that fought alongside the Prussian army, and thus on the British side against the French at the last battle of the Napoleonic Wars. Note also the engraving on the wall of the portrait of Napoleon by Jacques-Louis David, alluding to the imminent battle. Writing to his wife at the time of the picture, Millais was enthusiastic about the work as a populist image and surprised that the subject had not been more widely used by artists.

The painting took three months to complete and used Charles Dickens's (1812–70) daughter Kate as the model.

CREATED

London

MEDIUM

Oil on canvas

RELATED WORK

The 28th Regiment at Quatre Bras by Elizabeth Thompson (Lady Butler), 1875

Sir John Everett Millais *Born* 1829 Southampton, England

Died 1896

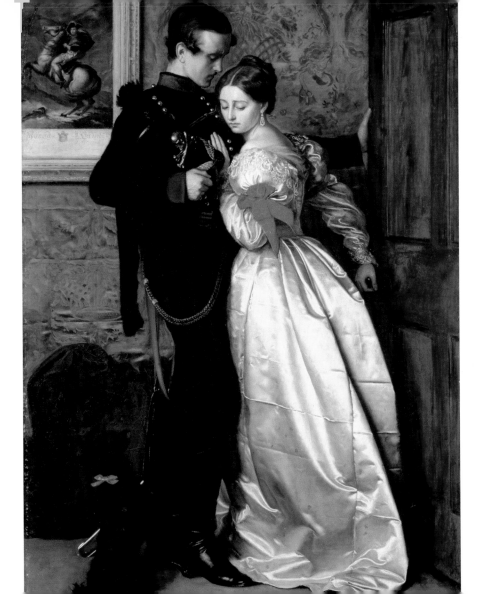

Hunt, William Holman

Claudio and Isabella, 1850

Prior to his depictions of social conscience, Hunt, like the other early Pre-Raphaelites, preferred literary scenes as the basis for his pictures. This scene is from Shakespeare's *Measure for Measure*, when the novice Isabella visits her brother Claudio in prison to tell him of her failure to secure his release unless she is prepared to lose her virginity to Angelo his captor.

When reviewing the picture in 1853 at the Royal Academy, the critics questioned its pictorial accuracy according to Shakespeare's text, criticizing Hunt's depiction of apparent resignation on the part of Claudio, when in fact Claudio pleads with Isabella saying: 'O: Sweet sister, let me live, What sin you do to save a brother's life, Nature dispenses with the deed so far that it becomes a virtue'.

What the critics missed of course was Hunt's portrayal of the exact moment before the words are spoken, the unease felt by Claudio at what he must ask and the tension and poignancy of that moment. It was this subtlety that made Hunt a good social commentator in the visual arts.

CREATED

Sevenoaks, Kent and London

MEDIUM

Oil on mahogany

RELATED WORK

Mariana by Sir John Everett Millais, 1851

William Holman Hunt *Born* 1827 London, England

Died 1910

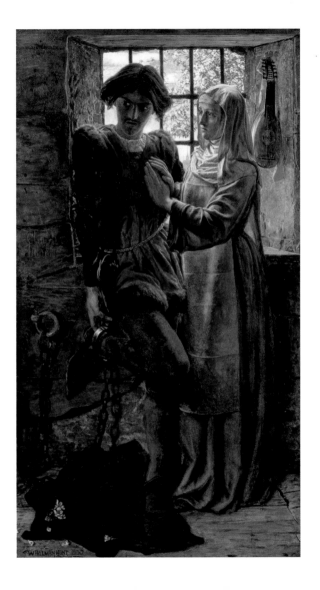

Hunt, William Holman

The Hireling Shepherd, 1851

In line with a continual search for realism in the early years of Pre-Raphaelitism, Hunt used an anonymous country girl as the model for the shepherdess in this painting. As William Michael Rossetti (1829–1919) pointed out much later, it was 'highly inexpedient for a painter occupied with an ideal or poetical subject to portray his personages from the ordinary hired models'. What Hunt and others did instead was to look for 'personages' that had an affinity with the work being portrayed. Millais' *Christ in the House of His Parents*, which used a real carpenter, is also a testament to this ideal.

The picture is taken from Shakespeare and the purpose of Hunt's use of the motif is revealed in his account dated 1897, in which he suggested that it was an allegory of the church neglecting the spiritual needs of its flock.

Ruskin, reviewing the picture at the Royal Academy in 1851, suggested that the face of the shepherdess was too coarse. The intended purchaser of the work, a Mr Broderip, requested that Hunt retouch the work before he purchased it for 300 guineas.

CREATED

Surrey

MEDIUM

Oil on canvas

RELATED WORK

Christ in the House of His Parents by Sir John Everett Millais, 1849–50

William Holman Hunt *Born* 1827 London, England

Died 1910

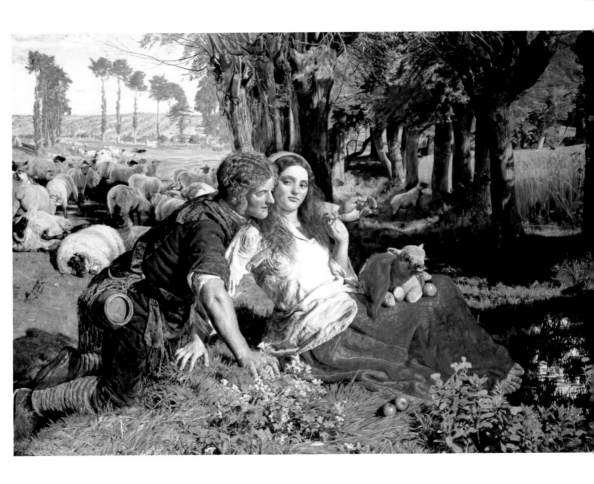

Hunt, William Holman

The Awakening Conscience, 1853

One of the most talked about pictures of its time and since, *The Awakening Conscience* deals with a social issue of its time, 'the kept mistress' defined by the gaudily furnished interior, which is anything but a family home. There is a feeling of claustrophobia emphasized by the oversized shiny furniture and the inappropriate overuse of gilt.

As in *Claudio and Isabella*, Hunt is depicting a particular moment in a scenario, when the mistress 'awakes', aware now of her sin. Hunt cleverly uses devices to emphasize the immediacy of 'the moment' – the ray of light that catches the bottom corner of the picture and the roll of sheet music that is unfolding on the floor from its outer covering.

Hunt is clearly marking the gender differences observed as part of Victorian mores, that of the 'double standard of sexual freedoms afforded to men and not women'. Again, Hunt emphasizes this in the hand gestures of the two protagonists, those clasped by the awakened and anxious young woman, and the open-handed gesture of the man that suggests indifference.

CREATED

London

MEDIUM

Oil on canvas

RELATED WORK

Found by Dante Gabriel Rossetti, 1853–82

William Holman Hunt *Born* 1827 London, England

Died 1910

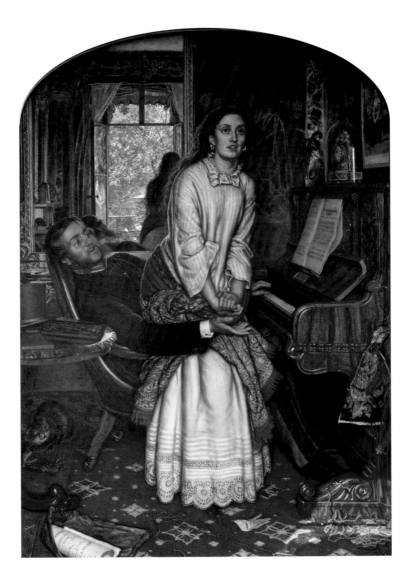

Rossetti, Dante Gabriel

Found, 1853–82

Dante Gabriel Rossetti worked on this unfinished picture from about 1853, which deals with a social issue of the period, the so-called 'fallen woman'. The picture shows a young man who has recognized his former fiancée on the streets of London, reduced to prostitution in order to live. She sinks to her knees and turns her face to the wall in shame, the former lover trying to exonerate her. The artist has used overt symbolism in the painting – the bollard as phallus and the enmeshed calf as metaphor for the present condition and fate of the young woman.

Throughout the course of the execution of the painting there were several important laws passed in protection of women's rights. Until 1857 women, particularly married women, had very few rights in law – men could divorce women but not vice versa. In 1857, *The Matrimonial Causes Act* allowed women to divorce men, but only if they could prove *aggravated* adultery. It was not until after 1870 that women were allowed to keep £200 of their own earnings, and it wasn't until 1882 that married women had any kind of property rights after a divorce.

CREATED

London

MEDIUM

Oil on canvas

RELATED WORK

Past and Present by Augustus Egg, 1858

Dante Gabriel Rossetti *Born* 1828 London, England

Died 1882

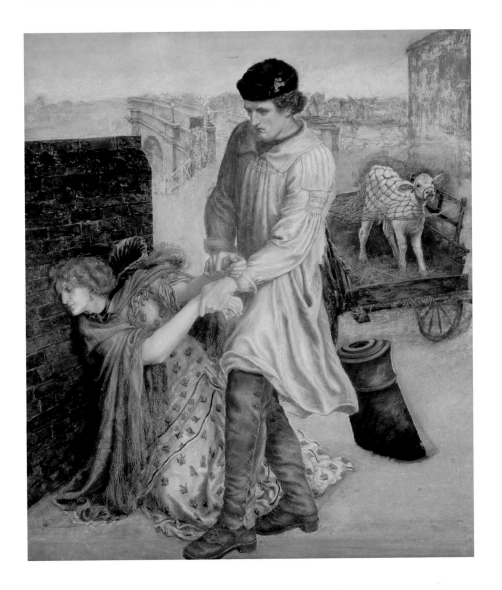

Rossetti, Dante Gabriel

St Catherine, 1857

The year 1857 was a busy one for Rossetti, and marked the beginning of the so-called second phase of Pre-Raphaelitism, after he had met William Morris (1834–96) and Edward Burne-Jones (1833–98). Apart from his commission to illustrate a book of Alfred Tennyson's (1809–92) poems for the publisher Edward Moxon, Rossetti was involved in a mural scheme at the newly built Debating Hall at the Oxford Union, a commission gained through his friendship with the architect Benjamin Woodward. In part, Ruskin, had been involved in much of the new building work at Oxford's Science Museum in the gothic-revival style, and may well have been instrumental in securing the commission. Ruskin had supported Rossetti from 1854 and continued to do so for the next 10 years, and he was also to support Morris in his quest for a social art and design ethos.

It was Ruskin who also commissioned this portrait of *St Catherine* from Rossetti. The painting shows the martyr being painted by a *Quattrocento* artist perhaps suggesting Carlo Crivelli (*c.* 1435–*c.* 1495), who painted a portrait of her in the late fifteenth century. St Catherine holds a wheel, the symbol of her martyrdom.

CREATED

Probably London

MEDIUM

Oil on canvas

RELATED WORK

St Catherine of Alexandria by Carlo Crivelli, 1491–94

Dante Gabriel Rossetti *Born* 1828 London, England

Died 1882

Rossetti, Dante Gabriel

The Beloved (The Bride), 1865–66

The current post-colonial culture has led some commentators to argue that this painting is racist, citing Rossetti's own comment that 'I mean the colour of my pictures to be like jewels and the *jet* would be invaluable.' They also suggest that Rossetti *intended* to portray the central figure of the white-skinned bride as racially superior to her 'servant'. This seems unlikely. Firstly the Pre-Raphaelites were supporters of abolition, a reasonably current issue after the Slavery Abolition Act was passed in 1833, outlawing slavery in British colonies. As the cultural historian Jan Marsh has argued, it is equally feasible that the 'mute but eloquent appeal' in the eyes of the child could actually be promoting the abolition campaign. The argument was continuing to rage in America where slavery was still legal, a situation being reported in Britain. The boy used in the picture was in fact the slave of an American visitor to London, Rossetti persuading his master to allow him to sit for the work.

The painting depicts the wedding scene from the Song of Solomon in the Bible.

CREATED

Probably London

MEDIUM

Oil on canvas

RELATED WORK

The Coat of Many Colours by Ford Madox Brown, 1866

Dante Gabriel Rossetti *Born* 1828 London, England

Died 1882

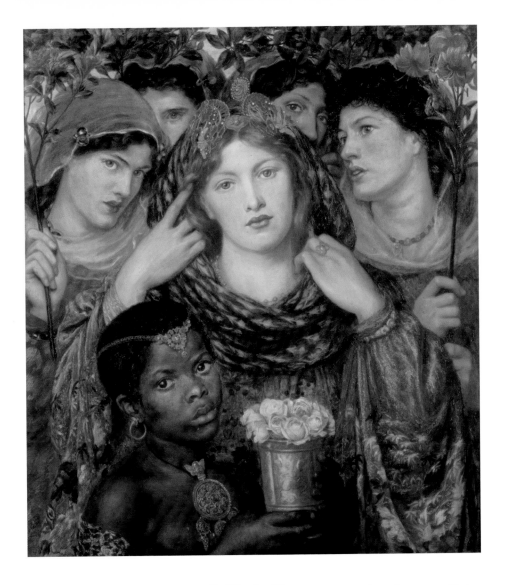

Rossetti, Dante Gabriel

Monna Vanna, 1866

In a letter contemporary to the painting, Rossetti makes it clear that he intended the picture to be, 'the Venetian ideal of female beauty'. The reference for the title, which means Lady Vanna, is taken from Dante's text in La Vita Nuova referring to her as 'bliss'. The painting's pose is similar to those adopted by other Venetian painters of the Renaissance such as Sebastiano del Piombo (c. 1485–1547).

Rossetti, like the other Pre-Raphaelites, was an artist with a social conscience, and a lover of beauty, who wanted to portray both qualities. Less than 40 years after this was painted, the Belgian writer Maurice Maeterlinck (1862–1949) wrote a play called Monna Vanna. Set in the fifteenth century, it tells the story of Prinzivalle, a Florentine mercenary who is besieging Pisa and also happens to be a lover of beauty. Before he vanquishes the city, he offers the Pisans a rescue package, namely that the commander's wife Monna Vanna, a woman of extreme honour and virtue, spend the night with him. The story is essentially one of moral decisions and social values, preoccupations for many in Victorian society such as Rossetti.

CREATED

Probably London

MEDIUM

Oil on canvas

RELATED WORK

Portrait of a Girl by Sebastiano del Piombo, 1515

Dante Gabriel Rossetti Born 1828 London, England

Died 1882

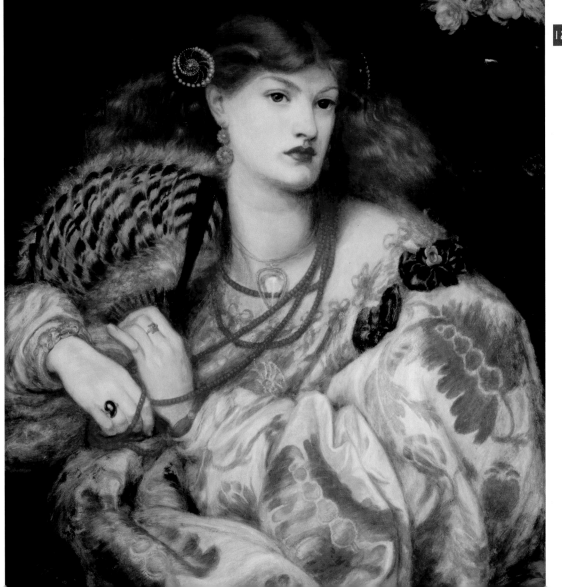

Collinson, James

The Renunciation of Queen Elizabeth of Hungary (detail), 1848–50

© Johannesburg Art Gallery, South Africa/The Bridgeman Art Library

This picture tells the story of Queen Elizabeth's renunciation of worldly goods in the thirteenth century. She was married to King Louis IV of Thuringia who died of the plague en route to the sixth crusade after which she vowed to help the poor of her country.

James Collinson was one of the original members of the Pre-Raphaelite Brotherhood (PRB), and also betrothed to the poet Christina Rossetti (1830–94), sister of Dante and William Michael, renouncing his own Catholic faith in order to marry her. The adverse press given to Millais' picture *Christ in the House of His Parents*, in which he was accused of blasphemy, caused Collinson to rethink his commitment to Anglicanism. As a result, he broke off his engagement with Christina, resigned from the Brotherhood and reverted to his original Catholic faith.

Following the religious wars of the sixteenth and seventeenth centuries in Britain, Catholics had only been able to hold public services again following the Catholic Relief Act of 1829. Until then, their refusal to renounce the ceremony of transubstantiation and the spiritual authority of the Pope meant Catholics were excluded from public life.

CREATED

London

RELATED WORK

Christ in the House of His Parents by Sir John Everett Millais, 1849

James Collinson *Born* 1825 Nottingham, England

Died 1881

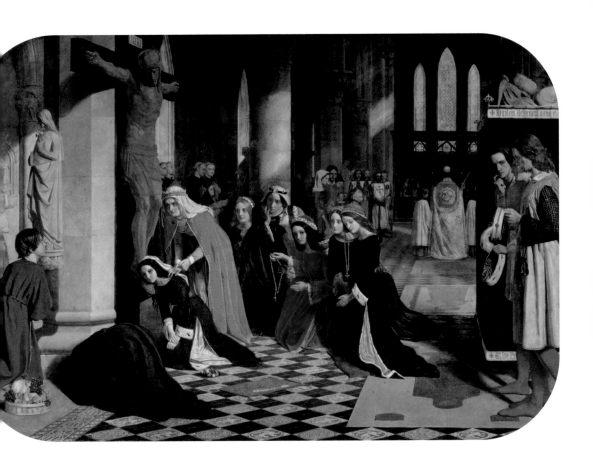

Stephens, Frederic George

Mother and Child, 1854

This unfinished picture is perhaps our best clue to why Frederic George Stephens gave up painting in favour of writing. The painting has been analysed and provides clues as to the Pre-Raphaelites' working techniques, revealing that they would meticulously finish one part before moving on to another. In the competent hands of Millais and Hunt for example that was straightforward, but for Stephens the overall composition of the painting looked awkward, a fault that the artist recognized, destroying much of his work in the late 1850s. His talent lay in art criticism.

From 1860 until 1901 he worked as an art critic for the influential art magazine *The Athenaeum*, and it is through this journal that we understand much of the ideals and agenda of the Pre-Raphaelites. However, the art historian Dianne Sachko Macleod has argued that much of his writing on them was neither objective nor independent, stating that Rossetti in particular vetted, and in some cases actually wrote, the articles that appeared concerning his paintings. Nevertheless, Stephens was the first to write a monograph (a relatively new concept then) on Rossetti.

CREATED

London

MEDIUM

Oil on canvas

RELATED WORK

Mother and Children Reading by Arthur Boyd Houghton, 1860

Frederic George Stephens *Born* 1828 London, England

Died 1907

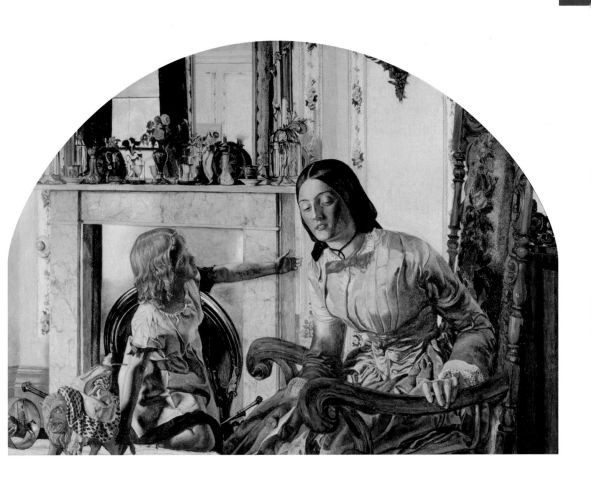

Brown, Ford Madox

Jesus Washing Peter's Feet, 1851–56

The figure modelling Jesus in this composition by Ford Madox Brown is Stephens, with others in the Brotherhood also modelling for the work although it is unclear who modelled for Peter. Significantly and symbolically, Judas, who is portrayed on the extreme left tying his sandal, was not modelled by any of the Pre-Raphaelites, Brown using a bricklayer's labourer instead.

The picture was originally painted and finished for exhibition at the Royal Academy in 1852, but Brown decided to rework the painting in 1856 to add what he called 'a more religious feeling' to some of the characters. William Michael Rossetti was one of the reworked 'apostles', an event tinged with irony since along with his brother he was an avowed atheist. The conflation of the model and character portrayed by the Pre-Raphaelites caused something of an outcry in their early careers, the public considering that insufficient veneration had been afforded to their religious subjects.

One of the curiosities of the picture is the halo around the head of Jesus, which appears only to the viewer rather than the other protagonists in the painting, an example of Pre-Raphaelitism striving for authenticity of detail.

CREATED

London

MEDIUM

Oil on canvas

RELATED WORK

The Child Jesus Going Down with His Parents to Nazareth by William Dobson, 1856

Ford Madox Brown *Born* 1821 Calais, France

Died 1893

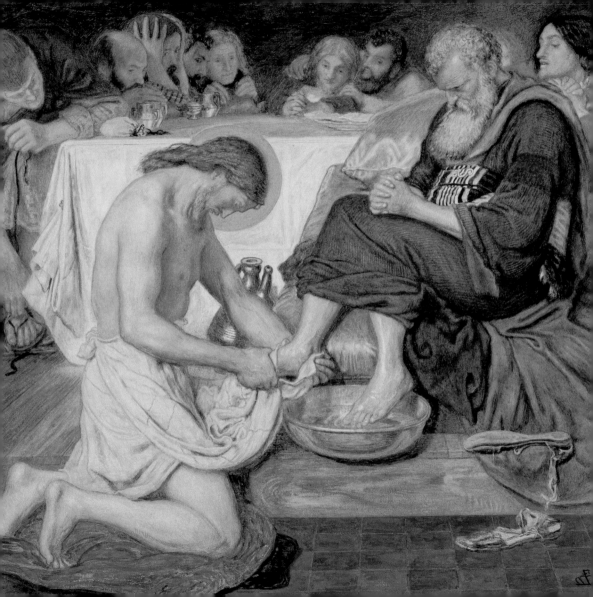

Brown, Ford Madox
The Last of England, 1855

The scene was inspired by Brown's Pre-Raphaelite associate Thomas Woolner (1825–92) and his departure for Australia in 1852, when emigration to the colonies was at its height and therefore a topical picture. Brown's picture is not, however, a romantic one, portraying instead the reality of the situation cramped together and cold on the open deck of a ship for a voyage that would take several weeks. The dominance of the two main characters, the circular shape of the image and the rail in the foreground present the viewer with a feeling of claustrophobia and alienation – such are the legacies of modernity.

One of the reasons that emigration became a hot topic was that from 1850 until about 1880, British trade unions actually encouraged emigration as a way of overcoming the continual peaks and troughs of the economy that adversely affected the working man. To support this idea, some trade unions actually provided funds for the passage not just to Britain's colonies such as Australia but also to America where there were abundant opportunities in a burgeoning economy.

CREATED

Hampstead, London

MEDIUM

Oil on panel

RELATED WORK

The Emigrant's Last Sight of Home by Richard Redgrave, 1858

Ford Madox Brown *Born* 1821 Calais, France

Died 1893

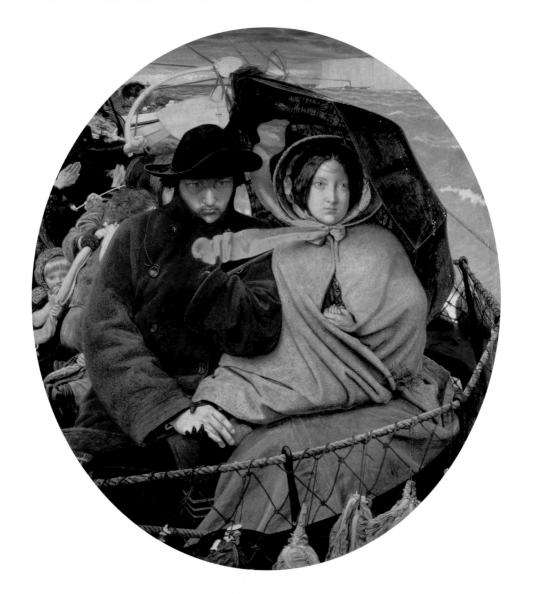

Brown, Ford Madox

Take Your Son, Sir!, c. 1857

This unfinished and complex picture was begun by Brown in 1851, returning to it in 1856–57 and then simply inscribing its title in pencil. The picture may originally have been a Madonna and child study, the halo-like mirror behind the woman alluding to that notion. However the mirror is borrowed from *The Arnolfini Marriage* by Jan van Eyck (c. 1390–1441), a favourite picture of the Pre-Raphaelites, in which is reflected the image of a man – the child's father? This would suggest that Brown, a great artistic commentator on social issues, was dealing with a 'fallen woman'.

The 'fallen woman' is a stereotype of Victorian society, a woman whose pre-marital sexual experience inevitably led to her ruin and expulsion from society – in effect a social outcast. The publication in 1850 of *David Copperfield* by Dickens had highlighted the issue through his character of Little Emily, very much the victim of Steerforth's caddishness, resulting in her need to emigrate to avoid social disgrace. Dickens also showed a personal interest in the problem opening a home for such unfortunates in London called Urania Cottage.

CREATED

London

MEDIUM

Oil on paper laid on canvas

RELATED WORK

The Arnolfini Marriage by Jan van Eyck, 1434

Ford Madox Brown *Born* 1821 Calais, France

Died 1893

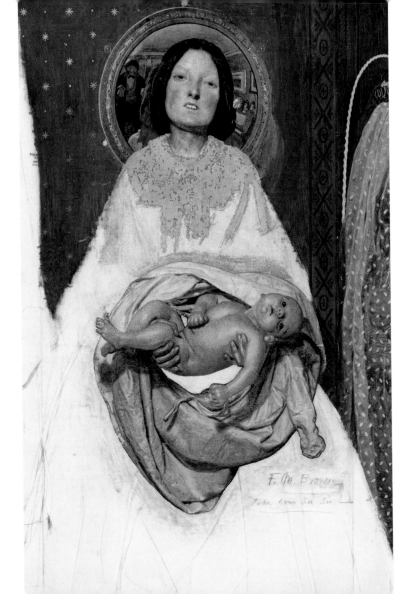

Brown, Ford Madox
Work, 1852–65

This wonderful tableaux of Victorian life in many ways epitomizes its era by emphasizing the strong work ethic of its society. The two figures on the right are the social commentators and reformers Thomas Carlyle (1795–1881) and the Reverend F.D. Maurice surveying a scene in Hampstead of a multi-classed society. Brown was an admirer of Carlyle's book *Past and Present* (1843), in which he dealt with the dehumanizing aspects of a civilized society, a scepticism that later writers such as Ruskin would find appealing. Carlyle, at least in this period of his writing, was commenting as Karl Marx had done on capitalism's ability to destroy individualism. Maurice was responsible for setting up the Working Men's College, in 1854 to educate working men in the arts. Ruskin taught drawing and Rossetti taught painting at the college, although he later relinquished his post in 1857 when Brown took over. On the left of the picture are several posters, one advertising the college. The painting, which is nearly two metres (6 ft 6 in) wide, was largely executed on the spot in the summer of 1852, later reworked in 1855 and 1856, and finally completed in 1865.

CREATED

Hampstead, London

MEDIUM

Oil on canvas

RELATED WORK

Vale of Rest by Sir John Everett Millais, 1858

Ford Madox Brown *Born* 1821 Calais, France

Died 1893

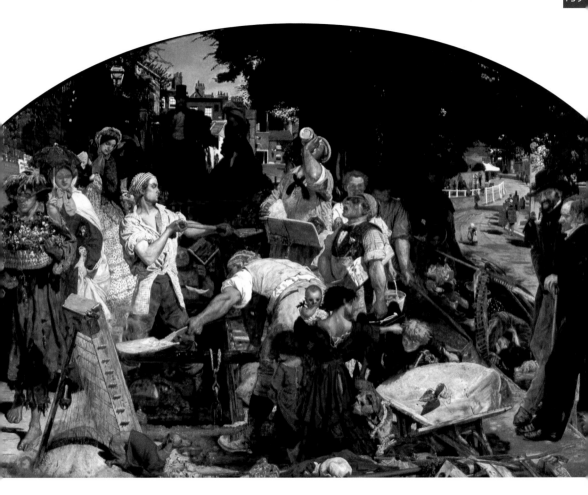

Hughes, Arthur
The Long Engagement (detail), 1859

During its first exhibition in 1859 at the Royal Academy, the picture by Arthur Hughes was inscribed with a quotation from Chaucer rather than the title that was added later. It read:

> 'For how might ever sweetnesse have been known
>
> To hym that never tastyd bitternesse ...'

The text is from *Troilus and Criseyde*, a tragic love story set during the Trojan War of a woman (Criseyde) who falls in love with a Greek prince (Troilus) only for her to be bartered as part of a hostage exchange, after which she forms a liaison with Diomedes a Greek warrior. In this version of the story, Chaucer is sympathetic to her plight. However the story was also told by Shakespeare as *Troilus and Cressida*, in which the heroine was portrayed as a whore, a play that was never performed during the Victorian period because of its sexual explicitness.

Both Chaucer and Shakespeare's tales were influential to the Pre-Raphaelites' pictures and Hughes may well have found the differing literary viewpoints of the same story appealing – a reflection of the Victorian era when sexual mores were being discussed and debated by its society.

CREATED

Pimlico, London

MEDIUM

Oil on canvas

RELATED WORK

The Proposal by William Powell Frith, 1853

Arthur Hughes *Born* 1832 London, England

Died 1915

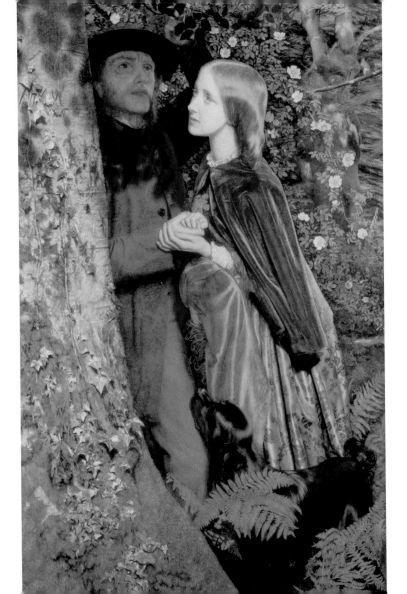

Hughes, Arthur

The Woodman's Child (detail), 1860

Although the Royal Academy was by far the most conspicuous place for exhibiting one's work up until the mid-nineteenth century, during the second half there were moves to provide alternatives, coming from ambitious art dealers and the artists themselves. One of the first of its kind, the Pre-Raphaelite Exhibition of 1857, was remarkable for its innovation. It was instigated by Brown who hired rooms in Russell Place, Bloomsbury, for the exhibition of over 70 Pre-Raphaelite works. This included a number of works by Rossetti who rarely actually showed his work in public.

In the following year, the influential and entrepreneurial art dealer Ernest Gambart organized an exhibition of modern British art that was dominated by Pre-Raphaelitism. The exhibition travelled to America, a new and innovative idea that was to become so instrumental in the sale of Impressionist works in the 1880s and 1890s. Gambart was better known, however, as a fine-art publisher, negotiating with all of the artists for reproduction copyrights. This was by far and away how most of the general public became aware of the Pre-Raphaelites' work.

CREATED

Unknown

MEDIUM

Oil on canvas

RELATED WORK

The Woodman's Daughter by Sir John Everett Millais, 1851

Arthur Hughes *Born* 1832 London, England

Died 1915

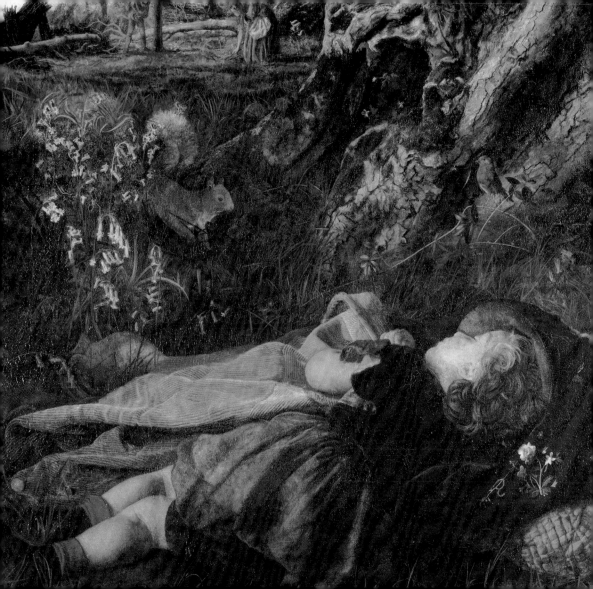

Hughes, Arthur
Home from Work, c. 1861

This picture is something of a departure from Hughes' Pre-Raphaelitism, a very sentimental genre image that was popular to Victorian taste. He appears to have renounced the highly detailed work of, for example, *April Love* for a work that uses a much looser brushwork and relies much less on bold assertive colour. These paintings would of course had taken less time to produce, making them ideal for publishers who commissioned book illustration. Hughes, like many other artists of his day, was attracted to illustration work as a more dependable route to financial stability than speculative painting.

By the mid-nineteenth century, the laborious flat-bed presses used in book illustration had been replaced by cylindrical presses, capable of producing faster and less expensive print runs. It was these factors that made books, and therefore education, more affordable and more accessible to a wider public. Moxon's edition of Tennyson, illustrated by Rossetti and published in 1857 is a prime example. Late nineteenth-century book publishing, particularly for children, was to be one of the most significant growth industries, with Hughes becoming one of its most important illustrators.

CREATED

Unknown

MEDIUM

Oil on canvas

RELATED WORK

My First Sermon by Sir John Everett Millais, 1863

Arthur Hughes *Born* 1832 London, England

Died 1915

Brett, John

The Stonebreaker, 1858

© Walker Art Gallery, National Museums Liverpool/The Bridgeman Art Library

In a sharp contrast to Gustave Courbet's (1819–77) contemporary picture of the same subject, John Brett's is an image of sentiment, emphasized by the dog playing nearby. Courbet's darker and altogether more painful depiction must, however, be seen within its context of political strife in France after the revolution of 1848, in which issues of rural poverty and labour were at the fore. Nineteenth-century revolutionary France cannot easily be compared with Britain, which enjoyed a stable political system under a constitutional monarchy. Both countries had an academic system for exhibiting paintings, but the French Salon was under the direction of the state and therefore politically sensitive, whereas in Britain the Royal Academy was relatively independent despite its royal patronage. It is therefore not surprising that the subject matter of many paintings exhibited in France during the nineteenth century was politically motivated.

Brett's depiction is altogether lighter in palette and mood, a more subtle approach to political comment. The milestone indicates 23 miles to London where capitalism was at its zenith – a two-day walk as far as the rural poor were concerned.

CREATED

Probably Maidstone, Kent

MEDIUM

Oil on canvas

RELATED WORK

The Stonebreakers by Gustave Courbet, 1849

John Brett *Born* 1831 Reigate, England

Died 1902

Wallis, Henry
The Stonebreaker (detail), 1857

© Birmingham Museums and Art Gallery/The Bridgeman Art Library

While Henry Wallis's picture shares the same political agenda as Brett's, namely the criticism of capitalism's apparent indifference to the rural poor, Wallis uses a much more powerful image to make his point. Wallis also used a political commentary by Carlyle in place of a title when it was exhibited (with Brett's picture) at the Royal Academy in 1858. The quotation came from Carlyle's *Sartor Resartus* (meaning 'tailor re-tailored'), an often-satirical work that intertwines fact and fiction, and presents the reader with a critique of Hegelian idealism scolding man for his inhumanity to his fellow man. This was of course in sharp contrast to the capitalism rife in England at this time – the creation of a bourgeois *nouveau riche* that had benefited from the Industrial Revolution at the expense of the working poor.

Wallis's image is one of a stonebreaker who has died of his labours. The dark brooding lurid colours add morbidity to a scene that calls out for human reflection on its tragedy. The melding of figure and natural background remind the viewer how easy it is to overlook this inhumanity.

CREATED

Unknown

MEDIUM

Oil on panel

RELATED WORK

The Hedger by John Brett, 1859–60

Henry Wallis *Born* 1830 London, England

Died 1916

Burne-Jones, Sir Edward Coley

Fair Rosamund and Queen Eleanor, 1862

This scene by Burne-Jones is factually based and depicts the encounter between Queen Eleanor of Aquitaine the wife of Henry II and his mistress Rosamund, whom Eleanor had discovered living within a secret room that the King had devised in his castle. Eleanor was responsible for murdering Rosamund by poisoning her in the twelfth century.

Eleanor was arguably the most powerful woman in medieval Britain. A very strong and intelligent woman, she was able to withstand not only her husband's infidelities but also a subsequent 16-year imprisonment at her husband's behest. Prior to that she had been both Queen of France and England, and had even gone on crusade despite a papal bull forbidding her. When Henry died, her eldest son Richard (The Lionheart) acceded to the throne, Eleanor acting as the head of government while he was away on crusade. Since the nineteenth century, Eleanor of Aquitaine has been seen as a very powerful matriarchal figure and also as the author of court etiquette and so-called 'courtly love' that was so appealing to the Pre-Raphaelites.

CREATED

Probably London

MEDIUM

Pen and ink, watercolour, gouache and gum on paper

RELATED WORK

Queen Eleanor by Anthony Frederick Sandys, 1858

Sir Edward Coley Burne-Jones Born 1833 Birmingham, England

Died 1898

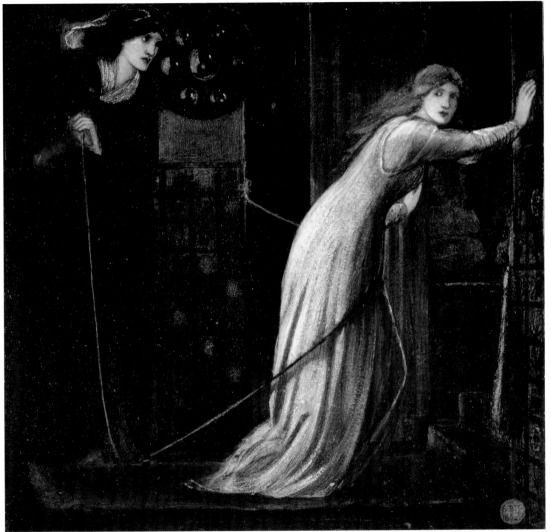

Burne-Jones, Sir Edward Coley

The Merciful Knight (detail), 1863

The scene of this picture is taken from a medieval tale, in which Christ is seen blessing a merciful knight who had earlier spared the life of his brother's murderer. The moral of the story, based on Christ's plea to God for the forgiveness of His crucifiers, is that all Christians should forgive their enemies as God has forgiven us for our sins against Him.

Charles Darwin (1809–82), who in 1859 published his *The Origin of Species*, brought into focus the debates around religion and morality that had been in evidence since the Enlightenment, when science began to explain phenomenon. The advance of science propagated by the Industrial Revolution, when anything and everything seemed possible, was a key factor in modern thought at the beginning of Victoria's reign when these issues were being debated. There was of course reaction to this scepticism by the church, building more churches during the Victorian period than before or since, and grander and more ornate churches to support a proliferation of new and original forms of worship. The dominant style of architecture in this period was gothic, with its emphasis on medieval archaism.

CREATED

Unknown

MEDIUM

Watercolour and gouache on paper

RELATED WORK

Jesus Washing Peter's Feet by Ford Madox Brown, 1852–56

Sir Edward Coley Burne-Jones *Born* 1833 Birmingham, England

Died 1898

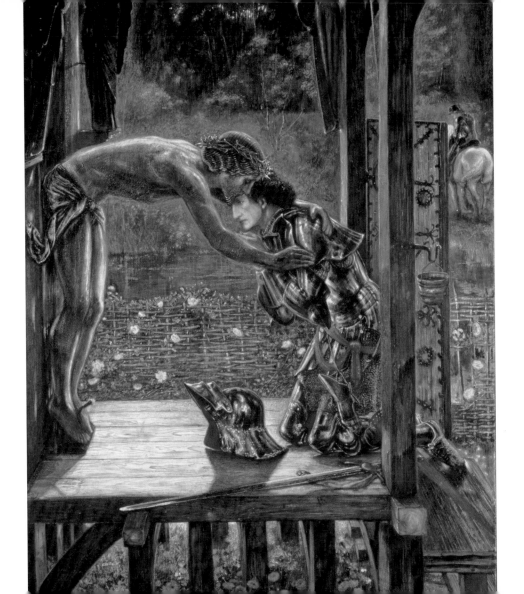

Burne-Jones, Sir Edward Coley

King Cophetua and the Beggar Maid (detail), 1884

© Tate, London 2007

The Pre-Raphaelite period, because of its characterized idiom of medieval archaism, is often seen as anti-modern; an inaccurate assessment for early Pre-Raphaelitism, given its protagonists were experimenting with new techniques as a result of new innovations in colour and paint technology. Their agenda was to portray the modern, often making social and political statements and commentaries in a visually didactic manner.

By the time of the so-called 'second wave' of Pre-Raphaelitism from the 1860s on, under Rossetti and most notable in the work of Burne-Jones, the 'modern' was spurned in favour of a return to medieval values to escape from and to counter industrialization, seen as the cause of inappropriate bourgeois values such as greed, and such social ills as poverty. For Burne-Jones, medievalism provided an antidote to modernity through its pictorial reference to romantic and chivalric notions of camaraderie. Gothic architecture, through Augustus Pugin (1812–52), had already established itself as the 'correct' style for the Christian faith in Britain. But it was Ruskin in *The Stones of Venice* who provided evidence that it was only the medieval age that demonstrated the individuality of the artisan.

CREATED

Probably London

MEDIUM

Oil on canvas

RELATED WORK

The Bower Meadow by Dante Gabriel Rossetti, 1871–72

Sir Edward Coley Burne-Jones *Born* 1833 Birmingham, England

Died 1898

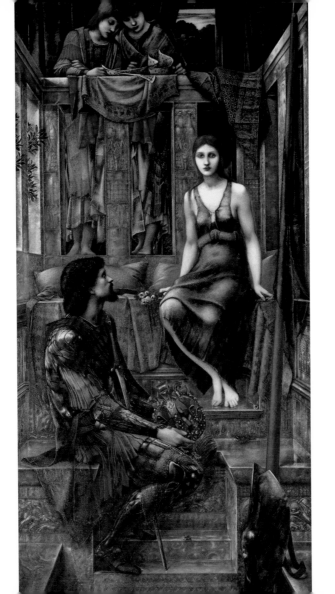

Scott, William Bell

Industry on the Tyne (Iron and Coal), 1855–60

The work shown here is in fact a watercolour study for the main oil painting commissioned for Wallington Hall in Northumbria, one of eight mural panels for the house's owner Charles Trevelyan depicting the history of Northumbria. Although older than the other Pre-Raphaelites, and with a different agenda to them, William Bell Scott was a personal friend of Rossetti and lived close by in Cheyne Walk, Chelsea, in the latter part of his life. Prior to that he lived in a castle in Scotland and was the master at the Government's School of Design in Northumberland.

The mural is a large-scale work that is comparable to Brown's *Work*. Scott's painting is, however, one of machinery in the modern world, a reflection of man's ingenuity and engineering capability, rather than an abstract of the 'work ethic' portrayed in Brown's. Because of this celebration of modernity and the machine aesthetic, Scott was at odds with Ruskin. For Ruskin the individuality of a (crafts)man was manifest in the unique artefact that he produced through his own labour. Thus industrialization's division of labour was anathema to him.

CREATED

Northumbria

MEDIUM

Watercolour

RELATED WORK

Work by Ford Madox Brown 1852–65

William Bell Scott *Born* 1811 Edinburgh, Scotland

Died 1890

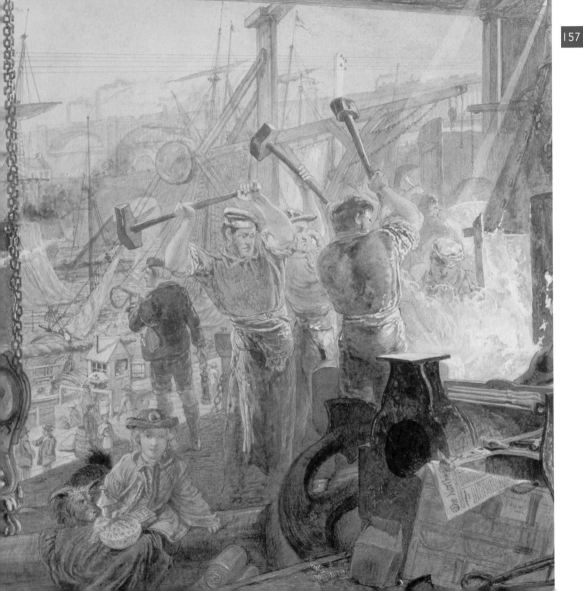

The Pre-Raphaelites

Places

Millais, Sir John Everett
Mariana, 1851

The inspiration for John Everett Millais' *Mariana* is Alfred Tennyson's (1809–92) poem *Mariana in the Moated Grange*, a tale of an anxious and frustrated woman awaiting the return of her lover Angelo. Tennyson's poem had in turn been taken from one of the characters in Shakespeare's play *Measure for Measure*, which was set in Vienna. Tennyson's poem does not have a specific geographical location but a 'moated grange' would suggest Britain as its locale. The room is medieval in feel and imagined except for the stained-glass window, which is heavily borrowed from the one at Merton College Chapel in Oxford, Millais spending time there in the summer of 1850. The main window denotes the joy of the Annunciation, a sharp contrast to Mariana's anxiety. The heraldic motif of the side window is Millais' own design.

Millais creates the scene of a woman weary from waiting a long time for her lover's return, as emphasized by the large tapestry that she has already completed, but more purposefully by the leaves strewn across the scene denoting the passing of the seasons.

CREATED

Oxford

MEDIUM

Oil on panel

RELATED WORK

Berengaria's Alarm for the Safety of her Husband, Richard Coeur de Lion by Charles Alston Collins, 1850

Sir John Everett Millais *Born* 1829 Southampton, England

Died 1896

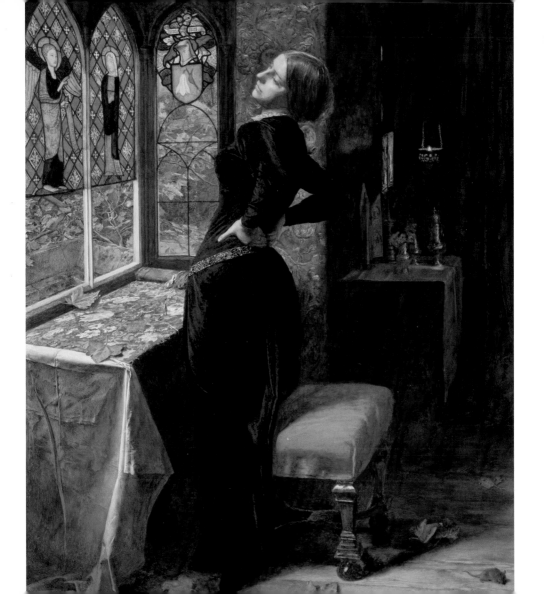

Millais, Sir John Everett

The Waterfall, 1853

In 1851 John Ruskin (1819–1900) wrote his pamphlet *Pre-Raphaelitism*, in which he sought to explain the Brotherhood's ideas and work, singling out Millais for particular praise. Ruskin saw Millais as the epitome of the movement, seeking to adopt him as his protégé. Ruskin's own agenda was to establish certain painters within the canon of great British art, artists whom he considered had 'defied all false teachings to do justice to the gifts with which they had been entrusted'. In short, he was looking to Millais as the natural successor to Joseph Mallord William Turner (1775–1851), who was to die later that year.

In the summer of 1853, Millais travelled with Ruskin and his wife Effie to Glenfinlas in the Scottish Highlands, in order to paint a portrait of the writer. Ruskin was keen to introduce Millais to mountainous regions (he had wanted to travel to Switzerland but Millais declined), which for him were both a quintessentially Turner subject and also evidence of The Almighty God in nature.

The painting shown here is a small study for the main portrait, which depicts a waterfall close to the house where they were staying.

CREATED

Glenfinlas, Scotland

MEDIUM

Oil on panel

RELATED WORK

Bonneville, Savoy with Mont Blanc by Joseph Mallord William Turner, 1803

Sir John Everett Millais *Born* 1829 Southampton, England

Died 1896

Millais, Sir John Everett

Portrait of John Ruskin, 1853–54

The Victorian era saw the popularization of Scotland and Scottish legend mainly through the novels of Sir Walter Scott (1771–1832) written in the half century or so before. Queen Victoria herself also popularized it through her purchase in 1848 of Balmoral Castle, where she often went with Prince Albert in summer.

Millais travelled with his brother William, Ruskin and his wife Effie to Scotland in July 1853 staying for about four months, during which time he painted this stunning portrait of the writer. After walking with Ruskin in the Trossacks for several days, they found a suitable location for the picture in which the writer would be 'looking over the edge of a steep waterfall'. Writing to his friend Charles Collins, Millais stated '(Ruskin) looks so sweet and benign standing calmly looking into the turbulent sluice below'.

The painting, less than a metre (3 ft 3 in) in height, is nevertheless monumental and typifies many aspects of the Victorian era, the protagonist a hero, romantic, social reformer, religious zealot, artistic reformer and naturalist. Ruskin was all of these and Victorian society's debt to him is captured in this ennobling portrait.

CREATED

Glenfinlas, Scotland and London

MEDIUM

Oil on canvas

RELATED WORK

John Ruskin Teaching Louisa Stewart Mackenzie to Draw by William Bell Scott, 1857

Sir John Everett Millais *Born* 1829 Southampton, England

Died 1896

Millais, Sir John Everett

A Dream of the Past: Sir Isumbras at the Ford, 1857

The fourteenth-century poem of Sir Isumbras was relatively unknown until it was published again in the nineteenth century, coming to Millais' attention as a suitable subject for depiction through his friend Tom Taylor, a writer for *Punch* who had parodied the original poem. It tells of a medieval knight who had fallen from grace, losing his family in the process and becoming a nomad. The picture, which is purely fictive, portrays Sir Isumbras taking two peasant children across a river in order to keep their firewood dry. The depiction is secondary to the painting's allegory on the brevity of life as indicated by the melancholy of the landscape and the juxtaposition of old man and young children.

The painting was heavily criticized by Ruskin, who referred to it as a 'catastrophe' and even his fellow Pre-Raphaelite Anthony Frederick Sandys (1829–1904) turned on him by producing a picture entitled *A Nightmare*, in which Millais takes the place of Sir Isumbras and the children are portrayed by William Holman Hunt (1827–1910) and Dante Gabriel Rossetti (1828–82); the horse became a donkey with Ruskin's initials branded on to it.

CREATED

Unknown

MEDIUM

Oil on canvas

RELATED WORK

A Nightmare by Anthony Frederick Sandys, 1858

Sir John Everett Millais *Born* 1829 Southampton, England

Died 1896

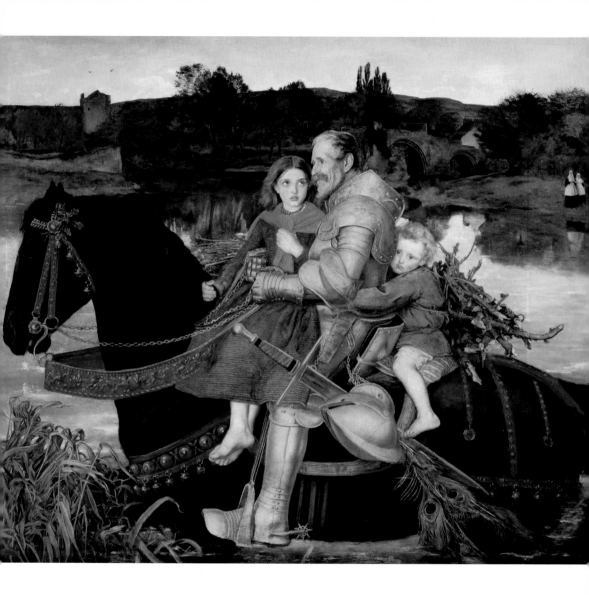

Hunt, William Holman

Love at First Sight, 1848

Prior to the formation of the Pre-Raphaelite Brotherhood (PRB), Hunt executed a small number of paintings in a traditional manner including this one *Love at First Sight*, which is possibly based on a short story by Thornton Leigh Hunt (no relation) of the same title published in 1847. However, academics have shown that in fact the picture was originally entitled *Blackheath Park* and a label was added, probably by Hunt's widow Edith, giving it its current title.

The painting seems to have been the result of a sketching expedition that Hunt went on with Rossetti in August of 1848 just prior to them sharing a studio in Cleveland Street, London. It is likely that the background was painted first and the figures added after, as with many of the subsequent Pre-Raphaelite works that were adherent to Ruskin's notions of 'truth to nature'.

The painting marks a transition in Hunt's oeuvre, the Pre-Raphaelite background that adheres to Ruskinian dogma, and the later figures, which bear little or no relation to it, added in order to make the picture saleable by creating a narrative.

CREATED

Blackheath, London

MEDIUM

Oil on panel

RELATED WORK

Windermere by Ford Madox Brown, 1848

William Holman Hunt *Born* 1827 London, England

Died 1910

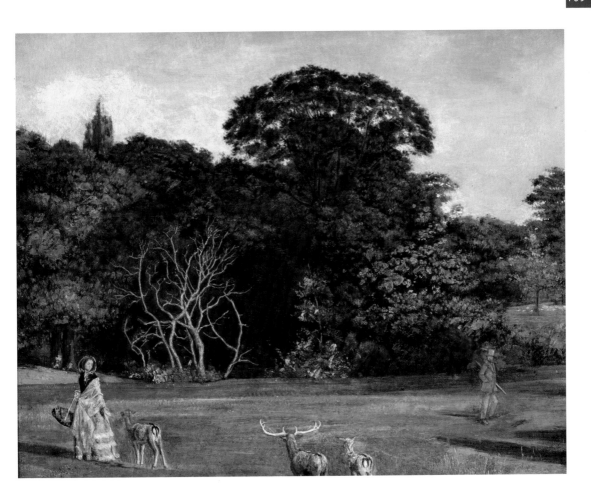

Hunt, William Holman
The Scapegoat, 1854–55

Having established himself and his reputation in London as part of the PRB, receiving critical acclaim for his pictures such as *The Awakening Conscience* and *The Hireling Shepherd*, Hunt set off for the Holy Land in January 1854. He was determined to push back the boundaries of what was possible in the visual arts, feeling that paintings of religious subjects needed to be executed in the correct geographical location if they were to be authentic and 'truthful to nature'. Stopping first in Egypt, he arrived in May at Jerusalem, which he used as his base until October 1855, when he returned to England. From this base he made several excursions including a two-month-long visit to the Dead Sea, where he painted the background to *The Scapegoat* beginning in November 1854. The painting refers to his interpretation of 'The Scapegoat in the Wilderness' from the book of Leviticus in the Bible. Hunt endured the extreme heat and inhospitable landscape as well as bandits in his quest for an authentic picture. He also purchased a white goat which he took to the site and which subsequently died of exposure.

CREATED

The Dead Sea and Jerusalem

MEDIUM

Oil on canvas

RELATED WORK

The Scapegoat by James Tissot, 1886

William Holman Hunt *Born* 1827 London, England

Died 1910

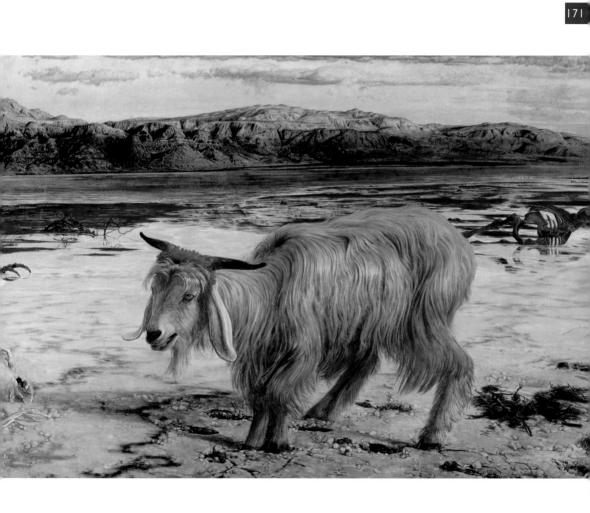

Hunt, William Holman

A Street Scene in Cairo; The Lantern Maker's Courtship, 1854

This painting typifies a number of pictures of the nineteenth century that can be expressed generally as 'Orientalist', depictions of an idealized Western construct of what the 'orient' and its inhabitants were. Hunt was one such 'Orientalist' highlighting notions of a romantic 'otherness', even depicting himself as such in his *Self Portrait* of 1867–75. The inspiration for the picture came from a visit to a bazaar in Cairo, where he watched a couple flirting; the boy, forbidden to lift the girl's veil, pressed his hand to her face in order that he could feel the contours. In many ways, this picture represents the insensitivity of one culture for another, the subject of much debate in today's post-colonial culture. That said, Hunt personally believed that his Orientalist narratives were in accordance with the spirit of the age, in much the same way as contemporary French artists such as Eugène Delacroix (1798–1863) were doing. In essence, Hunt was pandering to a Victorian taste, his Orientalist images having a resonance with the expansion of the British Empire.

CREATED

Cairo

MEDIUM

Oil on panel

RELATED WORK

The Women of Algiers by Eugene Delacroix, 1847–49

William Holman Hunt *Born* 1827 London, England

Died 1910

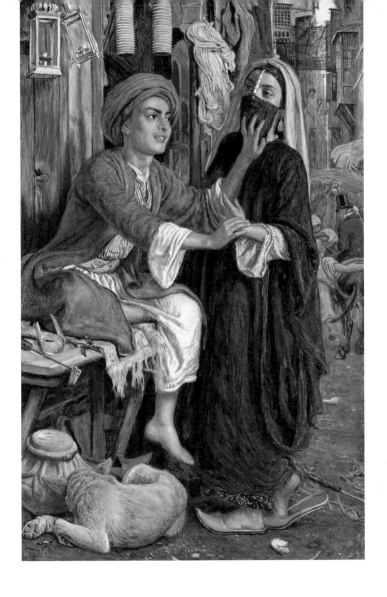

Hunt, William Holman

The Afterglow in Egypt, 1854–63

© Southampton City Art Gallery, Hampshire, UK/The Bridgeman Art Library

When Hunt visited Gizeh in April 1854, one of the things that surprised him was the lack of a veil or burko being worn by the women as they had done in Cairo. In a letter home, he suggested that these Bedouin women lacked religiosity, and 'are not treasured up like the wives and daughters of other Orientals'. Discussing this picture in 1984, Judith Bronkhurst suggests that Hunt perhaps should have read a contemporary text *The Manners and Customs of Modern Egyptians*.

The life-size painting was executed in two stages, the separate canvases joined in the middle across the woman's waist. Hunt chose to concentrate on the model's face and torso in Egypt in 1854, completing most of it there. He complained regularly of the unreliability of his model, and the unsuitability of the climate for the work *in situ*, abandoning the project for a further six years. The lower part and the finishing of the upper part were begun in 1860 but not completed until 1863. It was exhibited at the New Gallery in 1864 and sold to the art dealer Ernest Gambart for 700 guineas.

CREATED

Gizeh, Egypt

MEDIUM

Oil on canvas

RELATED WORK

An Egyptian Water-Carrier by Arthur Hill, 1881

William Holman Hunt *Born* 1827 London, England

Died 1910

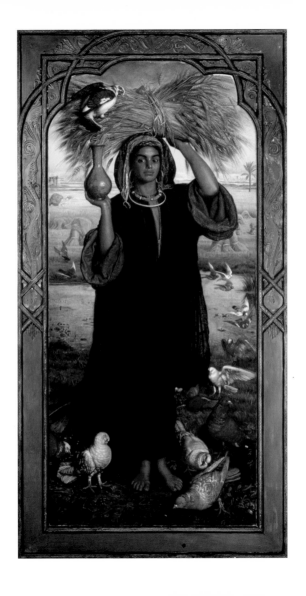

Hunt, William Holman

Isabella and the Pot of Basil, 1866–68

© Delaware Art Museum, Wilmington, USA, Samuel and Mary R. Bancroft Memorial/The Bridgeman Art Library

This painting is inscribed 'FLORENCE 1867' with the artist's initials next to it. Hunt arrived in the city with his pregnant wife en route to the Holy Land in September 1866, but was prevented from completing the journey by an outbreak of cholera. Hunt made the most of his opportunity to paint a scene inspired by a poem by John Keats (1795–1821) of the same name, whose legend was based in Florence. It tells the story of Isabella, a wealthy Florentine whose brothers kill her lover because they consider him an inappropriate suitor. Isabella subsequently hides his head in a pot of basil in order to preserve him. In the painting the pot rests on a shrine that Isabella has erected to Lorenzo her murdered lover.

Hunt had only been married to his wife for a year when she died following complications in childbirth during their stay in Florence. The painting therefore takes on a poignancy that is reflected in the bereaved Isabella's face. Hunt returned to London in 1867 with his baby son Cyril and completed the picture the following year.

CREATED

Florence

MEDIUM

Oil on canvas

RELATED WORK

Isabella and the Pot of Basil by John William Waterhouse, 1907

William Holman Hunt *Born* 1827 London, England

Died 1910

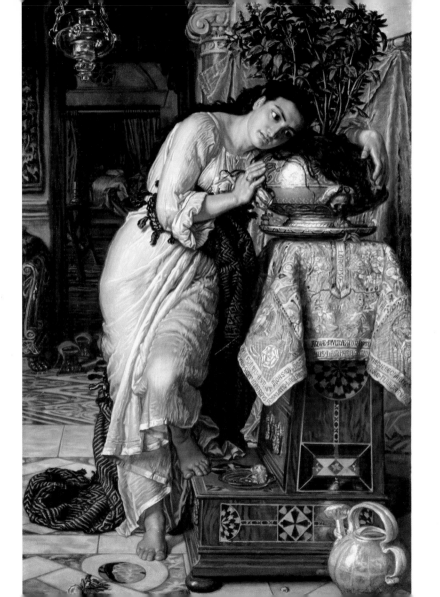

Rossetti, Dante Gabriel

How They Met Themselves, 1860

This picture is one of three versions made by Rossetti, one in ink and brush that he referred to as the 'Bogie' picture and the other two made in 1860 as watercolours, one of which is shown here. The original in black pen and wash was inscribed DGR 1851–1860, suggesting that the work took him nine years to complete. It is, however, more likely that the work, known to have been executed in 1860, was either in his mind at the earlier date or he backdated the picture, for some obscure purpose.

This unsettling *Doppelganger* picture was executed while Rossetti was on his honeymoon in Paris during 1860. On such an occasion this is an unusual picture for an artist, executed in a wood somewhere near Paris. The doppelgänger motif is suggestive of a premonition of death as the 'real' couple shown on the right of the picture are confronted by their doubles who appear surrounded by a ghostly light. Rossetti was fond of reading poetry and prose on this theme by writers such as Elizabeth Barrett Browning (1806–61) and Edgar Allen Poe (1809–49).

CREATED

Paris

MEDIUM

Watercolour (original in pen and brush)

RELATED WORK

The Light of the World by William Holman Hunt, 1851–53

Dante Gabriel Rossetti *Born* 1828 London, England

Died 1882

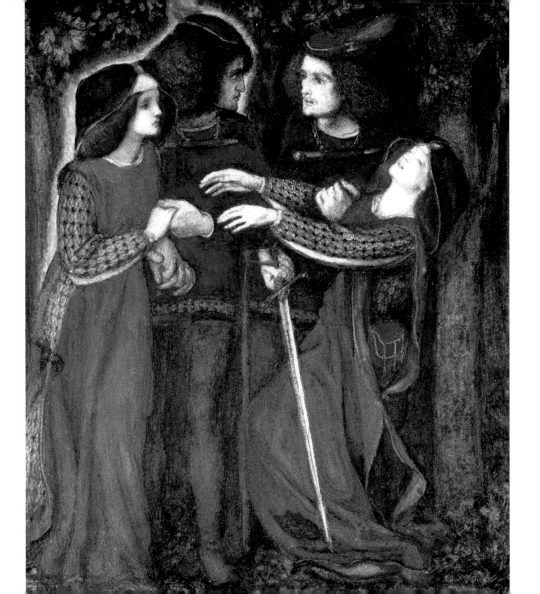

Rossetti, Dante Gabriel
Portrait of Elizabeth Siddal, 1854

This delicate and sensitive portrait of Elizabeth Siddal was one of several Rossetti drew or painted when they spent the spring of 1854 together at Hastings. Rossetti had 'discovered' her working in a milliner's shop in central London during 1849, and asked her to model for him and others in the Brotherhood. By the following year, she was only modelling for Rossetti. Although their relationship was intimate, Rossetti did not introduce her to his family until 1855, perhaps a measure of his uncertainty about their future. One of the problems was Lizzie's ill-health, which dogged her until the end of her very short life in 1862.

On their return to London in the summer of 1855, Rossetti began work on his *The Preparation for the Passover in the Holy Family*, which featured Lizzie as The Virgin. She appears again in a work of the same date, *The Annunciation*, in which there is clear evidence of Rossetti's use of the drawings he made in Hastings.

In 1860 Rossetti and Lizzie married, but she was to take her own life two years later, overdosing on laudanum.

CREATED

Hastings

MEDIUM

Watercolour on paper

RELATED WORK

Lady Clare by Elizabeth Siddal 1854–57

Dante Gabriel Rossetti *Born* 1828 London, England

Died 1882

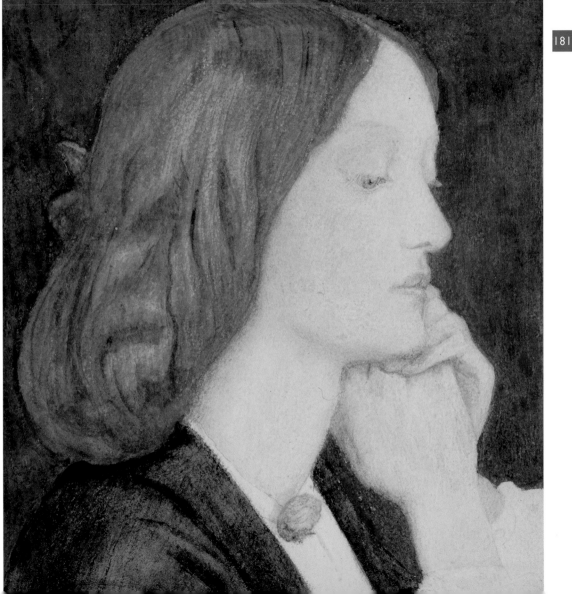

Rossetti, Dante Gabriel

Sir Lancelot's Vision, 1857

© Ashmolean Museum, University of Oxford, UK/The Bridgeman Art Library

In January 1856, the first issue of a new journal called *The Oxford and Cambridge Magazine* was published and, unknown to Rossetti, contained some of his poetry and reproductions of his art. Its editor was Edward Burne-Jones (1833–98) who, with Rossetti and William Morris (1834–96), were to herald the next phase of Pre-Raphaelitism. As the eldest and most established, Rossetti was called upon, unofficially, as their leader. Burne-Jones and Morris had been undergraduates at Oxford and on one of their trips around Birmingham in 1855 had discovered a copy of *Morte d'Arthur*. Rossetti shared the excitement of the find and, when the opportunity came to decorate the walls of the new Debating Hall at the Oxford Union, it seemed the ideal opportunity to recreate the Arthurian legend in mural.

Rossetti gathered a small group around him (seven as with the Brotherhood) including Morris and Burne-Jones and adding four others including Arthur Hughes (1832–1915). Although completed, they faded badly within a few years because of the incorrect methods used for such a task on new plasterwork.

The painting shown is a preliminary watercolour for the mural.

CREATED

Oxford

MEDIUM

Watercolour and gouache over black chalk on paper

RELATED WORK

Sir Galahad by Sir Edward Coley Burne-Jones, 1858

Dante Gabriel Rossetti *Born* 1828 London, England

Died 1882

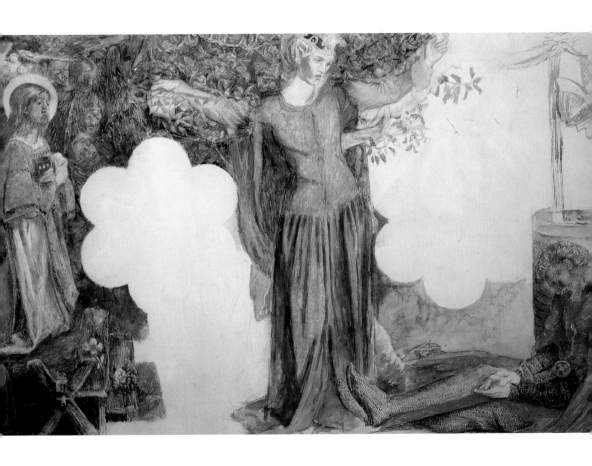

Rossetti, Dante Gabriel

Beata Beatrix, c. 1863

Beata Beatrix, executed in about 1863, was taken from some earlier sketches and drawings Rossetti had made of his wife Lizzie before her death in 1862. Following her suicide, Rossetti was distraught, needing to purge his guilt at the tragedy he felt he could have avoided.

Unlike his previous narrative treatment of the story of Dante and Beatrice in the 1850s, this painting is totally symbolic, Rossetti stating that it was 'not at all intended to represent Death, but to resemble it under the resemblance of a trance, in which Beatrice seated at the balcony overlooking the city is suddenly rapt from Earth to Heaven'. The artist reminds the viewer that the scene is in Florence (the Ponte Vecchio is in the background) and the two figures are Dante and Love (who is holding a flaming heart). The sundial points to nine, the time, according to Dante, of Beatrice's death. A bird has dropped some poppies into the hands of Beatrice, a probable reference to Lizzie's death by laudanum, an opiate.

CREATED

Probably London

MEDIUM

Oil on canvas

RELATED WORK

Isabella and the Pot of Basil by William Holman Hunt, 1866–68

Dante Gabriel Rossetti *Born* 1828 London, England

Died 1882

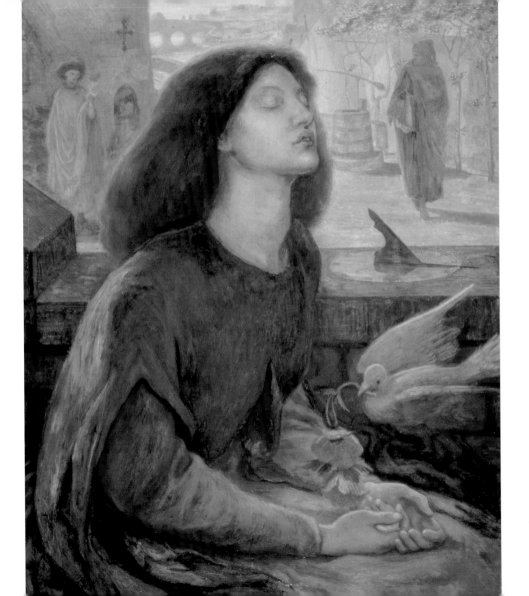

Rossetti, Dante Gabriel

La Pia de Tolomei, 1868–80

Another of Dante's great works was *The Divine Comedy*, in which he explains through a series of 'cantos' the journey of a soul in the afterlife, going through Hell and then Purgatory towards an eventual Paradise.

La Pia de Tolomei is a woman waiting in Purgatory following her death by poisoning at the hands of her jealous husband Nello della Pietra. The background depicts a small malarial-stricken town near Siena in which the heroine has been imprisoned on suspicion of adultery. When she fails to die of the fever, her husband poisons her, only to discover later that her brother, rather than her lover was in fact visiting her. *La Pia*, which means 'pious one', is alluded to in the painting by the inclusion of a devotional book and rosary.

The model for the picture was Jane Morris, who had become Rossetti's model and companion following Lizzie's death. The painting, which was executed over a number of years, must have been painful for the artist, its symbolic meaning having such a resonance with his own life and the tragedy of his wife.

CREATED

London and Kelmscott Manor, Oxford

MEDIUM

Oil on canvas

RELATED WORK

Georgiana Burne-Jones by Sir Edward Coley Burne-Jones, 1883

Dante Gabriel Rossetti *Born* 1828 London, England

Died 1882

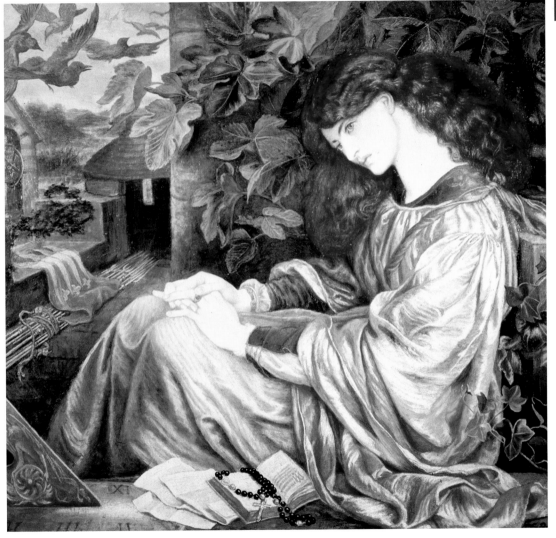

Rossetti, Dante Gabriel

La Ghirlandata, 1873

Painted in 1873, *La Ghirlandata* is one of a number of pictures of maidens playing musical instruments that were executed by Rossetti between 1871 and 1874. When it was completed, the artist described it as 'the greenest picture in the world' although another in this series *Veronica Veronese* could comfortably vie for that accolade.

Just prior to this series, Rossetti moved into Kelmscott Manor, a house that he leased with William and Jane Morris, often without William being there. Rossetti had spent the early months of 1871 in Scotland recovering from a nervous breakdown; his move to Kelmscott Manor was a continuation of that convalescence, in the care of Jane. It is unclear whether she and Rossetti were physical lovers, and it has been suggested that their relationship was one of mutual succour.

The model for this picture was unusually not Jane, but a former dressmaker called Alexa Wilding, who had modelled for several of his pictures since 1866 and to whom he paid a retainer of £2 per week. The model for the angels was William and Jane's daughter May.

CREATED

Kelmscott Manor, Oxford

MEDIUM

Oil on canvas

RELATED WORK

The Annunciation by Sir Edward Coley Burne-Jones, 1876–79

Dante Gabriel Rossetti *Born* 1828 London, England

Died 1882

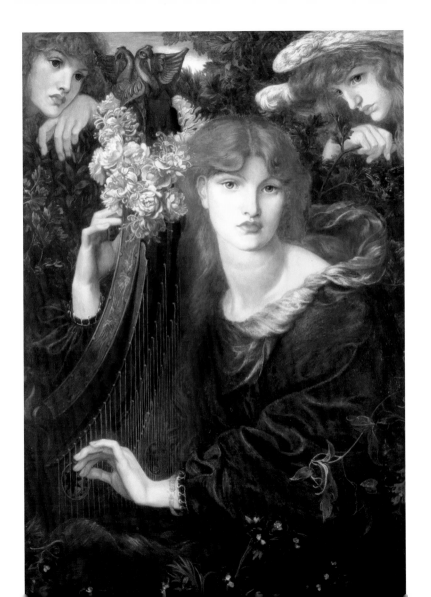

Stephens, Frederic George

The Proposal (The Marquis and Griselda), c. 1850

The Proposal is one of the few paintings that remain of Frederic George Stephens' short career as a painter, but like those of his Pre-Raphaelite Brothers it has as its theme a legendary tale. In this case it tells the story of Gualtieri, the Marquis of Saluzzo, who was pressured into marriage for fear of dying without an heir. He proposes to a woman of low station from the local village called Griselda, whose beauty ameliorated her social rank. Unsure of her devotion and loyalty, Gualtieri sets Griselda some tests that involve giving up her two children that she has had with him, knowing that they will be put to death. She agrees to his demand, only for him to cast her out of the house and recall her when he tells her he is to marry again, and asking her to be the bridesmaid. Again she agrees, whereupon the Marquis produces the 'bride' who is in fact their twelve-year-old daughter whom Griselda has not seen since infancy. Griselda passes the test and resumes her place as Gualtieri's wife.

The story is a fourteenth-century fable by the Italian writer Giovanni Boccaccio (1313–75).

CREATED

Knole, Kent

MEDIUM

Oil on canvas

RELATED WORK

The Long Engagement by Arthur Hughes, 1859

Frederic George Stephens *Born* 1828 London, England

Died 1907

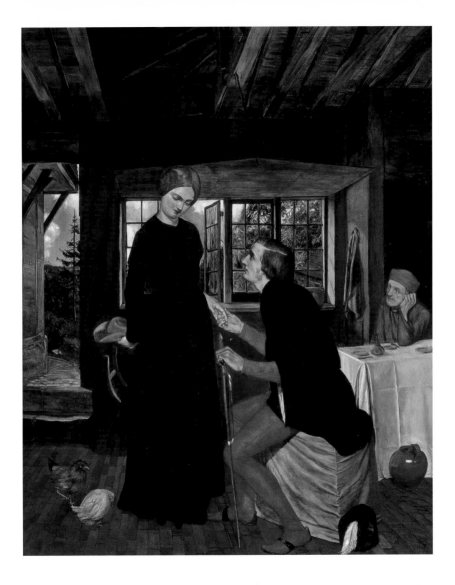

Deverell, Walter Howell

The Mock Marriage of Orlando and Rosalind, 1853

© Birmingham Museums and Art Gallery/The Bridgeman Art Library

When Hunt had first announced to the Brotherhood that he was to travel to the Holy Land in 1853, it was suggested that Walter Howell Deverell (1827–1854), Millais and Rossetti would all go as well. The latter two were unable in any event because of personal commitments, but Deverell was unable to go because of a terminal illness of the kidneys, diagnosed as Bright's disease. The tragedy was made worse by the recent death of both his parents, leaving him, as the eldest child, responsible for his siblings. To support him, the other Pre-Raphaelites clubbed together in order to buy one of his pictures, saving him from penury, as he was unable to work anymore because of the pain. News reached Hunt of Deverell's death while he was in Cairo.

Most of Deverell's work was depictions of Shakespeare's plays, most famously *Twelfth Night*. The painting shown here is a scene from Shakespeare's *As You Like It* with the wedding of Orlando and Rosalind set in the Forest of Arden where they had been forced to flee from court life.

CREATED

London

MEDIUM

Oil on canvas

RELATED WORK

Ophelia by Sir John Everett Millais, 1851–52

Walter Howell Deverell *Born* 1827 Virginia, USA

Died 1854

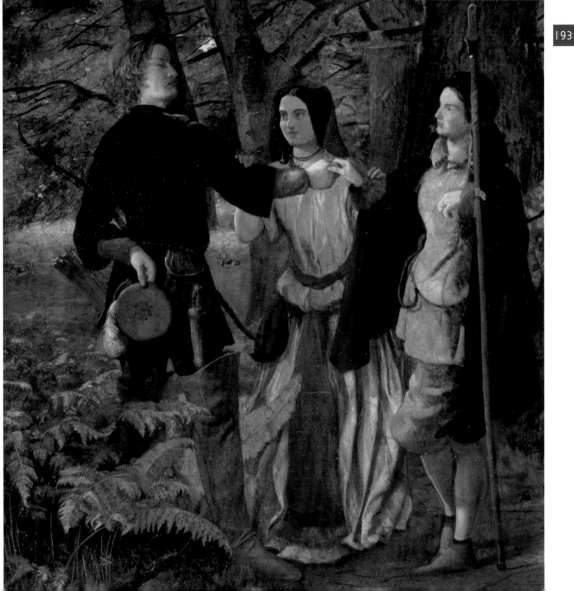

Brown, Ford Madox

Lear and Cordelia, 1849–54

In 1843 Ford Madox Brown made a trip to Paris, executing a number of pen and ink drawings based on the theme of King Lear. The story, which had great appeal to Brown, tells of an aged king (Lear) in pre-Roman times, who abdicates his throne and divides the kingdom up between his three daughters. His youngest daughter Cordelia refuses her share because of the conditions attached to it. She is banished from court, only then to marry the King of France who has aspirations of an English conquest. The scene depicted is at Dover where Cordelia is reunited with her old and very tired father, prior to the battle with France.

The drawings made were used in a series of three pictures on this subject, this one being the first, begun in the summer of 1849 shortly after seeing a production of the play with the great Shakespearean actor of his time, William Charles Macready, as Lear. The painting was finished the following March but remained unsold despite a good press. Brown reworked the picture over an eight-month period in 1853–54.

CREATED

London

MEDIUM

Oil on canvas

RELATED WORK

Cordelia Disinherited by John Rogers Herbert, 1850

Ford Madox Brown *Born* 1821 Calais, France

Died 1893

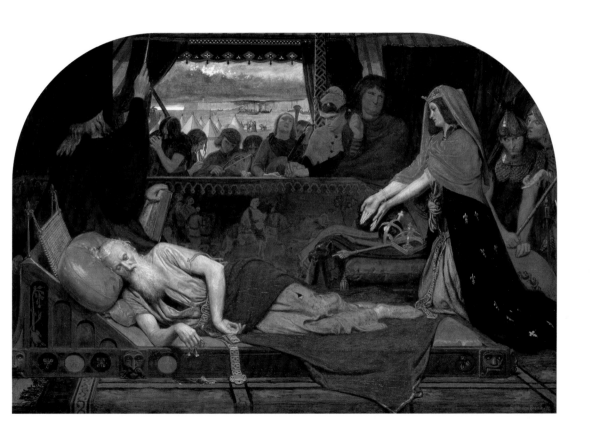

Brown, Ford Madox

An English Autumn Afternoon, 1852–54

In many ways this painting is redolent of the views of John Constable (1776–1837) from Hampstead Heath half a century before. The difference of course is the contemporary detail of life so wonderfully captured by Brown. For example, the spire of St Anne's Church at Highgate can be seen on the left of the picture, built only a year before. The emphasis is on the couple in the foreground (never a feature of Constable's paintings), spending an idle afternoon surveying the semi-rural location and chatting, their presence almost a foil to the landscape.

Brown had recently moved into lodgings in Hampstead and this painting was executed from his landlady's bedroom, adding the figures after. The unusual shape has been cleverly used by Brown to emphasize the panoramic view of London from Hampstead. The painting pre-dates his most famous picture of Hampstead, *Work*, which deals with the urbanization of the area. In *An English Autumn Afternoon*, Brown reminds the viewer that the area is still rural, depicting fruit harvesters in the fields below. The painting was not favourably received and remained unsold until it was reworked in 1854.

CREATED

Hampstead, London

MEDIUM

Oil on canvas

RELATED WORK

Hampstead Heath by John Constable, 1820

Ford Madox Brown *Born* 1821 Calais, France

Died 1893

Brown, Ford Madox
The Hayfield (detail), 1855

The scene for this painting is the Tenterden estate at Hendon, which at the time was within the county of Middlesex. The date of its execution can be precisely dated from Brown's diary that recorded what he had seen on his evening walks looking for subjects that 'will paint off at once'. The work was begun on 27 July 1855 at 5 p.m., returning to the spot each evening at the same time until 24 October, recording that he had spent 36 hours on the work in that one month. Brown continued to work on the picture in the autumn at his home in Finchley, adding the cart that he had seen in a market, and the figures for which he had no models. This small painting was one of a number of so-called 'pot-boilers' that artists painted that would sustain their income, usually while working on larger works. In Brown's case the larger work was *The Last of England*.

Brown's dealer refused this picture because of the unnatural colour of the hay, and it was bought instead by Morris.

CREATED

Hendon

MEDIUM

Oil on panel

RELATED WORK

The Blind Girl by Sir John Everett Millais, 1854–56

Ford Madox Brown *Born* 1821 Calais, France

Died 1893

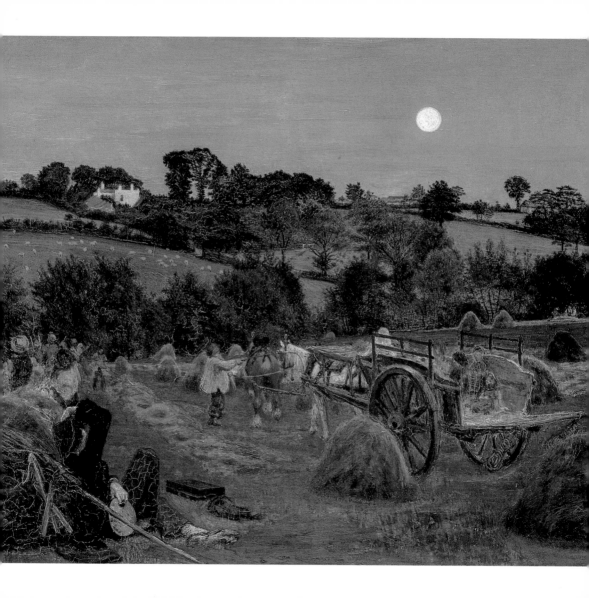

Brown, Ford Madox

Crabtree Watching the Transit of Venus in 1639, 1883

At the height of his reputation as an artist, Brown was commissioned in 1878 to paint 12 mural decorations for the Great Hall in the newly built Town Hall in Manchester. Alfred Waterhouse (1830–1905) had designed the building in the gothic-revival style, a fashion prevalent at that time for major public buildings. These 12 large murals took Brown a total of 15 years to complete, this image being one of them, finished in 1883. The murals depict historical scenes relevant to Manchester beginning with the Roman construction of a fort at Mancenion and ending with John Dalton collecting Marsh-Fire gas at the beginning of the nineteenth century. Learning by the mistakes made at the Oxford Union, Brown used the Gambier Parry process for the murals, ensuring their stability over time.

The work shown here is a smaller-scale copy of the original mural and depicts William Crabtree, a resident of Manchester, who was a merchant and keen astronomer, plotting the transit of the planet Venus across the sun in 1639.

CREATED

Manchester

MEDIUM

Tempera on panel

RELATED WORK

The Opening of the Bridgewater Canal in 1761 by Ford Madox Brown, 1891

Ford Madox Brown *Born* 1821 Calais, France

Died 1893

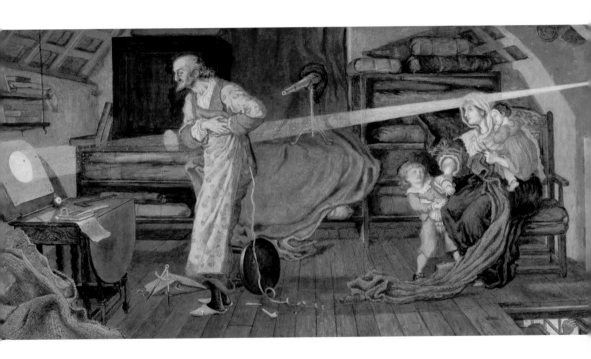

Hughes, Arthur
The Knight of the Sun, 1860

© Christie's Images/The Bridgeman Art Library

Many of the Pre-Raphaelite painters had a text engraved on to the picture's frame to elucidate or simply to enhance the subject portrayed. In this work by Hughes the caption on the frame reads 'Better a death when work is done, than earth's most favoured birth'. The words are from a contemporary poem *Better Things* by George MacDonald (1824–1905). *The Knight of the Sun* tells of a knight whose emblem was the sun, which he wore as a badge on his helmet. As he lay dying in his castle, he asked to be taken outside in order that he might feel the warmth and light from its rays for one last time. Symbolic of his imminent demise, the scene takes place at sunset.

The picture borrows heavily from the sunset in Millais' *Autumn Leaves* and is innovative in its use of Arthurian legend, one of the first pictures by the Pre-Raphaelites on that theme. Hughes' interest in the theme was probably fuelled by his recent work on the ill-fated Oxford Union murals in 1857, although the subject of this picture was in fact of Hughes' own invention.

CREATED

Unknown

MEDIUM

Oil on canvas

RELATED WORK

Merlin and Nimue by Sir Edward Coley Burne-Jones, 1861

Arthur Hughes *Born* 1832 London, England

Died 1915

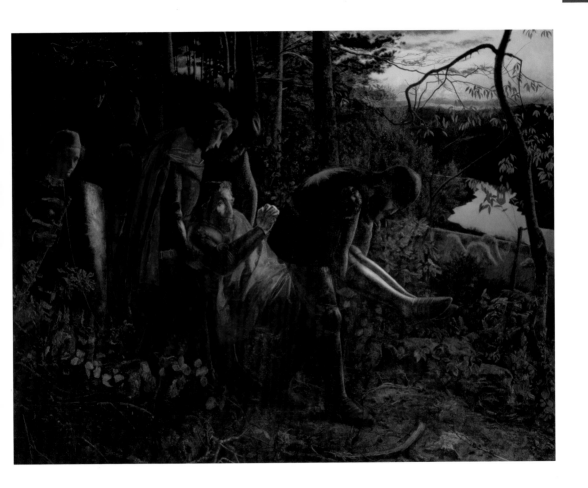

Hughes, Arthur

Home from the Sea, 1856–62

The landscape for the picture was painted *en plein air* at Chingford in Essex and depicts All Saints parish church with its graveyard in very authentic detail. The church was restored in 1929 and in this painting can be seen the beginnings of its ruinous, almost picturesque, state. The figure of the boy was added later in the studio. The painting was originally exhibited under the title of *A Mother's Grave* at the Pre-Raphaelite Exhibition in 1857 with only the boy in the scene. Unsold, Hughes added a second figure, the boy's sister modelled by the artist's own wife Tryphena. Hughes' own description of the work suggests it is a depiction of a boy who has returned from a sea voyage visiting the grave of his mother who has died while he was away. His sister, dressed in black, is there to comfort him.

The motif was taken from Hunt's etching *My Lady in Death*, an etching that was reproduced in *The Germ*. Hughes has adapted the scene and, in true traditions of Pre-Raphaelitism, produced one of the most accurately detailed paintings of the genre.

CREATED

Chingford, Essex

MEDIUM

Oil on panel

RELATED WORK

My Lady in Death by William Holman Hunt, 1850

Arthur Hughes *Born* 1832 London, England
Died 1915

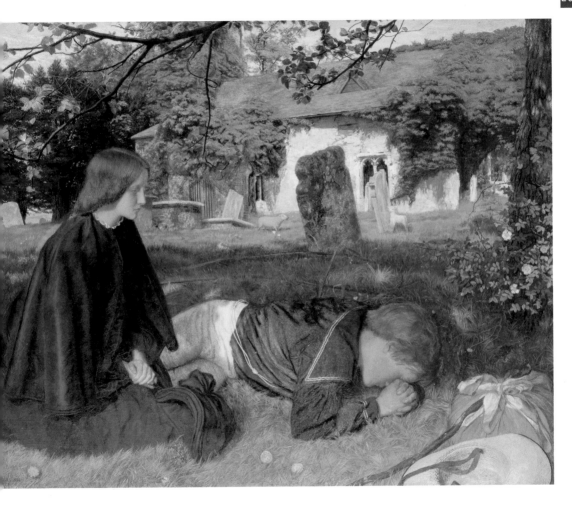

Hughes, Arthur
The Lady of Shalott, 1873

One of the most enigmatic of all Arthurian themes is *The Lady of Shalott* immortalized by both the Pre-Raphaelites and Tennyson, underling the notion that the visual arts and literature were inextricably linked in the Victorian era. The story's appeal is that we do not know, any more than the residents of Camelot knew, who the Lady was. Their first sighting of her is when she arrives by river, recumbent in a boat. The Lady had been imprisoned in a tower, for some unexplained reason, unable to look through the window for fear of incurring a curse, her only view of the outside world by way of mirrors. One day she sees the reflected image of Lancelot riding on his horse towards Camelot. Captivated by his looks she forgets the curse, looks straight from the window and is stricken by the curse. In a vain attempt to reach the knight she sets off in the boat whereupon she dies. The scene depicted here is her arrival at the shores of Camelot; the only clue to her identity is the name on the boat 'THE LADY OF SHALOTT'.

CREATED

Unknown

MEDIUM

Oil on canvas

RELATED WORK

The Lady of Shalott by John William Waterhouse, 1888

Arthur Hughes *Born* 1832 London, England

Died 1915

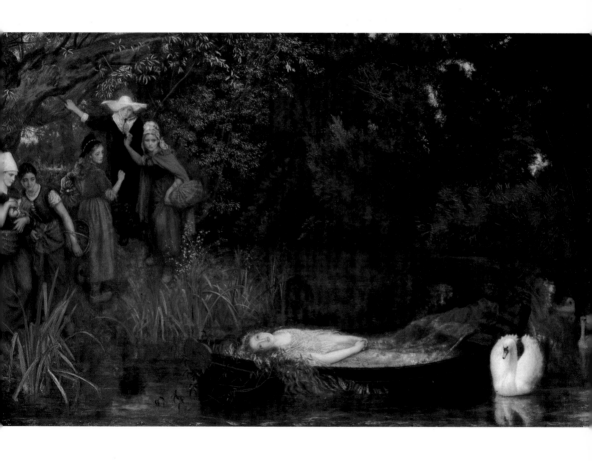

Inchbold, John William
The Lake at Lucerne (detail), 1857

Unlike most Pre-Raphaelite paintings this one is people-less, a tranquil study of the Swiss Alps executed in 1857 while the artist was staying at Lake Lucerne. John William Inchbold made several trips to Switzerland between 1856 and 1859 under the sponsorship of Ruskin, who wanted to find an artist to recreate some of Turner's ethereal mountain landscapes. One of the things about Turner that appealed to Ruskin was the freshness and vitality in his watercolours on white paper. What appealed to Ruskin about Inchbold was his meticulous attention to detail learned from his exposure to early Pre-Raphaelitism, and their use of a white ground in oil painting that created such a brilliant hue. What Ruskin hoped was that Inchbold could take these ideas and recreate the ethereal qualities of Turner by painting a 'truth to nature' in front of the motif. Unfortunately, Ruskin was too hard a taskmaster and Inchbold was never able to satisfy his sponsor's demands. He later returned to his earlier looser style of painting, and after several other trips abroad he eventually settled in Switzerland where he spent the rest of his life.

CREATED

Switzerland

MEDIUM

Watercolour

RELATED WORK

The Pass at St Gotthard by Joseph Mallord William Turner, 1843

John William Inchbold *Born* 1830 Leeds, England

Died 1888

Brett, John
The Val d'Aosta, 1858

In Ruskin's Academy review of 1845 he singled out John Brett for special praise for his picture *The Stonebreaker*, asking 'what would he make of the chestnut groves of the *Val d'Aosta*' in the light of this work of the Surrey Downs. Literally within a few days Brett was off to this location in the Italian Alps, staying close to the medieval castle just above the River Baltea, for a further five months.

Brett had always admired Turner's landscapes but chose instead to paint a view altogether more serene than the sublime interpretations of his predecessor. That said, Ruskin was as genuine a supporter of Brett's paintings as he had been of Turner's. The painting was executed in true Ruskinian spirit, as expressed in his *Modern Painters*, and Brett even summoned Ruskin to visit him in Turin to ask for his opinion. Not surprisingly, at the following year's Royal Academy Exhibition, Ruskin was fulsome in his praise, stating 'for the first time in history we have, by help of art, the power of visiting a place, reasoning about it, and knowing it as though we were there'.

CREATED

Val d'Aosta, Italy

MEDIUM

Oil on canvas

RELATED WORK

The Battle of Fort Rock, Val d'Aosta by Joseph Mallord William Turner, 1815

John Brett *Born* 1831 Reigate, England

Died 1902

Wallis, Henry

The Death of Chatterton (detail), 1855–56

Although only 18 when he took his own life by swallowing arsenic, Thomas Chatterton's (1752–70) writing was well known to the poets Keats and William Wordsworth (1770–1850). However, his likeness was not known to anyone, as there were no known portraits made of him, and so Henry Wallis decided to use another struggling writer of his own generation to model for Chatterton. Apart from the detail of the face, the rest of the picture is as accurate as possible according to journalistic accounts of the time, (August 1770). Wallis possibly used the actual room of Chatterton's suicide, in Brook Street, Holborn, for the picture, and has faithfully reproduced the torn up manuscript of Chatterton's poetry as it was right by his deathbed. Chatterton was something of a dandy who wore exquisite clothes, something that Wallis has acknowledged in the picture.

Such was the attention to detail, even by Pre-Raphaelite standards, that the press were unanimous in their praise for the picture when it was shown at the Royal Academy, one critic remarking that it had 'marvellous power and may be accepted as a safe augury of the artist's fame'.

CREATED

London

MEDIUM

Oil on canvas

RELATED WORK

Thomas Chatterton in his Garrett by John Joseph Barker, *c.* 1850

Henry Wallis *Born* 1830 London, England

Died 1916

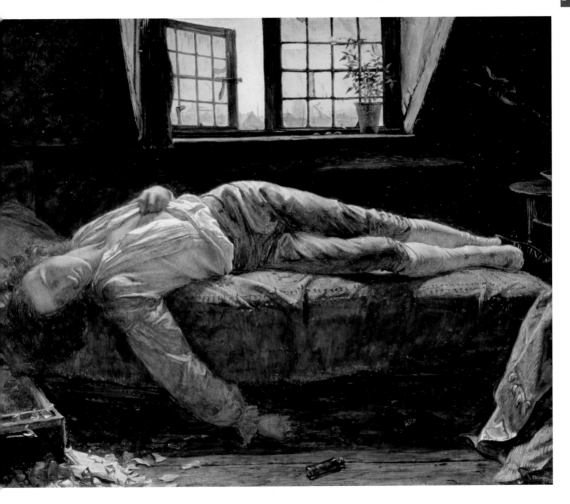

Windus, William Lindsay
Too Late, 1857–58

A naturally self-effacing artist, William Lindsay Windus had his confidence completely shattered by Ruskin when this picture was shown in 1859 at the Royal Academy. Ruskin, who had lightly praised and encouraged the artist when he showed his earlier picture *Burd Helen*, now suggested that Windus had either been ill or had sent the picture into the Academy in a hurry. The artist was not able to take such criticism and withdrew from painting, more or less, for the rest of his life. Brown attempted to reintroduce Windus into painting as late as the 1880s and wrote enthusiastically about him, but he remains one of the least known of the Pre-Raphaelites.

The painting, which was accompanied by a text from Tennyson's poem *Come not when I am Dead*, was executed in a friend's garden in Birkenhead, Cheshire. Windus was born in Liverpool, and spent his whole life in and around the city or in Preston. The scene depicted is of a young woman suffering from consumption, whose lover had gone away and returned, led by a small girl, when it was 'too late'.

CREATED

Birkenhead, Cheshire

MEDIUM

Oil on canvas

RELATED WORK

The Long Engagement by Arthur Hughes, 1854–59

William Lindsay Windus *Born* 1822 Liverpool, England

Died 1907

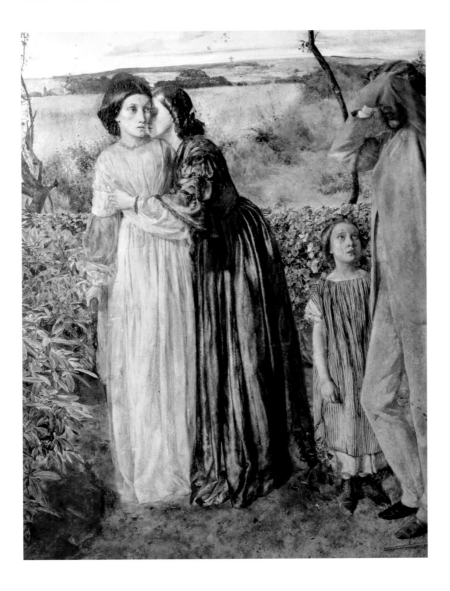

Burne-Jones, Sir Edward Coley

The Heart Desires (detail), 1875–78

There were a number of factors that came together prior to the painting of the *Pygmalion and the Image Series* (from which this painting belongs), making these a critical and decisive turning point in Burne-Jones's career. He had been suffering from insomnia and depression following the so-called 'Old Water Society Affair', in which Burne-Jones resigned from the society that accused him of indecency, following the submission of a male nude painting. At Ruskin's suggestion, the artist visited several cities in Italy, carefully studying the masters between 1870 and 1871 and again in 1873. As a result, Burne-Jones resolved to abandon watercolour painting in favour of oil, thus increasing the physical scale of his work. Another factor was the realization that the use of 'series' narratives of stained-glass designs he had been producing for Morris and Co. could be repeated in 'series' paintings.

Although *The Heart Desires* was the first of the 'Pygmalion' narratives, it was not necessarily the first picture he worked on in the series, preferring instead to work on parts of different pictures and return to them later. This way of painting would become his modus operandi from now on.

CREATED

Probably London

MEDIUM

Oil on canvas

RELATED WORK

Stained-glass designs for St Michael and All Angels Church, Brighton by Sir Edward Coley Burne-Jones, Ford Madox Brown and William Morris, 1862

Sir Edward Coley Burne-Jones *Born* 1833 Birmingham, England

Died 1898

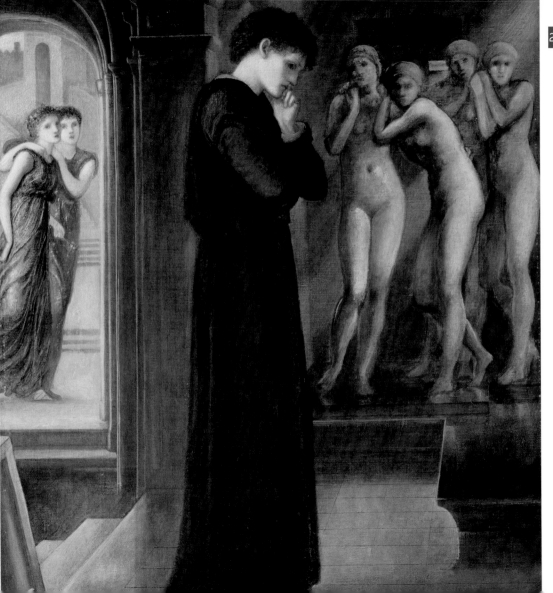

Burne-Jones, Sir Edward Coley
The Sleeping Beauty, 1870–90

This painting belongs to Burne-Jones's 'Briar Rose' series of works. Without originally intending to produce a 'series' on the subject, Burne-Jones had started on a number of pictures based on the 'Sleeping Beauty' story, work on which began in 1870 and became one of his pre-occupations for the next 20 years. The most significant theme of the series is sleep, a pre-occupation for the artist who had been suffering from insomnia, and one for the new Aestheticism of the late nineteenth century, whose practitioners included such artists as Albert Moore (1841–93) and George Frederick Watts (1817–1904). These artists came together with Burne-Jones and others at the new Grosvenor Gallery, opened in 1877, which promoted the 'new' art, one devoid of specific narrative in favour of a spiritual symbolism or Aestheticism as it came to be known. The Grosvenor Gallery became for a while the 'Palace of Art' where, unlike the Royal Academy, paintings were hung with space around them in surroundings conducive to buying paintings. Clearly aimed at the new upper-middle classes rather than the aristocracy, the 'new art' was to be an 'art for art's sake', an art that 'addresses itself directly to the sense of sight'.

CREATED

Probably London

MEDIUM

Oil on canvas

RELATED WORK

A Sleeping Girl by Albert Moore, 1875

Sir Edward Coley Burne-Jones *Born* 1833 Birmingham, England

Died 1898

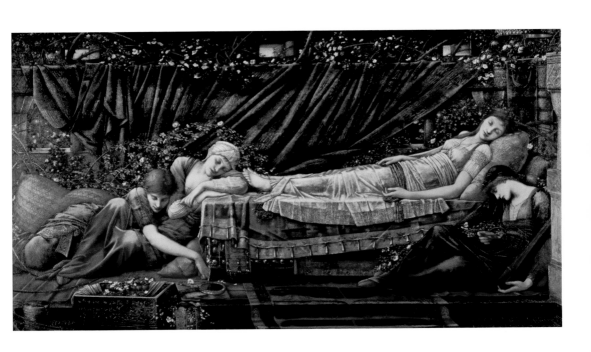

Morris, William

Queen Guinevere (La Belle Iseult), 1858

© Topham Picturepoint, 2007

At Rossetti's insistence, Morris took up painting after leaving Oxford, an occupation ill-suited to his temperament and skills as an artist. Despite several attempts at painting, this picture is the only completed oil by Morris. The model for Guinevere was Jane Burden, whom Rossetti and Morris had met while they were painting the Arthurian-legend murals at the Oxford Union in 1857, and who was to marry Morris in 1859.

It has been suggested that the bedroom used in the picture was 17 Red Lion Square, lodgings that Morris shared with Burne-Jones between the autumn of 1856 and the spring of 1859. The rooms there were full of 'medieval' objects that Morris in particular had collected, such as the brass jug depicted at bottom right of the painting.

The execution of the painting, which Morris referred to as 'a brute', was exasperating. At one point he apparently wrote across the canvas 'I love you but I can't paint you'. The picture was never sold and hung at Kelmscott Manor until 1938 when his daughter May bequeathed it to the Tate Gallery.

CREATED

London

MEDIUM

Oil on canvas

RELATED WORK

Thoughts of the Past by John Roddam Spencer Stanhope, 1858–59

William Morris *Born* 1834 Walthamstow, England

Died 1896

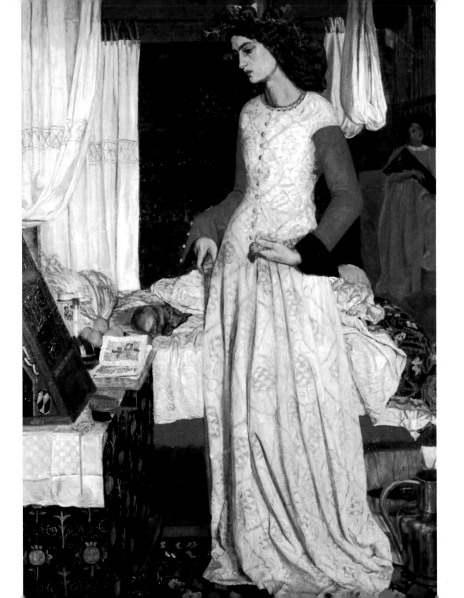

Sandys, Anthony Frederick

Love's Shadow, 1867

The parody of Millais' painting *Sir Isumbras at the Ford* by Sandys so amused and impressed Rossetti that they became firm friends thereafter. Evidence of this can be seen in this painting, so redolent of Rossetti's oeuvre at the time, as for example in his *Beata Beatrix*.

The considered pose of the painting is similar to Sandys' illustration for a poem by Rossetti's sister Christina (1830–94) called *If*, on which he was working the previous year. At that time, Sandys was working mainly on illustration rather than painting, a medium that he was to become more renowned for. The background for the illustration was drawn at Sheringham in Norfolk in November 1858, but the designs were not completed until 1866. Sandys developed a very successful career as an illustrator, his strong lines and draughtsmanship lending themselves particularly well to woodcut engravings.

His paintings during the 1860s are often of *femmes fatales* such as *Medea* painted in 1868 and the slightly later *Morgan Le Fay*. The *femme fatale* was a popular image in both the visual arts and in literature in most parts of Europe at the end of the nineteenth century.

CREATED

Chelsea, London

MEDIUM

Oil on panel

RELATED WORK

The Apparition by Gustave Moreau, 1874–76

Anthony Frederick Sandys *Born* 1829 Norwich, England

Died 1904

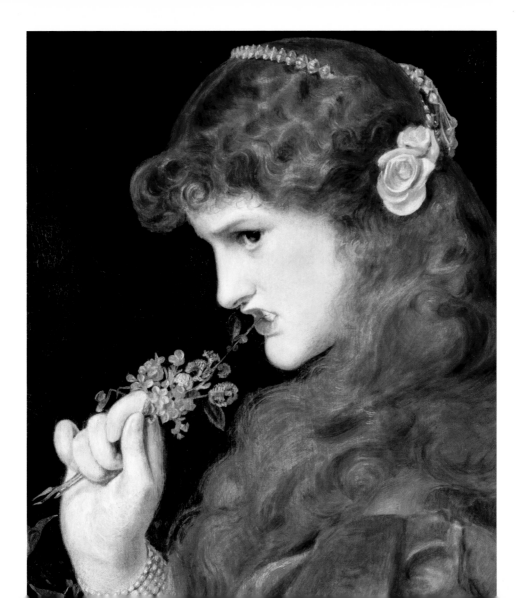

Scott, William Bell

Portrait of Algernon Charles Swinburne (detail), 1860

Algernon Charles Swinburne (1837–1909), born in the year that Queen Victoria came to the throne, was a poet of extraordinary intelligence, but renowned for his decadent poetry that dealt with Victorian taboo issues such as lesbianism, sadomasochism and irreligion. When William Bell Scott painted this portrait, Swinburne was only 22 and had recently been rusticated at Oxford, a fate that was also to befall Oscar Wilde (1854–1900). A close friend of Rossetti, Swinburne was introduced to the older Scott, with whom he stayed in September 1859 at Newcastle, visiting the Longstone lighthouse in Northumbria while staying with Scott's patron Charles Trevelyan. The following January, Swinburne stayed again with Scott, when this painting was begun, returning again in the autumn to complete the work. In the background is the Northumbrian coastline.

According to Scott's *Autobiographical Notes* published posthumously, Swinburne was particularly pleased with the painting, which hung in the artist's house until he died. By contrast, Swinburne had a different view and was scathing about the biography, causing Scott's widow to sell the painting. It was later presented to Balliol, Swinburne's old college at Oxford.

CREATED

Newcastle

MEDIUM

Oil on canvas

RELATED WORK

Portrait of Algernon Charles Swinburne by Dante Gabriel Rossetti, 1861

William Bell Scott *Born* 1811 Edinburgh, Scotland

Died 1890

THE W

The Pre-Raphaelites

GREAT

Influences

Giotto (Giotto di Bondone)

Lamentation of Christ, c. 1305

Like most of the Pre-Raphaelites, Giotto was a legend in his own lifetime thanks to his contemporaries writing about him and his work, recognizing his exceptionally innovative talents and documenting them. As such, he was the first artist to be afforded such an accolade. One of these writers was Dante (1265–1321), who made reference to him in his *The Divine Comedy*. Scarcely more than a hundred years after Giotto's death, Lorenzo Ghiberti (1378–1455) wrote about him in his *Commentarii* as the artist who resurrected Classical art from the Dark Ages.

In 1839 an important fresco by Giotto was discovered in the Bargello in Florence, hidden for many years under whitewash that depicted the artist painting a portrait of Dante. A watercolour copy of this was made and sent to the father of Dante Gabriel Rossetti (1828–82), who was a lifelong, almost obsessive, admirer of Dante. The theme of the painting was interpreted and repeated several times by Rossetti in his own watercolours.

Rossetti's enthusiasm aside, John Ruskin (1819–1900) was influential in promoting Giotto's oeuvre in his writings, stating that he had laid the foundations of all Christian art as in, for example, his frescoes at the Arena Chapel in Padua.

CREATED

Padua, Italy

MEDIUM

Fresco

RELATED WORK

Giotto Painting Dante's Portrait by Dante Gabriel Rossetti, 1859

Giotto di Bondone *Born c.* 1266 Vespignano, Italy

Died 1337

Angelico, Fra (Guido di Pietro)

The Martyrdom of St Cosmas and St Damian, c. 1440

Having sold his *Girlhood of Virgin Mary* for 80 guineas to the Dowager Marchioness of Bath in the spring of 1849, Rossetti set off on a tour of European galleries to look at the masters. First stop was the Louvre in Paris where he probably saw this painting by Fra Angelico. Rossetti's subsequent 'revivalist' style, as seen in his *Ecce Ancilla Domini!*, appears to support this, although he must have also seen many 'Annunciations' by other artists on his trip.

 Although Giotto had already established his reputation as the most innovative of Florentine artists to date, by the fifteenth century further innovations were taking place as alternatives to the traditional polyptych altarpieces of his predecessors. The most innovative of them was Fra Angelico, who brought more naturalism into painting, particularly in fresco projects such as the one shown at San Marco in Florence. Fra Angelico was a Dominican monk who began illuminating manuscripts before painting religious frescoes. No wonder then that Ruskin referred to him as 'not an artist properly so-called but as an inspired saint'.

CREATED

Florence, Italy

MEDIUM

Tempera on panel

RELATED WORK

Ecce Ancilla Domini! by Dante Gabriel Rossetti, 1849–50

Fra Angelico *Born c. 1400 Tuscany, Italy*

Died 1455

van Eyck, Jan
The Arnolfini Marriage, 1434

References to Jan van Eyck, and in particular *The Arnolfini Marriage*, occur in a number of Pre-Raphaelite paintings by several artists. The painting itself, having been purchased by the National Gallery in London in 1842, would have been seen by anyone interested in art after that date. An early example of the borrowed motif of the mirror and its reflection is *Take Your Son, Sir!* by Ford Madox Brown (1821–93). As Elizabeth Prettejohn has argued, however, Brown's use may be more than just borrowing the motif, since both pictures are suggestive of childbirth out of wedlock, a social taboo in both cultures.

However, the Pre-Raphaelite picture that is least like and yet borrows the most from the van Eyck picture is *The Lady of Shalott* by William Holman Hunt (1827–1910). The most overt borrowing is in the clogs, shown in the foreground of both pictures. Hunt is thereafter more subtle. The chandelier of the van Eyck becomes the overly decorated samovar in front of 'The Lady' and the 'mirror', the focal point of both paintings, is enlarged in Hunt's picture to show the reflection of Sir Lancelot en route to Camelot.

CREATED

Bruges, Belgium

MEDIUM

Oil on panel

RELATED WORK

The Lady of Shalott by William Holman Hunt, 1886–1905

Jan van Eyck *Born c.* 1390 Maastricht, The Netherlands

Died 1441

Lippi, Fra Filippo

Virgin and Child from the Barbadori Altarpiece, c. 1437

© Louvre, Paris, France, Lauros/Giraudon/The Bridgeman Art Library

Vasari described Fra Filippo Lippi's Barbadori altarpiece as 'a work of rare excellence, which has ever been held in the highest esteem by men versed in our arts'. The composition of the work, emphasized by the verticality of the standing Virgin and Child, became a format for tableaux painting thereafter. This vertical axis is central to the formation of the pyramid, another compositional ruse used in many Western paintings from the fifteenth century on. Lippi has also used an innovative variation of figurative stances that today we take for granted. Another innovation for Florentine painting at this time is the colourful costumes used as a result of Lippi's fascination with contemporary Dutch painting, most evidenced in, for example, the Ghent altarpiece of van Eyck.

The earliest Pre-Raphaelite painting to express these innovations is Brown's *The First Translation of the Bible into English*, a pyramidal tableau that shows Wycliffe reading to John O'Gaunt in the presence of Chaucer. It lacks the colour of Lippi, however, something that Hunt addressed in a slightly later picture, again using a pyramidal composition, Valentine *Rescuing Sylvia from Proteus*.

CREATED

Florence, Italy

MEDIUM

Oil on panel

RELATED WORK

Valentine Rescuing Sylvia from Proteus by William Holman Hunt, 1850–51

Fra Filippo Lippi *Born c. 1406 Florence, Italy*

Died 1469

Pierro della Francesca
The Baptism of Christ, 1450s

© National Gallery, London, UK/The Bridgeman Art Library

What appears to be a notable innovation of the Pre-Raphaelites was the use of the arched top to a painting, something that can be traced back to the early Renaissance. Then, its use was probably as a result of producing altarpieces, scaled-down icons of an original altar wall that had an arched top. A most notable early example is Giotto's *The Last Judgement* at the Scrovegni Chapel in Padua, although there are many earlier examples of frescoes and mosaics in Byzantine churches of the sixth century. As the Piero della Francesca picture shown here demonstrates, the tradition continued into the *Quattrocento* and even into the High-Renaissance period after which its use fell into decline.

The Pre-Raphaelites appear to have adopted this idea even outside of the context of a religious icon, as in Brown's *Geoffrey Chaucer reading the 'Legend of Constance' to Edward III and his Court* from 1851. Brown used the idea again in his most famous painting of contemporary life, *Work*. The following year, Hunt repeated the idea in his picture of contemporary life, *The Awakening Conscience*.

CREATED

Borgo San Sepolcro, Italy

MEDIUM

Egg tempera on poplar panel

RELATED WORK

Work by Ford Madox Brown, 1852–65

Pierro della Francesca *Born c.* 1415 Borgo San Sepolcro, Italy
Died 1492

Gozzoli, Benozzo di Lese

Angels in a Heavenly Landscape, c. 1460

According to legend, the Pre-Raphaelite Brotherhood (PRB) was formed one evening in September 1848 after looking at a book of engravings based on the frescoes at the Campo Santo in Pisa by Benozzo di Lese Gozzoli. What they found so refreshing in these works was what Hunt called 'that freedom from corruption, pride and disease that we sought'. In essence, although Hunt and the others were able to see the imperfections and distorted perspective in the work, by adopting what they saw as an uncomplicated and simpler art form, they could be free from the conventions of academic training that for them had become arrogant.

That initial meeting was in the studio of John Everett Millais (1829–96), when only Millais, Hunt and Rossetti were present, the other four not being elected until December of that year when a formal meeting was convened. However, the spirit of the September meeting held sway, a meeting that was to herald a new approach to art based on Renaissance painting before Raphael (1483–1520).

Gozzoli was trained in the studio of Fra Angelico and then worked for a time under contract to Ghiberti before becoming an accomplished fresco painter in Tuscany.

CREATED

Florence, Italy

MEDIUM

Fresco

RELATED WORK

Berengaria's Alarm for the Safety of her Husband, Richard Coeur de Lion by Charles Alston Collins, 1850

Benozzo di Lese Gozzoli Born 1420 Florence, Italy

Died 1497

Memling, Hans
Adoration of the Magi, c. 1470–72

Writing in the 1950s, the art historian Erwin Panofsky suggested that Victorian artists considered Hans Memling's oeuvre both 'sweet' and derivative but at the very summit of medieval art. There are a number of reasons why his paintings were so influential to the Pre-Raphaelites in particular.

Memling was of the next generation in Netherlandish painting after van Eyck, developing a style of optic realism that is unique. Although his paintings were generally devotional and typical in subject matter, his pictorial world was not a reality easily understood at the time. His figures, which were sometimes portraits of his patrons, appear modelled, sculptural and static, each within their own space, in a landscape that appears merely to serve as a backdrop. His paintings are *tableaux vivants*, theatrical, with the figures set on the stage ready to play out a scenario. His colours are very bold, the garments worn by the 'actors' are vibrant, which adds to their sculptural quality and enhances the feeling of space around them.

CREATED

Probably Bruges, Belgium

MEDIUM

Oil on panel

RELATED WORK

Finding the Saviour in the Temple by William Holman Hunt, 1854–55

Hans Memling *Born c. 1433 Seligenstadt, Germany*

Died 1494

Botticelli, Sandro

The Birth of Venus, c. 1485

© Galleria degli Uffizi, Florence, Italy, Giraudon/The Bridgeman Art Library

During the 1870s there were a number of striking resemblances to the paintings of Sandro Botticelli in the work of the Pre-Raphaelites, most notably by adherents to Pre-Raphaelitism rather than the original Brotherhood and their associates. In the previous decade, the National Gallery in London had acquired Botticelli's picture *Mars and Venus* and, in 1871, the writers Walter Pater (1839–94) and Ruskin began to discuss his work. Although famous and renowned in his lifetime, his work was very quickly overshadowed by the next generation of Italian masters such as Raphael, the proponents of the High-Renaissance style that the Pre-Raphaelites eschewed. This 'overshadowing' had caused Botticelli's work to be ignored until Ruskin and Pater took up the cause.

At one time the most popular painter in Florence, Botticelli had made his reputation with a mix of both religious and secular paintings of myth and legend, most notably *La Primavera* and, as shown here, *The Birth of Venus*. What the Pre-Raphaelites took from Botticelli was the use of flowing drapery on his figures that created a lyrical, flowing feeling to the pictures.

CREATED

Florence, Italy

MEDIUM

Tempera on canvas

RELATED WORK

Love and the Maiden by John Roddam Spencer Stanhope, 1877

Sandro Botticelli *Born* 1445 Florence, Italy

Died 1510

Reynolds, Sir Joshua
Self Portrait, 1775

When Sir Joshua Reynolds died in 1792, his legacy was his *Discourses*, a series of lectures published between 1769 and 1790 on the 'rules in art'. He was the foremost portraitist of his generation although his historical paintings were less successful. Ruskin was praiseworthy of Reynold's moves to raise the status of art and of artists, although he, like the Pre-Raphaelites, was critical of his 'sloshy' method of imprecise bravura painting, a technique that earned him the nickname 'Sir Sloshua'. It would, however, be a mistake to assume that Reynolds was the enemy of Pre-Raphaelitism, more that he was the personification of an old school tirelessly producing pictures by an outdated mode of painting that had deteriorated since the Renaissance.

The Pre-Raphaelites were, however, in agreement with Reynolds on the hierarchical priority given in his *Discourses* to history painting, a subject that had been neglected by English painters, who generally seemed to prefer 'low priority' landscape and genre painting.

Despite his early advocacy of an anti-Reynolds stance on the 'Grand Manner' paintings, it was Millais who, after becoming an Associate Academician, produced Reynolds-like pastiches such as his *Bubbles*.

CREATED

London

MEDIUM

Oil on canvas

RELATED WORK

Bubbles by Sir John Everett Millais, 1886

Sir Joshua Reynolds *Born* 1723 Plympton, England

Died 1792

Overbeck, Friedrich

The Adoration of the Kings, 1813

Friedrich Overbeck was possibly the most important artist in the revival of religious art at the beginning of the nineteenth century. A man of great artistic and religious integrity, he was originally trained at the Viennese Akademie, but left in 1809 to find his own independent mode of expression, which promoted subjective feelings in painting, aligned with his own code of morality. With a small group of other artists he set up the *Lukasbrüder*, an association that believed in religion as the foundation of art. They had a somewhat ambivalent attitude to Raphael, preferring instead the Italian art of the *Quattrocento*. Overbeck, like the Pre-Raphaelites after him, believed that 'true art' had deteriorated during and since the High Renaissance. He completed a number of devotional works for private patrons as well as large frescoes, creating something of a revival in the process, and decorated a number of important commissions such as the Casa Massimo, in which he painted narrative scenes from Dante. His most satisfying work was probably *The Vision of St Francis* over the entrance to the Cappella della Porziuncola that he painted while staying at the Franciscan monastery at Assisi.

CREATED

Rome, Italy

MEDIUM

Oil on panel

RELATED WORK

A Converted British Family Sheltering a Christian Missionary by William Holman Hunt, 1849–50

Friedrich Overbeck *Born* 1789 Lübeck, Germany

Died 1869

Schadow, Wilhelm
Agnes Rauch (detail), 1825

A slightly later member of the *Lukasbrüder*, Wilhelm Schadow worked with Overbeck on an important commission between 1816 and 1819 – a series of frescoes at the Casa Bartholdy depicting the story of Joseph. The painting's characters are set in landscapes and architectural frameworks, similar to those used in the Italian Renaissance.

By 1818, however, the *Lukasbrüder* was no longer a religious fraternity and had become absorbed instead into a looser collective of artists satirically known at the time as the Nazarenes, because of the inextricable link between their religious and artistic integrities. Simple and sincere images of individuals had given way to more monumental and revival styles of portrayal, and by the 1840s that had in turn been overtaken by an artistic quest for realism. The artists also began to paint images of myth and legend as well as of religious subjects. By this time, the Nazarene painters had also taken up teaching posts in different parts of Europe and thus began the dissemination of their ideas, ideas that found a favourable audience in the Pre-Raphaelites through Brown, who visited Rome in 1845.

CREATED

Probably Berlin, Germany

MEDIUM

Oil on canvas

RELATED WORK

Christ and the Two Marys by William Holman Hunt, c. 1847

Wilhelm Schadow *Born* 1789 Berlin, Germany

Died 1862

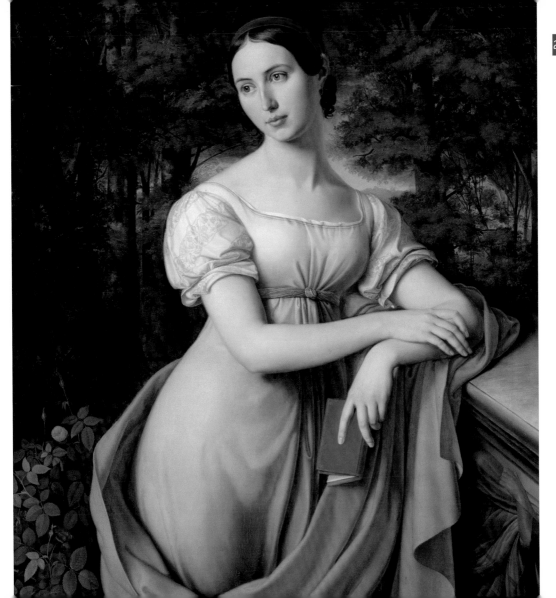

Ruskin, John

Study of Rocks and Ferns, 1843

At the time this watercolour was painted, Ruskin was only 24 years old and already an accomplished practitioner of the arts. The only child of prosperous Scottish parents, his mother encouraged him in the liberal arts of poetry and drawing (he was taught by the watercolourist Copley Fielding (1787–1855)). He was also a keen student of the natural sciences and accompanied his parents on their many European trips.

While at Oxford from 1837, his output of both Romantic poetry and the drawing of nature and architectural forms were prodigious. After the trip with his parents to Venice in 1835, he developed a love of Venetian architecture, something that would inspire his writings on gothic for the rest of his life.

More importantly for the Pre-Raphaelites, he became an art critic in 1841, anonymously writing the first edition of *Modern Painters* as early as 1843. By the time the second volume was written in 1846, Ruskin had expounded his artistic ideas more formally, a love of gothic and the medieval spirit, and a love of nature that demanded artists adhere to a doctrine of faithfully depicting a 'truth to nature'.

CREATED

Perthshire, Scotland

MEDIUM

Watercolour on paper

RELATED WORK

In the Highlands by Anthony Vandyke Copley Fielding, *c.* 1820

John Ruskin *Born* 1819 London, England

Died 1900

Ruskin, John

Gneiss Rock at Glenfinlas (detail), 1853–54

At the end of volume one of *Modern Painters*, Ruskin made extensive reference to the notion of 'truth to nature', suggesting that artists should 'go to nature in all singleness of heart ... rejecting nothing, selecting nothing and scorning nothing'. His repetition of this edict in the pamphlet on Pre-Raphaelitism published in 1851, specifically called on the Brotherhood to depict every detail with meticulous fidelity as part of an artistic duty. For Ruskin this was a way of redressing the infidelity, as he saw it, of most post-Renaissance painting.

He was of course faithful to his own edict as this watercolour shows, meticulously reproducing the pink gradations and coarseness of the Gneiss rock he saw when on a painting excursion with Millais in 1853 at Glenfinlas. It was on that trip that Millais became intimate with Ruskin's wife Effie, who had accompanied them to Scotland. At that time, Ruskin had been married for five years but had failed to consummate the marriage, leading to a scandalous dissolution and Effie finding consolation in Millais, whom she was to later marry.

CREATED

Glenfinlas, Scotland

MEDIUM

Pen, wash and gouache on paper

RELATED WORK

Portrait of John Ruskin by Sir John Everett Millais, 1853

John Ruskin *Born* 1819 London, England

Died 1900

Ruskin, John
Velvet Crab, 1870–71

Ruskin and Oxford were inseparable, even though their relationship was difficult at times. As an undergraduate, although he had won prestigious prizes for his drawing and poetry, he was always an outsider and had to leave his studies on hold after suffering a mental breakdown when he was only 21.

Between 1855 and 1861 he was heavily involved in the design and decoration of the Oxford Museum of Natural History, an architectural exercise of iron structure with a Venetian gothic façade and decorative interior detail. Ruskin was ideal for the job, having more than just a passing interest in Venetian-gothic architecture, and he was also very knowledgeable about natural history, as this watercolour drawing demonstrates.

In 1869 he was elected Oxford's first Slade Professor of Fine Art, publishing a series of lectures on art and architecture. As such he established a new methodology for teaching at the university, developing an in-house art collection that could be used didactically. His interest in natural history was, however, to be his undoing at Oxford, and he resigned his post in 1885 following the university's decision to allow vivisection.

CREATED

Unknown

MEDIUM

Watercolour over pencil on paper

RELATED WORK

A Young Palm, Valentia by John William Inchbold, 1865

John Ruskin *Born* 1819 London, England

Died 1900

Ruskin, John

The Dream of St Ursula, after Carpaccio, 1876

Until Ruskin began writing about Vittore Carpaccio (*c.* 1460–*c.* 1525) in the 1860s, the *Quattrocento* Venetian artist had been all but forgotten in England. What Ruskin saw in his work was a combination of the religious reverence of earlier painters, such as Giotto, with a sense of morality that Ruskin could empathize with. He was also attracted to the absolute wealth of detail and richness of texture in Carpaccio's painting that was missing from his predecessors. The religiosity of Carpaccio's pictures was, according to Ruskin, heartfelt, something that he, as an evangelical Christian, could identify with.

Ruskin was interested in the story of St Ursula, a fourth-century princess of Roman-British origin. Having accepted a proposal of marriage, Ursula requested of her father, the King, that she be allowed firstly to embark on a pilgrimage across Europe with 11 virginal handmaidens. During the voyage their ship was besieged by the Huns, who summarily executed all the virgins including Ursula. Carpaccio produced a cycle of nine paintings depicting the life of Ursula, which Ruskin saw and admired on his visits to Venice.

CREATED

Probably London

MEDIUM

Gouache on paper

RELATED WORK

The Dream of St Ursula by Vittore Carpaccio, 1495

John Ruskin *Born* 1819 London, England

Died 1900

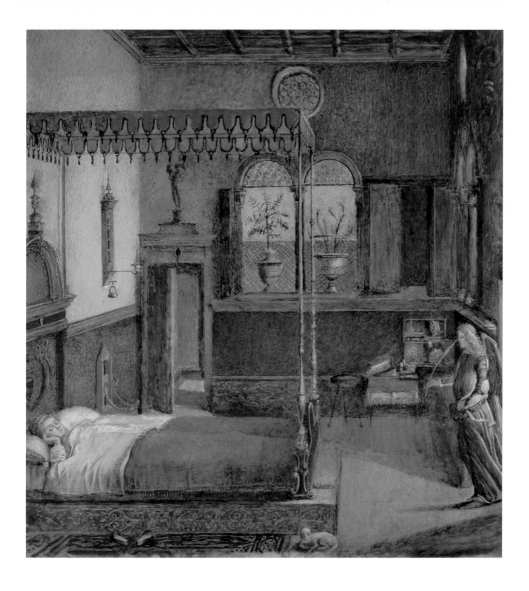

Dyce, William

Titian Preparing his First Essay in Colouring, 1856–57

William Dyce served as a link between the Nazarenes in Europe and the Pre-Raphaelites, causing him to be dubbed 'The British Nazarene'. A deeply religious man, Dyce completed a number of paintings of religious subjects, such as *Dead Christ* of 1835, as well as pagan subjects of myth and legend, for example *Bacchus Nursed by the Nymphs of Nysa* from 1836.

His paintings of the 1840s, those that influenced the Pre-Raphaelites, were responsible for his Nazarene epithet, an example being his *Virgin and Child* of 1845, the figures in which are characterized by a distinct clarity and sharpness of line that differentiated itself from academic 'sloshiness'. This was considered at the time a radical style for religious painting.

In the painting shown, Dyce highlights the *disegno e colore* debate of the sixteenth century, which sought to establish whether the value of a painting was in the artistic idea explored through drawing (*disegno*) or in the faithful portrayal of nature through the exploration of colour (*colore*). Titian (*c.* 1485–1576) was of the latter school, something that accorded with the Pre-Raphaelite agenda.

CREATED

Probably London

MEDIUM

Oil on canvas

RELATED WORK

Aurelia Fazio's Mistress by Dante Gabriel Rossetti, 1863–73

William Dyce *Born* 1806 Aberdeen, Scotland

Died 1864

Burton, William Shakespeare

The Wounded Cavalier, c. 1856

© Guildhall Art Gallery, City of London/The Bridgeman Art Library

The subject matter for this picture was almost certainly inspired by Millais' painting *The Proscribed Royalist 1651* exhibited at the Royal Academy in 1853, which depicts a cavalier hiding in an oak tree under a woman's watchful eye. This depiction by William Shakespeare Burton is more confrontational, a wounded, probably dying, cavalier being tended by a woman under the watchful eye of an enemy puritan, the pose redolent of a Renaissance *Pieta* scene. Burton was the son of a dramatist, an influence evident in this *mise en scène*.

The picture acts to highlight religious and, by extension, moral differences – the oversized Bible in the hands of the puritan contrasting with the playing cards strewn around the cavalier. The woman shown is probably the puritan's wife or sister who, unlike him, shows compassion for a dying man irrespective of his faith, serving to highlight family differences and divisions in a time of civil war. Despite Ruskin's enthusiasm for the painting and the artist when it was shown at the Royal Academy in 1856, Burton was a forgotten figure within a very short time, his career as a Pre-Raphaelite never established.

CREATED

Guildford, Surrey

MEDIUM

Oil on canvas

RELATED WORK

The Proscribed Royalist 1651 by Sir John Everett Millais, 1853

William Shakespeare Burton *Born* 1824 London, England

Died 1916

Calderon, Philip Hermogenes
Broken Vows, 1857

One of the problems of identifying Pre-Raphaelitism is in deciding whether it is an aesthetic consideration based on style, or on the social homogeneity of its protagonists, a like-minded artistic fraternity. Philip Hermogenes Calderon's art originated as the former, an adopter of the Pre-Raphaelite mode that used a specific romantic interlude set within an elaborately painted landscape. The use of the narrative and the purple dress are redolent of Arthur Hughes (1832–1915), and the landscape setting with direct sunlight is borrowed from Hunt. The painting shown here, depicting a woman's betrayal by her lover through a garden fence, made Calderon's reputation overnight, when it was exhibited at the Royal Academy in 1857. It was a popular image and reproduced as an engraving in 1859.

The 'adoption' of the Pre-Raphaelite style by Calderon was, like Millais', short-lived as both sought and gained Royal Academician status, Millais in 1853 and Calderon in 1867. Calderon's career developed as a member of the St John's Wood Clique, a group specializing in the depiction of biblical and historical scenes shown in dramatic light settings. Clearly *Broken Vows* was a 'work in progress'.

CREATED

Probably London

MEDIUM

Oil on board

RELATED WORK

April Love by Arthur Hughes, 1855–56

Philip Hermogenes Calderon *Born* 1833 Poitiers, France

Died 1898

Martineau, Robert Braithwaite

The Last Day in the Old Home, 1862

The Last Day in the Old Home by Robert Braithwaite Martineau is his best-known and most widely celebrated work. Having studied at the Royal Academy Schools, he became a pupil of Hunt in 1851, the two remaining friends until Martineau's early death in 1869. Clearly Hunt's influence is shown in the painting's didactic qualities that show a young aristocrat who has gambled away the family fortune, drinking a glass of champagne, indifferent to his suffering family around him. The painting enjoyed critical success at the 1862 International Exhibition in London.

An earlier picture *Kit's Writing Lesson* taken from an episode in *The Old Curiosity Shop* by Charles Dickens (1812–70), employs the use of an arched top in the canvas redolent of Brown's epic painting *Work*, in which Martineau modelled for the 'gentleman' on the left of the picture. Another painting of similar date, *Picciola*, which used another literary source, Shakespeare's *The Taming of the Shrew*, also employed the 'arched top', further indicating the strong influence of Pre-Raphaelitism on his oeuvre.

CREATED

London

MEDIUM

Oil on canvas

RELATED WORK

Work by Ford Madox Brown, 1852–65

Robert Braithwaite Martineau *Born* 1826 London, England

Died 1869

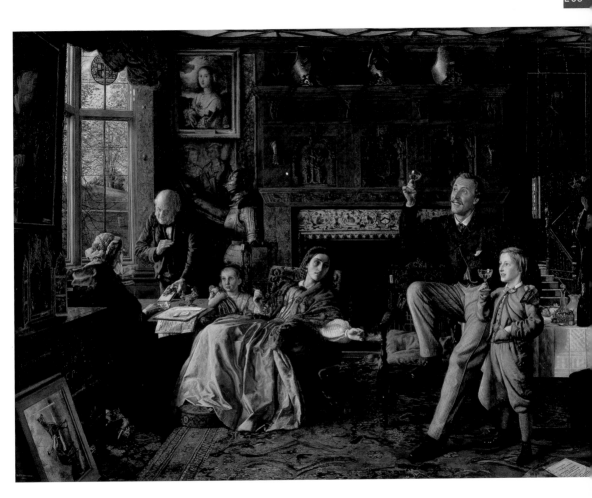

Prinsep, Valentine Cameron
Study of a Girl Reading, c. 1860s

Valentine Cameron Prinsep was a man of considerable independent wealth, who was encouraged by his mother to take up painting under the tutelage of George Frederick Watts (1817–1904), a guest at his house. He was fortunate to secure a participation in the Oxford Union murals in 1857 alongside Rossetti and Edward Burne-Jones (1833–98), adopting their Pre-Raphaelite style in his early work. In 1859 he travelled with Burne-Jones to Italy to study the Italian 'primitives' before joining Charles Gleyre's (1806–74) atelier in Paris for a year. While he was there he met fellow student George Du Maurier (1834–96), who made him an 'honorary' member of the St John's Wood Clique. Prinsep, who was not a resident of St John's Wood, was ineligible for normal membership, but his residency in Kensington brought him into contact with a far more influential group around Frederic, Lord Leighton (1830–96), who influenced his later style. Like him, Prinsep developed a passion for the 'Orient' and its depiction, in pictures such as *At the Golden Gate*. In 1878 Leighton was elected president of the Royal Academy, the same year that Prinsep was given academic status.

CREATED

London

MEDIUM

Oil on canvas

RELATED WORK

Odalisque by Frederic, Lord Leighton, 1862

Valentine Cameron Prinsep *Born* 1838 Calcutta, India

Died 1904

Watts, George Frederick
Love and Death, 1874–77

By the time Watts had come to stay at the home of the Prinseps in 1851, he had already established his reputation as an academic painter, executing portraits of society women as well as pictures of Classical myth and legend. He had, however, fallen out with the Academy the previous year, following the poor hanging of one of his pictures. Watts was to stay at Little Holland House until 1875 as their house guest, bringing him into contact with their social circle that included Alfred Tennyson (1809–92), the photographer Julia Margaret Cameron and the Pre-Raphaelite painters. It was in this period that Watts painted a number of memorable portraits of this circle including those of William Morris (1834–96) and Burne-Jones.

Through these influential contacts and after a trip to Venice in 1853, Watts continued to secure his position gaining commissions for frescoes at important houses such as those at Carlton House Terrace for the Earl Somers. By the late 1860s he was again exhibiting with the Royal Academy and gained full Academician status in 1868. During the 1870s and 1880s he was exhibiting with Burne-Jones and others as the fashionable Grosvenor Gallery.

CREATED

Probably London

MEDIUM

Oil on canvas

RELATED WORK

The Wheel of Fortune by Sir Edward Coley Burne-Jones, 1875–83

George Frederick Watts *Born* 1817 London, England

Died 1904

Stanhope, John Roddam Spencer
Love and the Maiden, 1877

© Christie's Images/Corbis

John Roddam Spencer Stanhope began his artistic career working on the Oxford Union murals alongside Rossetti in 1857. Prior to this, Stanhope had been taught by Watts and become a part of the Little Holland House circle. In 1858, Stanhope moved into a studio next door to Rossetti in Blackfriars, where he painted perhaps his most famous work, *Thoughts of the Past*. Typically Pre-Raphaelite in style and subject, it is a narrative picture of a 'fallen' woman reflecting on her past, evidence of her status as a prostitute surrounding her.

It was Stanhope's friendship with Burne-Jones that was to be more influential to his later style, as the picture shown here demonstrates. His style became more lyrical as he moved away from contemporary narratives to ones of poetic and mythological subjects. Due to his asthma, Stanhope spent the winters in Florence, where he gained first-hand knowledge of *Quattrocento* painting. He began using tempera as a medium for his work and even had his picture frames made by a Florentine craftsman. The painting shown here is redolent of Botticelli, particularly in the pose and the use of the drapery on the figure.

CREATED

Probably Florence, Italy

MEDIUM

Oil on canvas

RELATED WORK

Laus Veneris by Sir Edward Coley Burne-Jones,' 1873–78

John Roddam Spencer Stanhope *Born* 1829 Cawthorne, England

Died 1908

Alma-Tadema, Sir Lawrence

The Meeting of Anthony and Cleopatra, 41 BC, 1883

After travelling to Italy in 1863, the Dutch-born artist Lawrence Alma-Tadema developed a passion for the Classical world. His gold medal for a painting at the Paris Salon of 1864 brought him to the attention of another Neoclassical artist Jean-Léon Gérôme (1824–1904) and, more importantly, to the attention of the art dealer Ernest Gambart, who began to promote his work in England. Due to his subsequent success based on paintings such as *Pheidias and the Parthenon* painted in 1868, he became a permanent resident. His success brought him into contact with other notable painters of his generation who were also interested in the Neoclassical motif, such as Leighton, Watts and, of course, Burne-Jones. The lighter palettes of the Pre-Raphaelites noticeably influenced the change in his style after moving to England, although it could not be said that Alma-Tadema was ever a Pre-Raphaelite painter. He became a full Academician in 1879 and, like Burne-Jones, enjoyed the success afforded to him by the Grosvenor Gallery, which by the 1880s had established itself as the exhibition forum of 'modern' painting and the artists who epitomized Aestheticism.

CREATED

Probably London

MEDIUM

Oil on panel

RELATED WORK

King Cophetua and the Beggar Maid by Sir Edward Coley Burne-Jones, 1880–84

Sir Lawrence Alma-Tadema *Born 1836 Dronrijp, The Netherlands*

Died 1912

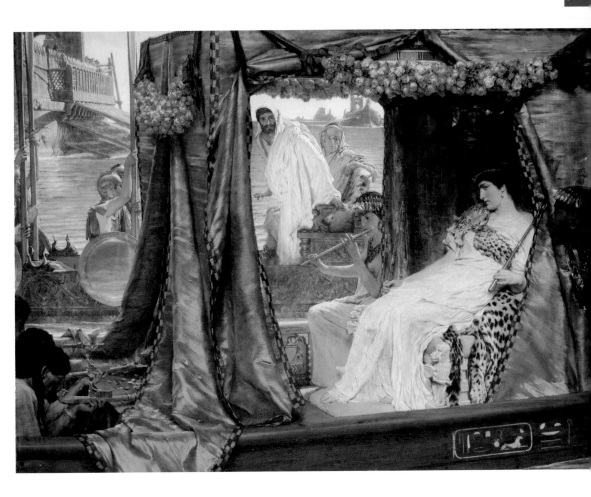

Morris, William

Cray, 1884

Morris's career as a Pre-Raphaelite artist was over as quickly as it had begun, completing only a handful of paintings, including his contribution to the Oxford Union murals. Instead he continued to be influential as a designer and interior decorator from the 1860s onwards within the firm he established in 1861, Morris Marshall Faulkner and Co., later abbreviated to Morris and Co. and often referred to as 'The Firm'.

Morris married Jane Burden in 1859 and shortly afterwards moved into their newly built home, The Red House in Bexley, Kent. Morris executed the furnishings and interior decoration with the help of Rossetti and Burne-Jones, who between them created a handcrafted 'palace of art' for a community of like-minded artists interested in the work of their medieval predecessors. Morris's version of gothic was not historicist in the same way as Augustus Pugin's (1812–52), but one that utilized handcraft skills to create the more simplified forms as used in the medieval period. For Morris it was equally about the social considerations of medieval gothic, a factor that resonated with Ruskin's ideas of social reform.

CREATED

Merton Abbey, Surrey

MEDIUM

Printed cotton

RELATED WORK

Dantis Amor by Dante Gabriel Rossetti, 1860

William Morris *Born* 1834 Walthamstow, England

Died 1896

Morris, William

The Angels Window (detail), 1869

© Church of St Michael, Tilehurst, Berkshire, UK, Martyn O'Kelly Photography/The Bridgeman Art Library

It is likely that, had he not been a politically active socialist, Morris may well have become Tennyson's successor as poet laureate, such was the quality of his poetry. He was also a writer of very eloquent prose, which he used to further his socialist ideals in the latter part of his life. In that respect he had a great affinity with all of the Rossettis, Christina (1830–94), William Michael (1829–1919) and Dante Gabriel.

It was, however, as a designer that he made his name. Morris himself is best remembered for his flat-patterned wallpapers and fabrics, but his collaboration with Rossetti and Burne-Jones on stained glass is unsurpassed. Their success is due in no small part to the gothic-revival architecture used in the massive church building and restoration programme of the Victorian era. The glass was of modern construction and they made no attempt to reconstruct medieval stained glass in a historicist way, instead utilizing the simple forms of the period and recreating them using brighter colours. Morris, however, later refused to include new glass in restoration programmes.

CREATED

Tilehurst, Berkshire

MEDIUM

Stained glass

RELATED WORK

Stained-glass series *The Legend of St George* by Dante Gabriel Rossetti, 1862

William Morris *Born* 1834 Walthamstow, England

Died 1896

de Morgan, Evelyn

Hero Holding the Beacon for Leander, 1885

Evelyn de Morgan (née Pickering) was the niece and one-time pupil of Stanhope, who later attended the newly opened Slade School of Art in 1873, a somewhat liberal and advanced institution for art education by Victorian standards. The Slade was one of the few institutions of any kind at which young ladies could be educated at this time, making her success at gaining a Slade scholarship the more remarkable.

After her formal education, de Morgan travelled to Italy and spent the next few winters living and working in Florence where she came under the influence of Botticelli's work. Her time in London was spent under the influence of Burne-Jones, exhibiting with him and others at the fashionable Grosvenor Gallery. There is, however, in Evelyn's paintings always a sense of heroizing a woman, as seen from another woman's perspective, something that differentiates her work from others such as Burne-Jones.

In 1887, Evelyn married the ceramicist William de Morgan (1839–1917) and, although instrumental in helping his career, she continued as a painter of mythological and allegorical subjects, very much in the same vein as Botticelli.

CREATED

Unknown

MEDIUM

Gouache on paper

RELATED WORK

Pallas and the Centaur by Sandro Botticelli, c. 1482

Evelyn de Morgan *Born* 1855 London, England

Died 1919

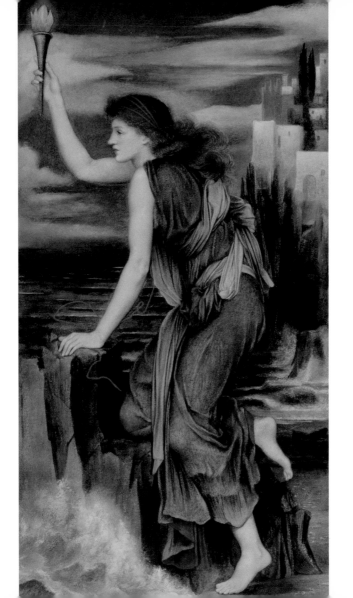

Hallé, Charles Edward

Paolo and Francesca (detail), 1888

One of the least well-known artists of the Victorian period, Charles Edward Hallé was the son of the musician and orchestra leader Sir Charles Hallé, who came from France to England with his family following the Revolution of 1848. Charles Jr entered the Royal Academy Schools in the 1860s and then began travelling to France where he worked for a time with Victor Mottez, a one-time pupil of Jean-Auguste-Dominique Ingres (1780–1867). It is possible that the inspiration for the picture shown here came from that period, as Ingres used the same motif in his painting *Francesca da Rimini and Paolo Malatesta*. Ingres' use of Classicism was adopted in Hallé's work, both works emanating from an ideal of human form as suggested in antiquity. The subject of the motif was popular with the Pre-Raphaelites, particularly Rossetti – a scene from Dante's *The Divine Comedy*, in which two lovers, who have been duped into marriage, await their fate at the hands of Francesca's intended 'arranged' husband.

Hallé enjoyed success as a painter in this Neoclassical idiom, exhibiting his work alongside Burne-Jones, Alma-Tadema and others at the Grosvenor Gallery.

CREATED

Probably London

MEDIUM

Oil on canvas

RELATED WORK

Francesca da Rimini and Paolo Malatesta by Jean-Auguste-Dominique Ingres, 1819

Charles Edward Hallé *Born* 1846 Paris, France

Died 1919

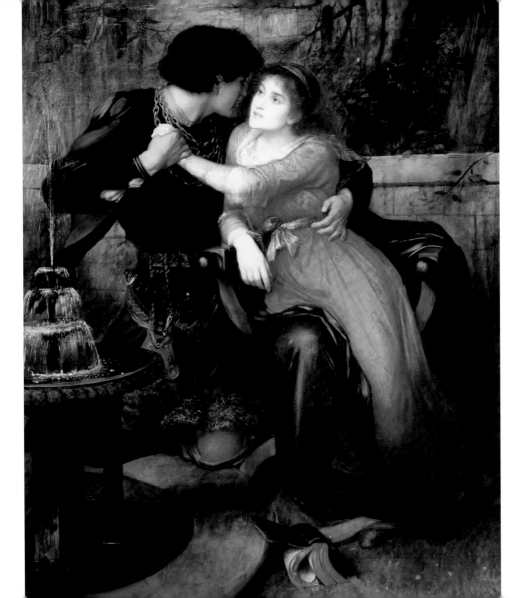

Merritt, Anna Lea

Love Locked Out, 1889

Like her exact contemporary and fellow American Mary Cassatt (1844–1926), Anna Lea Merritt went to Paris at a time when Édouard Manet (1832–83) was at his most radical and the avant-garde was cutting its teeth in the art world. Unlike Cassatt, who remained in Paris and made a name for herself as part of Impressionism's onslaught, Merritt went to London, continuing her studies under the tutelage of Henry Merritt, an art restorer who also wrote on art. Eventually in 1877 they were married, but unfortunately Henry died three months later, leaving her devastated.

The painting shown here is in memory of her husband, an allegory depicting Cupid knocking at a door in a futile attempt to cheat death. The figure of Cupid is naked and, according to Victorian social mores, it was necessary to use a boy as the model rather than a man, since the artist was a woman. The use of a solitary illuminated figure set against a door is redolent of Hunt's *The Light of the World*, a painting that Merritt was bound to have seen.

CREATED

Unknown

MEDIUM

Oil on canvas

RELATED WORK

The Light of the World by William Holman Hunt, 1851–53

Anna Lea Merritt *Born* 1844 Philadelphia, USA

Died 1930

Strudwick, John Melhuish
The Ramparts of God's House, 1890s

As the date of this painting demonstrates, the Pre-Raphaelite legacy continued throughout the Victorian era, lasting over half a century and making it one of the most continuous and enduring styles of picture making. At the height of its popularity in the 1870s, Burne-Jones was overrun with work and found it necessary to take on studio assistants. One of those was Thomas Matthews Rooke (1842–1942) who stayed with Burne-Jones up until his death in 1898. Rooke became an accomplished painter in his own right, producing a number of paintings around the theme of the Old Testament. Another assistant was John Melhuish Strudwick, who worked with Burne-Jones in the 1870s. Although Burne-Jones was always in charge of designs and worked much of the picture himself, he often left the minutiae to his assistants. Such minutiae would include, for example, the detail of a frieze, an angel's wings, or the tedious repetition of a motif. Since many of the paintings were on a large scale it necessitated very careful and meticulous handling of detail, and therefore the most important consideration for an assistant was the quality of his draughtsmanship.

CREATED

Probably London

MEDIUM

Oil on canvas

RELATED WORK

The Story of Ruth by Thomas Matthews Rooke, 1876

John Melhuish Strudwick *Born* 1849 London, England

Died 1935

Waterhouse, John William

Ophelia (detail), c. 1894

Like most of the Pre-Raphaelites, John William Waterhouse studied at the Royal Academy Schools, but the fact that he entered in 1870 demonstrates that he was a generation younger than the original Brotherhood. The exposure to other artists of this time, such as Alma-Tadema and Leighton, whose interests lay in the 'Oriental' and the Classical, as well as the Pre-Raphaelites, led Waterhouse to the development of a particular style – the fusion of all these elements. His scenes with their strong light and deep shadow are akin to Pre-Raphaelitism, but his brushwork is much bolder and looser than theirs with less attention to 'truth to nature'. Although the subjects used are from similar literary sources to those of the Pre-Raphaelites, Waterhouse imbues his figures with elements of Classicism, idealizing his female figures so that they dominate the scene. This can be illustrated by comparing the 'Ophelias' of Millais and Waterhouse. The former complies with 'truth to nature' in the detailed use of flora and the deathly look of the passive Ophelia as she drowns, whereas Waterhouse's Ophelia is preparing herself for the inevitable, shown as a strong upright figure of alluring beauty and femininity.

CREATED

Unknown

MEDIUM

Oil on canvas

RELATED WORK

Ophelia by Sir John Everett Millais, 1851–52

John William Waterhouse *Born* 1849 Rome, Italy

Died 1917

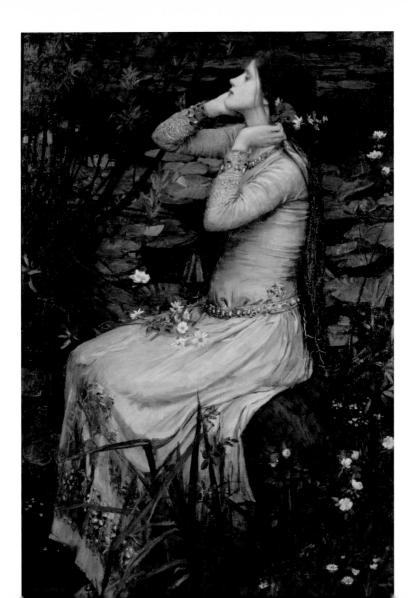

Crane, Walter

Summer, 1895

Walter Crane was only 15 when he was apprenticed to the engraver William Linton. Prior to this, his father, a portrait painter himself, had introduced his son to Ruskin, who encouraged his precocious talent. Crane evolved a style of illustration for books, known as 'toy-books', which were among the first mass-produced books using colour pictures, specifically for children. Their popularity was due to Crane's designs that used flat areas of colour and simplified forms. Many of these ideas originally came from the early Pre-Raphaelite experiments with *Quattrocento* revivalist painting that eschewed notions of perspective, ideas that had evolved into late nineteenth-century Aestheticism.

In 1871, Crane spent his honeymoon in Italy and on his return developed a style of painting that was redolent of Botticelli. Believing, like Ruskin, in the didactic purpose of art, Crane produced a number of pictures using allegory such as his *Renascence of Venus*.

Crane's declining faith in the exhibitions at the Royal Academy led him, with Hunt, to set up the *Arts and Crafts Exhibition Society* in 1888, a successful enterprise that brought together fine and applied arts on an equal basis.

CREATED

Probably Sussex

MEDIUM

Watercolour and gouache on paper

RELATED WORK

The Sleeping Beauty by Sir Edward Coley Burne-Jones, 1871

Walter Crane *Born* 1845 Liverpool, England

Died 1915

Leighton, Frederic, Lord
Flaming June, c. 1895

Flaming June was painted in the last year of Leighton's illustrious career, at the height of his power as President of the Royal Academy, when his pictures were the personification of late Victorian visual art. He was an extremely well-travelled artist who came to prominence at the 1855 Royal Academy Exhibition with his picture *Cimabue's Celebrated Madonna is Carried in Procession Through the Streets of Florence*, painted during a stay in Rome. This painting was purchased by Queen Victoria, which gave Leighton a promising start to his career. The next few years were difficult, however, and he faced opposition from the established Academicians. Undeterred, he established close links with the Pre-Raphaelites by joining the short-lived Hogarth Club, a private exhibition forum set up by Brown. Through this, Leighton's work was brought to the attention of Ruskin, who continued to champion his work, and he painted a number of works that accorded with Pre-Raphaelite motifs such as *Dante in Exile* in 1864. Following this period of stability, Leighton turned more towards Classical subjects that incorporated ancient themes such as his *Return of Persephone*.

CREATED

London

MEDIUM

Oil on canvas

RELATED WORK

The Favourite Poet by Sir Lawrence Alma-Tadema, 1888

Frederic, Lord Leighton *Born* 1830 Scarborough, England

Died 1896

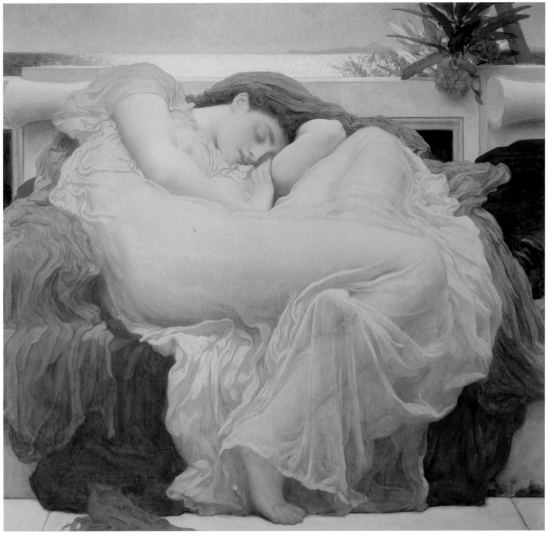

Shaw, John Byam Liston

Boer War, 1900 (Last Summer Things Were Greener), 1901

At the time this picture was painted, the origins of the Pre-Raphaelite Brotherhood were now over half a century old, and of the original Brothers only Hunt was still alive. And where the Brothers had used the *Quattrocento* for inspiration, the new adherents of Pre-Raphaelitism at the turn of the century such as John Byam Liston Shaw were seduced by the early paintings of the Brothers and their circle. Like them, Shaw entered the Academy Schools, becoming a prodigious talent at an early age with pictures such as *Blessed Damozel* painted in 1894 when he was only 22, a painting that clearly shows the influence of the Pre-Raphaelites.

In *Boer War, 1900* Shaw clearly shows his indebtedness to Millais in particular, utilizing a 'truth to nature' in the lush flora he uses in the landscape. The figure too seems to encompass all that is early Pre-Raphaelite, an amalgam of Millais and Hughes in its posturing. As if to underline his debt to the Pre-Raphaelites, Shaw adds a caption on the picture's frame, not Tennyson or John Keats (1795–1821), but Christina Rossetti, 'Last summer things were greener – brambles fewer, skies bluer'.

MEDIUM

Oil on canvas

RELATED WORK

April Love by Arthur Hughes, 1855–56

John Byam Liston Shaw *Born* 1872 Madras, India

Died 1919

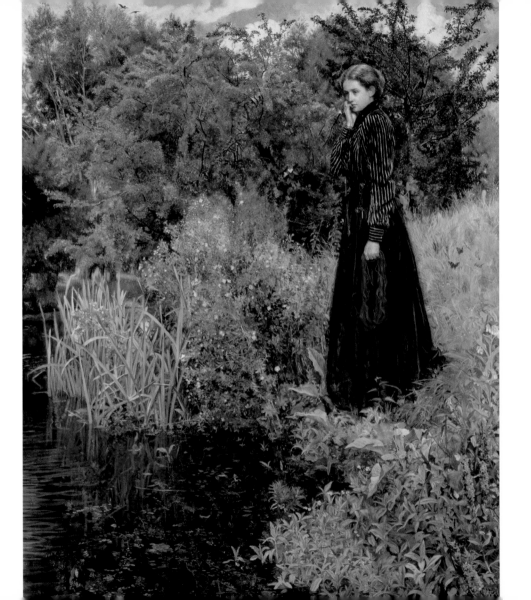

Poynter, Sir Edward John

A Hot-House Flower, 1909

After only a brief time at the Royal Academy Schools, Edward John Poynter joined Gleyre's atelier in Paris to learn history painting. He had already been admiring Leighton's grand-scale works in London, and had visited Rome. Like Leighton, he established his career and reputation very quickly, executing a large number of Classical and Egyptian scenes, and becoming an Academician in 1869. He gained an appointment as the first Slade Professor at University College London, where he began a series of lectures that challenged Ruskin's ideas of a 'truth to nature', giving preference and credence to French academic painting instead. These principles were upheld in his own painting at the time, such as *A Visit to Aesculapius*. He followed up these didactic principles when he was created Director of the National Art Training Schools in South Kensington.

Poynter was an exponent of 'High Art' in the late Victorian period, a 'style' that embodied Classicism, and often aspects of Orientalism or an 'otherness' to Western culture, but that did not necessarily have to be narrative. *A Hot-House Flower* is an exemplary picture of this ideal.

CREATED

London

MEDIUM

Watercolour, bodycolour and gum arabic heightened with gold

RELATED WORK

The Garden of the Hesperides by Frederic, Lord Leighton, 1892

Sir Edward John Poynter *Born* 1836 Paris, France

Died 1919

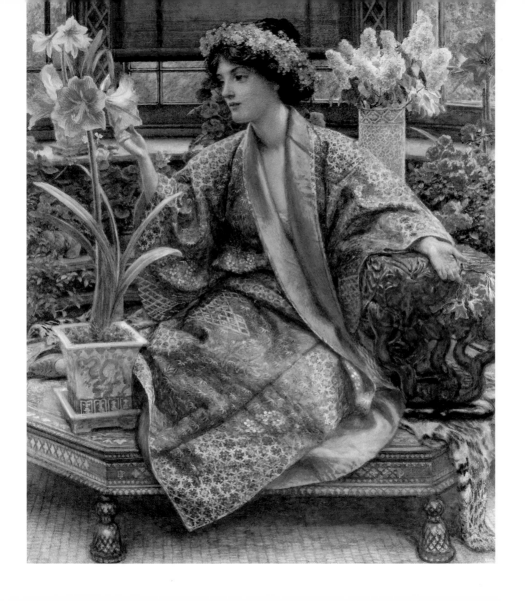

Brickdale, Eleanor Fortescue

A Knight in Armour, c. 1909

Eleanor Fortescue Brickdale, whose first name was actually Mary, was a follower of the Pre-Raphaelite tradition and, like Shaw, took her inspiration from the early Brotherhood and their circle. In fact she and Shaw became close friends and lived as near neighbours in Kensington, around the circle of Leighton, Prinsep and Watts. Like them, she was educated at the Royal Academy Schools but, unlike them, was unable to attend life classes because of her gender. Her paintings were mainly of medieval subjects, which led to her working on some stained-glass designs, in which she developed a sense of flat patterning, ideal for illustration work.

Brickdale gained many commissions early in her career for illustration work, fulfilling a burgeoning market for illustrated books, including a new edition of Tennyson's poems, such were their popularity. In the Edwardian era, more lavishly illustrated books came on to the market, making the names of several illustrators, each of whom was influenced, some indirectly, by the Pre-Raphaelites. Artists such as Arthur Rackham (1867–1939), Edmund Dulac (1882–1953), Kate Greenaway (1846–1901), Richard Doyle (1824–83) and many others were all indebted to the Pre-Raphaelite 'style'.

CREATED

Probably London

MEDIUM

Oil on canvas

RELATED WORK

Sir Isumbras at the Ford by Sir John Everett Millais, 1857

Eleanor Fortescue Brickdale *Born* 1871 London, England

Died 1945

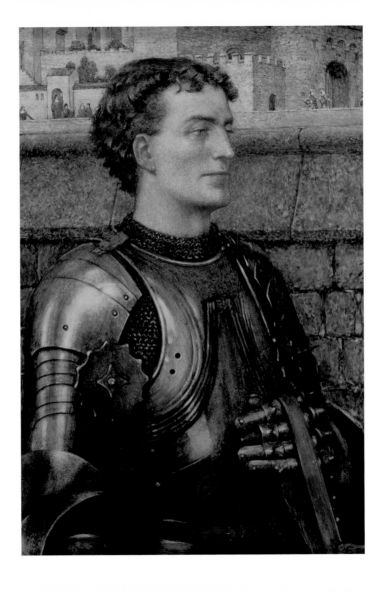

Redon, Odilon
The Black Pegasus (detail), *c.* 1909–10

The link between Odilon Redon and the Pre-Raphaelites is one of Symbolism rather than style. In the second phase of Pre-Raphaelitism, Rossetti and Burne-Jones embarked on a series of paintings that moved away from objective Realism in favour of portraying an essence of a subject, its spiritual character rather than its manifest presence. In the work of the Pre-Raphaelites this was shown, for example, in the sensuous nature of a woman, an example being Rossetti's *Venus Verticordia*, in which her bare flesh is made more sensual by her holding an apple and an arrow that symbolizes an allusion to physical love.

Redon, on the other hand, used mythical creatures to 'transport us to the ambiguous world of the indeterminate'. Redon's early pictures are full of darkness and more nihilistic in tone, but at the turn of the century they become more optimistic often brimming with light. The main inspiration for all his work was 'the dream' and in this painting Redon depicts Pegasus, who at one time had carried Eos the goddess of dawn, riding across an indeterminate sky bringing hope to all.

CREATED

Probably Paris, France

MEDIUM

Oil on canvas

RELATED WORK

Venus Verticordia by Dante Gabriel Rossetti, 1864–68

Odilon Redon *Born* 1840 Bordeaux, France

Died 1916

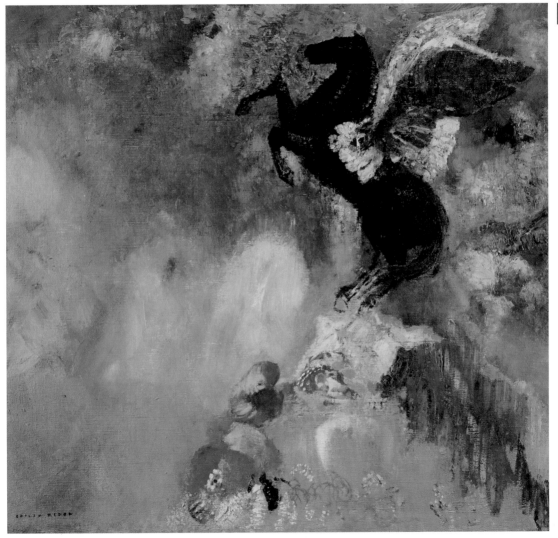

The Pre-Raphaelites

Styles & Techniques

Millais, Sir John Everett

Christ in the House of His Parents (detail), 1849

This painting, John Everett Millais' first religious picture, is contemporary with Dante Gabriel Rossetti's (1828–82) *Girlhood of Virgin Mary*. It was a seminal painting for two reasons. Firstly, it was the first time that so many characters had been shown in a tableau on this subject. The second and more contentious issue was in the use of 'everyday' figures, devoid of religious iconography such as halos. The picture is, however, imbued with Christian symbolism, such as the wood and nails on the bench alluding to Christ's crucifixion, underpinned by the Boy's cut hand and the blood dripping on to his foot. John the Baptist is also seen, carrying a bowl of water to bathe Christ's wound, suggesting his role in the later baptism. In line with early Pre-Raphaelite doctrine, the setting was in fact a carpenter's shop in central London.

Reaction to the painting at the Royal Academy was ferocious, due to the lack of reverence for such a scene. Millais had used extensive realism in the picture, even down to the dirt under Joseph's fingernails. The most vicious attack came from Charles Dickens (1812–70), who described Christ's depiction as a 'hideous, wry-necked blubbering boy'.

CREATED

London

MEDIUM

Oil on canvas

RELATED WORK

The Girlhood of Mary Virgin by Dante Gabriel Rossetti, 1848–49

Sir John Everett Millais *Born* 1829 Southampton, England

Died 1896

Millais, Sir John Everett

The Return of the Dove to the Ark (detail), 1851

In a letter to one of the Pre-Raphaelite patrons, Thomas Combe, Millais specified that he was going to include three figures in the picture, the third being Noah himself, and that there were to be other species of bird in the picture as well as the dove. He may well have got this idea from seeing Thomas Landseer's (1795–1800) picture of the same subject in the Royal Academy Exhibition of 1844, which included several figures and a menagerie. Millais' picture was hung at the Royal Academy in 1851 and sold to Combe, who also purchased *Convent Thoughts* by Charles Alston Collins (1828–73) at the same exhibition.

The picture was painted before John Ruskin (1819–1900) lent his support to the Brotherhood, and in his exhibition review Ruskin was critical of the botanical inaccuracy of the olive branch held by the figure on the left. Ruskin's subsequent support encouraged 'young artists of England' to 'go to nature in all singleness of heart, rejecting nothing, selecting nothing and scorning nothing'. From this point on, his 'truth to nature' also became the credo of the Pre-Raphaelites.

CREATED

Oxford

MEDIUM

Oil on canvas

RELATED WORK

Convent Thoughts by Charles Alston Collins, 1851

Sir John Everett Millais *Born* 1829 Southampton, England

Died 1896

Millais, Sir John Everett
The Bridesmaid (detail), 1851

The Bridesmaid is a painting full of symbolism that anticipates Rossetti's second phase of Pre-Raphaelitism and certain aspects of the Aesthetic Movement pictures of the 1880s. The girl's luxuriant red hair and moistened parted lips are both sensual, but the large overt display of orange blossom at her breast attests to her chastity. The picture, however, is a not just about an abstract notion of beauty as in Rossetti's pictures, there is also a narrative. The girl is passing a piece of wedding cake through a wedding ring, legend suggesting that by so doing, she will in turn see a vision of her future husband.

Christine Riding, a curator at the Tate Gallery, has suggested that this picture should be seen within the context of Millais' other paintings of the time, *Mariana* and *Ophelia*, which suggests a sequence from the youthful yearning of an adolescent, through the sexual frustration of a mature woman to the suicide of a spurned lover. *Mariana* and *The Bridesmaid* are also linked by the inclusion of the same prop used in the picture, the silver caster.

CREATED

Probably Oxford

MEDIUM

Oil on panel

RELATED WORK

Regina Cordium by Dante Gabriel Rossetti, 1866

Sir John Everett Millais *Born* 1829 Southampton, England
Died 1896

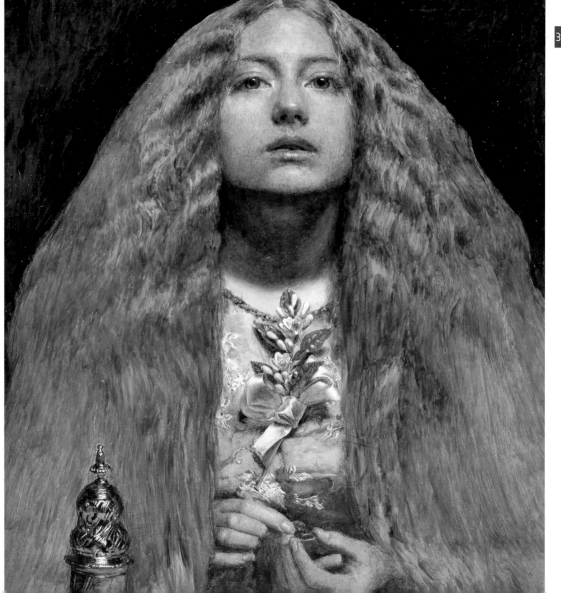

Millais, Sir John Everett
Autumn Leaves, 1856

The years 1855–56 mark a departure from Pre-Raphaelitism in Millais' oeuvre, after his separation from the group following his marriage to Effie Gray, Ruskin's former wife. In her journal she noted that Millais 'wished to paint a picture full of beauty and without subject'. *Autumn Leaves* is the first of the paintings, full of symbolism but without a specific narrative. The painting represents a phenomenon of modernity, transience, what Charles Pierre Baudelaire referred to as the 'ephemeral ... the half of art whose other half is the eternal and the immutable'.

Although the painting was originally received and viewed as a genre painting, Millais intended the work as a modern allegory: three girls collecting the dead leaves for use as a pyre, suggestive of the passing of life. This allegory is underscored by the use of twilight in the background and the autumnal colouring.

The scene for the picture was apparently inspired by a visit that Millais made to Alfred Tennyson's (1809–92) house in the autumn of 1854, when leaves were being cleared. The subject of autumn is a recurrent theme in much of Tennyson's poetry.

CREATED

Perth, Scotland

MEDIUM

Oil on canvas

RELATED WORK

Autumn by Anthony Frederick Sandys, 1860–62

Sir John Everett Millais *Born* 1829 Southampton, England

Died 1896

Millais, Sir John Everett

Waiting (detail), 1864

Waiting is a small oil painting on panel intended as a 'cabinet picture'. Rarely much larger than this size, cabinet pictures were developed for collectors to acquire a number of pictures, usually to be shown within a 'cabinet' or small room to a select number of visitors. The fad for these highly detailed pictures began in Holland in the seventeenth century, with a 'cabinet' often being a small room in a large house, although there are examples of cabinet pictures by Raphael (1483–1520) before that date.

The Dutch developed the market for these pictures through artists who belonged to the Leiden School of 'fine' painting, producing highly detailed paintings with a very high finish. The trend continued in Germany and, to a lesser extent, in England in the eighteenth century, producing small genre type paintings for a collector suitable for an unpretentious small house interior. This painting and others like it were always intended for a private patron rather than as an exhibition picture. In this case the painting was for Joseph Arden, who had already purchased Millais' *The Order of Release 1746*.

CREATED

Unknown

MEDIUM

Oil on panel

RELATED WORK

The Grocer's Shop by Gerrit Dou, 1647

Sir John Everett Millais *Born* 1829 Southampton, England

Died 1896

Millais, Sir John Everett

The Boyhood of Raleigh, 1870

Following his period of painting pictures 'without subject', Millais returned to a specific narrative, easily read and understood by the Victorian public. At this time he selected a number of subjects of a heroic or patriotic nature, in this case both. Victorian England was basking in the glory of its seafaring adventures and colonial enterprises, a vast Empire that knew no bounds. The Empire began in the Elizabethan age, with the establishment of mercantile trading resulting from seafaring voyages by men such as Walter Raleigh. Although the scene is a fictive one, the old sailor pointing to the horizon is foretelling Raleigh's future, a prophecy underpinned by the toy ship depicted at bottom left of the painting.

 The painting depicts the young Raleigh and his brother, modelled by Millais' own boys Everett and George, listening to a real-life old sailor, who sat for the picture. Although Millais had moved away from Pre-Raphaelitism, he still retained the credo 'truth to nature', using the Devon coastline (Raleigh's home) for the picture's background.

CREATED

Devon

MEDIUM

Oil on canvas

RELATED WORK

The Seventh Earl of Cardigan Relating the Story of the Cavalry Charge at Balaclava to the Prince Consort by James Sant, 1854

Sir John Everett Millais *Born* 1829 Southampton, England

Died 1896

Hunt, William Holman
A Converted British Family, 1850

© Ashmolean Museum, University of Oxford, UK/The Bridgeman Art Library

This painting (full title *A Converted British Family Sheltering a Christian Priest from the Persecution of the Druids*) by William Holman Hunt was exhibited at the Royal Academy in 1850 and given this long title in order to explain the complex tableau. The painting was originally intended as a Gold Medal entry to the Academy for a competition whose theme was 'An Act of Mercy', but Hunt found the brief for the work too restricting. As usual with early Pre-Raphaelitism, the landscape was executed first on visits to Hackney Marshes, accounting for the wonderfully accurate portrayal of the river and reeds. Hunt sought out some gypsies for the figures, whom he found at Battersea Fields.

As with many of the religiously themed pictures of the Pre-Raphaelites, this one contains many symbols of Christianity. The fishing nets hanging outside of the hut are symbolic of Christian 'fishers of men' and at the same time show contempt for the druids who forbade the capture of these sacred creatures. The loin cloth of the man second from left is made of fur, an apparel worn by John the Baptist, and the figure standing next to him is squeezing grapes into a cup, suggesting a communion rite.

CREATED

Lea Marshes, London

MEDIUM

Oil on canvas laid down on panel

RELATED WORK

Christ in the House of His Parents by Sir John Everett Millais, 1849–50

William Holman Hunt *Born* 1827 London, England

Died 1910

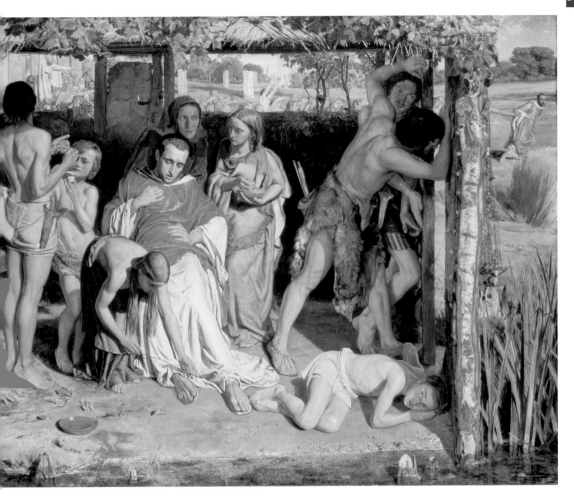

Hunt, William Holman

Our English Coasts, 1852

Sheep appear in a number of Pre-Raphaelite paintings on a religious theme, particularly those by Hunt, as symbolic of the Christian flock. Having recently completed *The Hireling Shepherd*, Hunt travelled to Fairlight in Sussex in the summer of 1852 to fulfil a commission he had been given for a picture that contained only sheep in a landscape. Hunt stayed with the parents of his pupil Robert Martineau (1826–69), where, on a previous visit, he had noted a lover's seat on top of the cliffs. Taking the small canvas to the spot, he sketched in the pencil outline of the design *in situ*. According to Hunt's correspondence on the subject, the details of the picture, the sheep, the ledge and the vegetation were all taken from different viewpoints. Although most of the work was executed outdoors, the inclement weather that summer and autumn caused difficulties for the artist, whose patron, Charles Maud, insisted on capturing the bright summer sun. The butterflies and some other details were added in Hunt's studio in London and the painting was completed in November.

CREATED

Fairlight, Sussex

MEDIUM

Oil on canvas

RELATED WORK

A Study in March by John William Inchbold, *c.* 1855

William Holman Hunt *Born* 1827 London, England

Died 1910

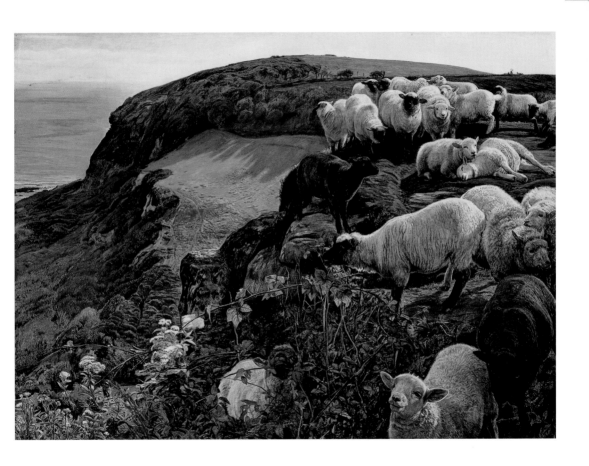

Hunt, William Holman

The Light of the World, 1853

The less-than-romantic reality of the painting was its execution at Worcester Park Manor House in Surrey with the Christ figure knocking on an abandoned hut door. The picture was actually painted during the night *in situ*. However, the picture is not about reality but an allegory based on a Bible text from Revelations, 'Behold I knock at the door', in which the door symbolizes man's spiritual conscience. The other symbols in the picture are the weeds, ivy and neglected orchard in the background, suggestive of man's neglect of God's gifts, and the bat at the top of the door is the lover of darkness. Against this is Christ carrying a lantern, the redeemer who can bring man out of the darkness through His intercession, and who wears a crown, the symbol of ultimate power.

The Pre-Raphaelite patron Combe purchased the original half-life-size painting, and after he died his widow presented it to Keble College, Oxford. Hunt painted a full-sized replica at the turn of the century, which, after a tour around the country, was presented to St Paul's Cathedral.

CREATED

Worcester Park Manor House, Surrey

MEDIUM

Oil on canvas

RELATED WORK

The Baptism of Christ by Piero della Francesca, 1450

William Holman Hunt *Born* 1827 London, England

Died 1910

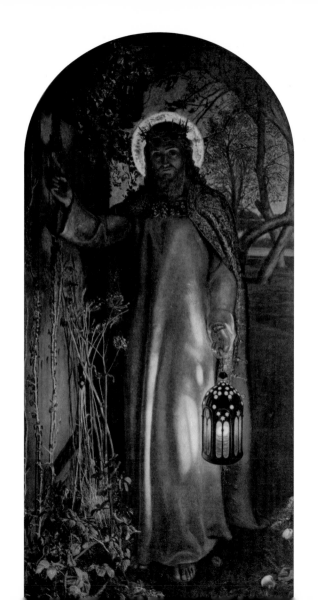

Hunt, William Holman

The Triumph of the Innocents, 1883–84

There are two almost identical versions of this picture, the first of which was begun in Jerusalem in 1875, just after his marriage to Edith Waugh, who accompanied the artist to the Holy Land. The picture was fraught with difficulties from the beginning; Hunt relying on local linen for the painting that was susceptible to wrinkling. Abandoning work on the painting in 1879, he returned to England with it, convinced that the 'devil' had been its saboteur. Resuming work after having the linen backed by canvas to improve its rigidity, the wrinkled piece, which contained the Madonna and Child, was cut out and replaced in 1887. In the meantime, Hunt had also executed another painting of similar size on canvas, completed in 1884.

In these paintings, Hunt has fused nature and the spiritual world, anticipating the Magic-Realism pictures of the 1920s. His subject is the flight from the Holy Land by Joseph, Mary and Jesus, led by the spirits of the massacred innocents of Herod's wrath. In the top left are the spirits awakening from their earthly death, ready to join the others in the procession.

CREATED

The Holy Land and London

MEDIUM

First version (1875–84) oil on linen, laid on canvas; second version (1883–84) oil on canvas

RELATED WORK

The Holy Innocents by Giotto, 1304–06

William Holman Hunt *Born* 1827 London, England

Died 1910

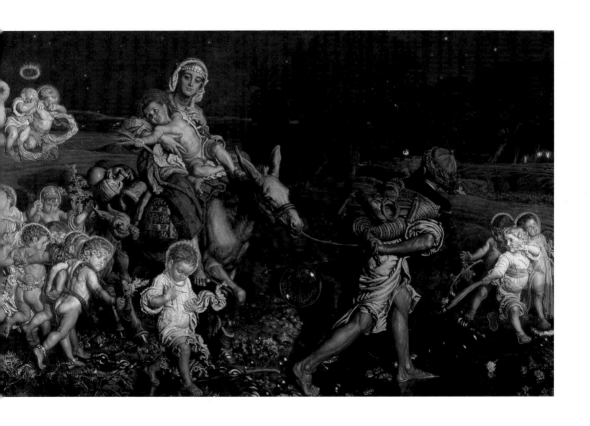

Hunt, William Holman
The Lady of Shalott, 1886–1905

Tennyson, and in particular his character *The Lady of Shalott*, was influential to most of the Pre-Raphaelites at some time in their careers, but for Hunt it spanned his entire working life. What appealed to all of them was the elusiveness and mystery of Tennyson's text. *The Lady of Shalott* was originally written in 1832, revised in 1842 and became so popular that the publisher Edward Moxon decided to produce an illustrated version using the Pre-Raphaelites for the pictures. Hunt produced a drawing in 1850 but did not execute an oil painting until returning to the motif in the 1880s, when he painted two versions, one a large-scale, almost life-size work and a small 'cabinet' painting, both not completed until the end of his career.

At first it appears to be a straightforward depiction of the poem, when 'the mirror cracked from side to side', but should also be seen as an allegory of the consequences of straying from one's designated duty, a theme he used in his earlier painting, *The Hireling Shepherd*.

CREATED

London

MEDIUM

Oil on panel

RELATED WORK

The Lady of Shalott by John William Waterhouse, 1888

William Holman Hunt *Born* 1827 London, England

Died 1910

Rossetti, Dante Gabriel

Ecce Ancilla Domini!, 1849

Originally, according to the artist's brother William Michael (1829–1919), this painting was executed as one of a pair, the other showing the Virgin's death. The latter was never realized, but *Ecce Ancilla Domini!* was begun late in the autumn of 1849 and progress was slow, owing to the several changes of sitter that Rossetti used, including his brother and sister Christina (1830–94). The extensive use of white by the artist is suggestive of purity, and the use of blue and red are synonymous with The Virgin and Christ, respectively. Rossetti also brings in elements of Christian symbolism, the dove representing the Holy Spirit, by whom the Virgin conceives, and the lily with one bud still to open, symbolic of conception. Rossetti inaccurately dated the picture, inscribing 'March 1850' on the work, probably to tie in with the Feast of the Immaculate Conception. The painting was heavily criticized by the Anglicans as too 'Popish' in sentiment and religiously didactic in intent, an opinion probably justifiable given the use of a Latin title from St Luke's Gospel, the powerful symbolism and the use of nimbuses around the heads of the Holy figures.

CREATED

London

MEDIUM

Oil on canvas

RELATED WORK

The Annunciation by Duccio, 1311

Dante Gabriel Rossetti *Born* 1828 London, England

Died 1882

Rossetti, Dante Gabriel

Paolo and Francesca da Rimini, 1855

Although Ruskin had famously shown support for the Pre-Raphaelites in 1851, it was not until 1854 that Rossetti actually met him. In the following year, Ruskin advised his protégé Ellen Heaton to commission a work from Rossetti, who obliged with the watercolour shown here. The subject was close to Rossetti's heart, a scene from Dante's (1265–1321) texts, in this case *Inferno*. It is similar in design to a pictorial fresco and is in three parts, beginning with the lovers kissing on the left. They are embracing after considering the book on their laps in which the story of Lancelot and Guinevere is told. Dante and Virgil are in the centre of the picture looking upon the fate of the lovers, who are being showered by the tongues of flame in Hell for their adultery. Both Rossetti in his painting and Dante in the text show compassion in their depiction of their intense love for each other and the cruel death that befell them.

Because of Victorian social mores, Heaton declined the picture as 'unsuitable for a lady's collection', and it remained in Ruskin's collection.

CREATED

London

MEDIUM

Watercolour on paper

RELATED WORK

Dante's Divine Comedy by William Blake, 1824–27

Dante Gabriel Rossetti *Born* 1828 London, England

Died 1882

Rossetti, Dante Gabriel

Dantis Amor, 1859

Dantis Amor or Dante's Love is one of three mahogany panels decorated by Rossetti that formed part of a settle belonging to William Morris (1834–96). Originally the settle stood in Morris's London home but was moved to the Red House, his new home built for him and his new bride Jane Burden. The painting depicts the figure of Love holding a sundial (unfinished), an allegory of her timeless capacity as the dynamic force of the world, something that Dante and Rossetti both subscribed to. The figure at the bottom right is Beatrice, being lovingly looked down on by the face of Christ. The sundial was unfinished, but in the pencil drawing for the work, Rossetti intended to set the dial at nine, according to Dante the time of Beatrice's death.

There were two other panels in the settle that flanked this one. The first, on the left, depicted *The Salutation of Beatrice in Florence* and the third image on the right was of *The Salutation in the Garden of Eden.* The central panel was therefore the event that occurred between the two others.

CREATED

London

MEDIUM

Oil on mahogany

RELATED WORK

Dante's First Meeting with Beatrice by Simeon Solomon, 1859–63

Dante Gabriel Rossetti *Born* 1828 London, England

Died 1882

Rossetti, Dante Gabriel

Bocca Baciata (Lips That Have Been Kissed), 1859

The title *Bocca Baciata*, meaning 'lips that have been kissed', was adopted by Rossetti from lines by the fourteenth-century Italian poet Giovanni Boccaccio (1313–75), lines that he inscribed on the reverse of the painted panel. It was painted as a 'cabinet' painting for his friend George Boyce. The model for the picture was Fanny Cornforth, Rossetti's housekeeper and a former prostitute. She also sat for Rossetti's unfinished picture *Found*, which dealt with the subject of the 'fallen woman'.

The painting marked a departure for Rossetti, who, until the time of its execution, had been almost exclusively painting watercolours. Rossetti began to move away from narrative depictions in favour of symbolic ones without subject, anticipating the Aestheticism of the next decade and beyond, in the work of, for example, James McNeill Whistler (1834–1903). In this picture, Rossetti begins to explore beauty for its own sake and not as part of a narrative, imbuing his subject with a freshness and vitality of its own.

CREATED

London

MEDIUM

Oil on panel

RELATED WORK

Rose and Silver by James McNeill Whistler, 1864

Dante Gabriel Rossetti *Born* 1828 London, England

Died 1882

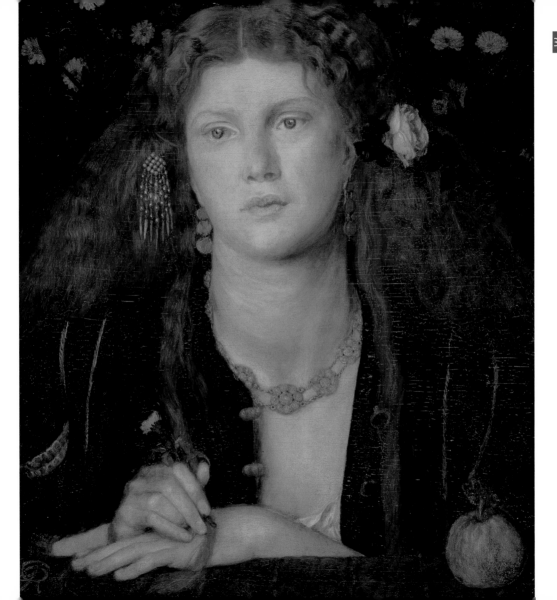

Rossetti, Dante Gabriel

Lucrezia Borgia, 1860–61

The *femme fatale* had been a character deployed in literature and art prior to the Victorian era, but had not been exploited so well before. Some of these characters were portrayed by the Pre-Raphaelites, most notably Rossetti and Edward Burne-Jones (1833–98), themselves allured by their seductive and often dangerous nature. The scene depicts Lucrezia washing her hands after poisoning her husband Duke Alfonso Biscegli, aided in her crime by Pope Alexander IV. The painting uses the round mirror motif inspired by *The Arnolfini Marriage* by Jan van Eyck (*c.* 1390–1441). In Rossetti's painting, it shows the reflection of the Duke, who will die shortly from the effects of the poison, being escorted by the Pope, who was Lucrezia's father.

In many ways, Lucrezia is the archetypal *femme fatale*, who used a combination of physical beauty, feminine sexual allure and guile to exploit the known weaknesses of her suitors for financial or political gain. Usually the 'victim' is driven to the point of obsession and is no longer capable of rational thought.

Rossetti's initial inspiration for the picture may well have come from Donizetti's opera *Lucrezia Borgia* performed in London in December 1843.

CREATED

London

MEDIUM

Pencil and watercolour on paper

RELATED WORK

Sidonia von Bork, 1560 by Sir Edward Coley Burne-Jones, 1860

Dante Gabriel Rossetti *Born* 1828 London, England

Died 1882

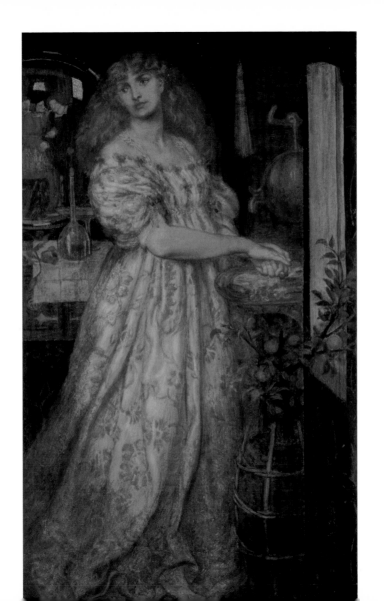

Rossetti, Dante Gabriel

Venus Verticordia, 1867

The original and more familiar painting of this subject, executed in oil between 1864 and 1868, was, like most of his work in this medium, painstakingly undertaken. The figure in that version is illuminated by a nimbus, and is surrounded by blossoms of honeysuckle and roses all meticulously painted, as are the butterflies that have been added to the picture. The work shown here was executed in chalk as a cabinet painting (the oil painting was almost a metre (3 ft 3 in) in height) and completed very rapidly. Rossetti often made copies of major works, executed in a more immediate medium such as chalk or pencil. The copy would be less refined and contain none of the meticulous detailing of the original, and was usually intended as a gift for a friend, or to sell quickly.

From the 1860s on, Rossetti returned again and again to the theme of the *femme fatale*, the alluring but equally dangerous woman symbolized by the golden arrow that is Cupid's dart of love, the same poisoned arrow that killed Paris at the siege of Troy.

CREATED

London

MEDIUM

Chalk on paper

RELATED WORK

Fair Rosamund and Queen Eleanor by Sir Edward Coley Burne-Jones, 1862

Dante Gabriel Rossetti *Born* 1828 London, England

Died 1882

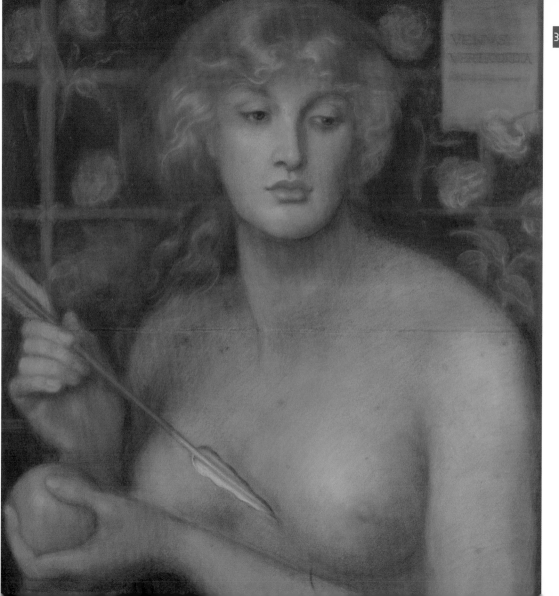

Rossetti, Dante Gabriel
The Blessed Damozel, 1875–78

William Graham, the MP for Glasgow at the time, gave the commission for this painting in 1871 but Rossetti did not actually start work on it until four years later. The idea for the work came from a poem of the same title that Rossetti himself had written in 1850, and that had appeared in the Pre-Raphaelite journal *The Germ*. The sitter for the painting was one of Rossetti's often-used models Alexa Wilding, a former dressmaker whom the artist had first used in his 1866 painting *Monna Vanna*.

On seeing the completed painting, Graham asked Rossetti to add a predella, a horizontal panel added at the bottom of an altarpiece. Its purpose was twofold. Firstly it raised the main panel, thus giving it greater visibility, and secondly the painting on the added panel was used to provide a visual commentary on the main panel. The earliest example of a predella is a fourteenth-century *Maesta* in Siena by Duccio (*c.* 1255–*c.* 1318).

Here, Rossetti has used the predella to depict the bereaved lover looking up towards his recently departed 'blessed damozel', a scene that has a resonance with his own feelings at the suicide of his wife Lizzie.

CREATED

Kelmscott Manor, Oxford and London

MEDIUM

Oil on canvas

RELATED WORK

The Blessed Damozel by Sir Edward Coley Burne-Jones, 1856–61

Dante Gabriel Rossetti *Born* 1828 London, England

Died 1882

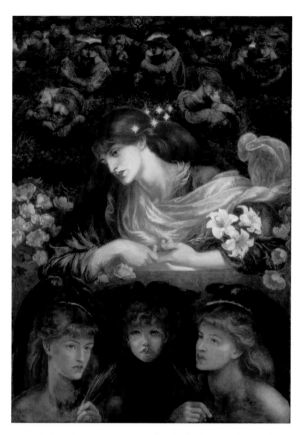

Rossetti, Dante Gabriel

Astarte Syriaca, 1877

© Manchester Art Gallery, UK/The Bridgeman Art Library

Jane Morris sat for this painting between October 1875 and the following June, at Aldwick Lodge in Sussex, where Rossetti was staying at that time. Clarence Fry, who paid over £2,000, the highest price ever paid directly to the artist at the time, commissioned the picture.

The figure adopts the traditional, so-called 'pudica' pose used in many depictions of Venus, most notably that by Sandro Botticelli (1445–1510). However, Rossetti's Venus has more presence and the pose is more 'mannered', similar to the goddesses found in the High Renaissance by artists such as Michelangelo (1475–1564), modelled on the *Venus de Medici*. Rossetti has also added a number of glazes to the painting, similar to those found in the work of Titian (*c.* 1485–1576), whose work the artist had been studying at this time.

The chain around the hips of Venus is made from roses and pomegranates, suggestive of the power to incite love by the wearer. The two torchbearers behind her draw the viewer's attention to the depiction of both the sun and the moon in the same sky, suggesting that love is for always and for all times.

CREATED

London

MEDIUM

Oil on canvas

RELATED WORK

Venus de Medici by an unknown sculptor, 1st century BC

Dante Gabriel Rossetti *Born* 1828 London, England

Died 1882

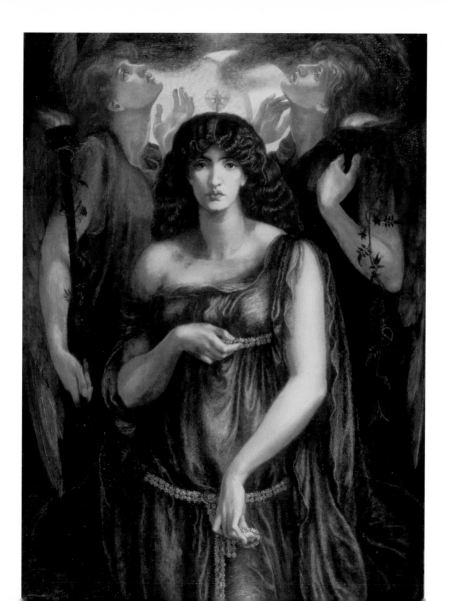

Collinson, James
The Writing Lesson, 1855

© Christie's Images/The Bridgeman Art Library

After leaving the Pre-Raphaelite Brotherhood in 1850 to pursue his vocation as a Jesuit priest, James Collinson abandoned his studies for the priesthood in 1854 and resumed painting. His paintings before and during his membership of the Brotherhood were genre depictions that bore little resemblance to the aspirations of Pre-Raphaelitism and were more akin to those by Richard Redgrave (1804–88). After resuming his painting career, he began to paint in a Pre-Raphaelite style and, despite his strict religiosity, painted perhaps his two best-known works, *To Let* and *For Sale* that depict flirtatious women with ambiguous poses and titles.

He continued to paint genre subjects such as the one depicted here, and in 1861 was elected to the Society of British Artists (upgraded by royal charter in 1886), where he served as secretary under the presidency of Frederick Yeates Hurlstone (1800–69), a history painter. The darker palette used subsequently by Collinson may well be attributable to the artists around him at that time.

Genre subjects exhibited at both the Society of British Artists and the Royal Academy were always easily understood by visitors, making them readily saleable commodities.

CREATED

Probably London

MEDIUM

Oil on canvas

RELATED WORK

The Poor Teacher by Richard Redgrave, 1844

James Collinson *Born* 1825 Nottingham, England

Died 1881

Brown, Ford Madox

Chaucer at the Court of King Edward III, 1847–51

The picture shown here is the original painting made by Ford Madox Brown on a large historical-painting scale, measuring almost three metres (9 ft 10 in) in height and nearly four metres (13 ft) across. The full title of the work is *Geoffrey Chaucer Reading 'The Legend of Custace' to Edward III and his Court, at the Palace of Sheen on the Anniversary of the Black Prince's Forty-Fifth Birthday*. The replica, which is now in the Tate Gallery, is somewhat more modest in scale at one metre (3 ft 3 in) in width. The scale of the original was important for Brown, who was seeking notoriety in his early career. Originally the work was planned as a triptych with two side wings but, after meeting Rossetti in 1849, Brown was advised to abandon such an ambitious project for commercial and exhibition reasons. The work took about four years to complete and in that time Brown took reference from his trip to Rome, where he studied figures and drapery within a Classical context. Although the work predates Pre-Raphaelitism, its artist still using a bitumen ground, it features some of the Pre-Raphaelite associates known to Brown at that time, including Rossetti who posed for Chaucer. The literary Chaucer, a hero of the Pre-Raphaelites, is dominant in the picture, not in the least humbled by his royal company.

CREATED

Rome and London

MEDIUM

Oil on canvas

RELATED WORK

Pizzarro Seizing the Inca of Peru by Sir John Everett Millais, 1846

Ford Madox Brown *Born* 1821 Calais, France

Died 1893 .

Brown, Ford Madox

Mauvais Sujet (detail), 1863

This strange painting with an equally strange title suggests to us today that it is based on a particular narrative. However the term *'mauvais sujet'* had a common currency in the Victorian period and suggested someone who was a ne'er-do-well character. It was used, for example, in the *Ingoldsby Legends* published in 1837, a series of myths, legends and ghost stories that were very popular in Victorian society.

The picture is of a naughty girl confined to her desk to undertake the writing of repetitive lines as a punishment. Her hair is dishevelled and her fingernails and hands dirty, possibly from the ink she is using. Her look is one of contempt for the supposed middle-class viewer, since she is obviously from a lower class. Her contempt is underpinned by the eating of an apple, traditionally a gift for the teacher. However, the eating of the apple may well suggest her forthcoming adulthood, as the temptress Eve. The girl is also wearing an inexpensive choker, an item of apparel often associated with prostitution, a further indication of her possible fate.

CREATED

Probably London

MEDIUM

Watercolour on paper

RELATED WORK

Leisure Hours by Sir John Everett Millais, 1864

Ford Madox Brown *Born* 1821 Calais, France

Died 1893

Brown, Ford Madox

Elijah Raising the Widow's Son, 1864

The inspiration for this painting may well have come from Mendelssohn's oratorio *Elijah*, which was written and first performed in England in 1846. The story of Elijah raising the widow's son is told in the Old Testament as one of a number of miracles that the prophet performed eight centuries before Christ. The link between Christ and Elijah is important because of the latter's prophecy of the Coming, at a time when his contemporaries were worshipping idolatrous subjects. Some commentators have gone so far as to suggest that Christ was in fact the reincarnation of Elijah, who according to the Bible did not die, but was taken to heaven in a chariot of fire.

The link is important in understanding Brown's motivation for the picture, painted at a time when his Pre-Raphaelite associates were moved to depict scriptural narratives around the life of Christ. With the exception of Hunt, the other Pre-Raphaelites were not particularly religious but were aware of the potential of such stories as the basis for narrative pictures in an increasingly commercial marketplace where patrons were often of a particular faith.

CREATED

Probably London

MEDIUM

Oil on canvas

RELATED WORK

The Light of the World by William Holman Hunt, 1851–53

Ford Madox Brown *Born* 1821 Calais, France

Died 1893

Hughes, Arthur

The Eve of St Agnes, 1856

Based on Hunt's picture of the same title dated 1848, Arthur Hughes elected to show his painting as a pseudo-altarpiece triptych. The picture was inspired by a poem by John Keats' (1795–1821), published in 1820 and well known to the Pre-Raphaelites. The elaborate and ornate 'ecclesiastical' frame made for the painting shows the three separate panels, (although they were all painted on one canvas), with a verse from the poem engraved under the centre panel that explains the pictures. The left panel is of the arrival of Porphyro at the castle where a banquet is already under way; the centre panel is the awakening of Madeline; and the right-hand panel depicts the lovers' escape, past the drunken porter asleep on the floor.

This painting also demonstrates the importance of a frame to a picture, a major consideration for Victorians, who sought a total *Gesamtkunstwerk* (total work of art) for their richly decorated and often ostentatious interiors. This was a trend that began with the Pre-Raphaelite artists, and continued with the artists of the Aesthetic Movement for the same reasons. Frederic, Lord Leighton (1830–96) and Lawrence Alma-Tadema (1836–1912) were exemplars of this.

CREATED

Pimlico, London

MEDIUM

Oil on canvas

RELATED WORK

The Seed of David by Dante Gabriel Rossetti, 1858–64

Arthur Hughes *Born* 1832 London, England

Died 1915

They told her how upon St. Agnes' Eve
Young virgins might have visions of delight,
And soft adorings from their loves receive
Upon the honey'd middle of the night.

If ceremonies due they did aright;
As, supperless to bed they must retire,
And couch supine their beauties, lily white;
Nor look behind, nor sideways, but require
Of Heaven with upward eyes for all that they desire.

Hughes, Arthur
The Nativity, 1858

© Birmingham Museums and Art Gallery/The Bridgeman Art Library

The Nativity and *The Annunciation* were a pair of paintings that Hughes was working on between 1857 and 1858. The idea for them probably came from Rossetti's Nativity 'altarpiece', *The Seed of David*. This triptych had a central panel for the Nativity scene itself, flanked by two depictions of David, one as the boy who slew Goliath and the other as a thoughtful king. The panels were separately painted on wood, and framed in *Quattrocento* altarpiece-style frames. Hughes' daughter was the model for the infant child.

Hughes himself seems to have been satisfied with a central panel on its own which he has nevertheless stylized in a way that is redolent of the *Quattrocento* in the use of the arched top and the nimbus around Christ's head. The rest, however, is more modern. Although there was a precedent for the 'host' of angels at the top of the picture in the Renaissance, Hughes' cherubs are more modern in look, actually resembling young contemporary girls. The lantern, symbolic of Christ's purpose in the world, is obviously borrowed from Hunt's *The Light of the World*.

CREATED

Pimlico, London

MEDIUM

Oil on canvas

RELATED WORK

The Star of Bethlehem by Sir Edward Coley Burne-Jones, 1887–91

Arthur Hughes *Born* 1832 London, England

Died 1915

Hughes, Arthur
The Brave Geraint, c. 1859

Tennyson started writing his *Idylls of the King* in 1856, a cycle of poems based on Arthurian legends. Parts of the cycle were two poems, *The Marriage of Geraint* and *Geraint and Enid*, clearly the inspiration for this painting, which also aroused the sensibilities of the artist's patron J. Hamilton Trist, who purchased the painting in 1863. The large gilt frame for the painting bears the opening lines to the poem *The Marriage of Geraint*, although the scene depicted by Hughes bears little relationship to the text.

The story is one of enduring love between the two when Enid is tested. Having married Enid, Geraint, a handsome and brave knight of King Arthur's court, gives up fighting in tournaments and is taunted by his fellow knights as unchivalrous. Enid blames herself and tries to ameliorate the situation, only for Geraint to misunderstand and think she has been unfaithful. He makes her join him on a dangerous journey, commanding her not to speak to him. After a number of adventures and challenges the couple are reconciled, their love mutually proven, and return to Camelot once again.

CREATED

Pimlico, London

MEDIUM

Oil on canvas

RELATED WORK

Illustrations for Tennyson's *Idylls of the King* by Gustav Doré, 1868

Arthur Hughes *Born* 1832 London, England

Died 1915

Hughes, Arthur

L'Enfant Perdu (The Lost Child), 1866–67

Although many of Hughes' paintings are pigeon-holed as Pre-Raphaelite in style, the artist rarely used the light background colouring that his contemporaries used, preferring instead the moonlight or twilight for his settings. L'Enfant Perdu is an exemplar of this, as is Home from Work, a painting executed some five years before. The models for the man and the child (Hughes' youngest daughter Emily) are the same in both pictures and there is a striking similarity in the lanterns used. For L'Enfant Perdu Hughes made a number of preparatory drawings and oil sketches that all have the background figure of the woman omitted, suggesting that she was added as an afterthought.

The painting, like most of Hughes' work, received great critical acclaim when it was shown at the Royal Academy in 1867, including praise from Frederic George Stephens (1828–1907), an original member of the PRB turned art critic. The picture was sold for 350 guineas, a large sum and certainly the most ever paid for one of his paintings during his own lifetime.

CREATED

Unknown

MEDIUM

Oil on canvas

RELATED WORK

The Woodman's Daughter by Sir John Everett Millais, 1851

Arthur Hughes Born 1832 London, England

Died 1915

Brett, John

Glacier of Rosenlaui (detail), 1856

Although John Brett had not even met Ruskin prior to painting this picture, he held a deep reverence for his credo of employing a 'truth to nature' as advocated in *Modern Painters*. Following his reading of volume four, Brett left England for Switzerland to find exactly what Ruskin was writing about, the superiority of granite and gneiss to slate. What Ruskin could only write about and illustrate in monochrome, Brett has brought to life in vivid colour as well as extraordinary detail. Brett was fortunate enough during his stay to meet with another Pre-Raphaelite painter John William Inchbold (1830–88), with whom he shared ideas on the depiction of landscape according to Ruskin's ideas. According to Brett's own diary entry, after his return from Switzerland he found that painting was considerably easier, so exhilarated was he by the experience.

Ruskin was very pleased with the finished result and its attention to detail when it was shown at the Royal Academy in 1857. Geology had become very popular in the Victorian age, one of the so-called 'earth sciences', as a result of a definitive book on the subject in 1830, *Principles of Geology* by Sir Charles Lyell (1797–1875).

CREATED

Rosenlaui, Switzerland

MEDIUM

Oil on canvas

RELATED WORK

Study of Gneiss Rock, Glenfinlas by John Ruskin, 1853

John Brett *Born* 1831 Reigate, England

Died 1902

Burne-Jones, Sir Edward Coley

Sidonia von Bork, 1560, 1860

The gothic romance *Sidonia the Sorceress* was translated into English by Lady Wilde, Oscar's mother, in 1849, a tale about the evil Sidonia who was eventually burnt at the stake as a witch. The painting shown here is one of a pair, the other being a portrait of her sister, Clara, who meets a gruesome death at the hands of Sidonia. The story was also a catalyst for other Pre-Raphaelite artists such as Rossetti to depict the various *femme fatale* figures they developed a penchant for.

The dress being worn by Sidonia appears to be heavily borrowed from the Tudor portrait of Isabella d'Este at Hampton Court, and the overall tenor of its Elizabethan-gothic style appealed to High-Victorian taste.

Burne-Jones painted the two pictures using watercolour and gouache (bodycolour), a medium that in skilful hands such as his creates a painting that has a freshness and an immediacy that brings a subject alive in the mind of the viewer. The works were painted just prior to Burne-Jones's wedding, for his early patron James Leathart, an industrialist who amassed a large collection of Pre-Raphaelite paintings.

CREATED

Probably London

MEDIUM

Watercolour and gouache on paper

RELATED WORK

Isabella d'Este by Giulio Romano, *c.* 1530

Sir Edward Coley Burne-Jones *Born* 1833 Birmingham, England

Died 1898

Burne-Jones, Sir Edward Coley
Pan and Psyche, c. 1872–74

The nineteenth century saw a revival of the interest in myths and legends, particularly those around love stories. One such story was that of Psyche and Cupid revived by a poet called Mary Tighe and published in 1805, a work that in turn inspired Keats' poem 'Ode to Psyche'. Morris also retold the story in his *Earthly Paradise* published in 1870.

 The story is one of love and jealousy. Venus had seen Psyche as a threat to her own status as goddess of Love because of her physical, albeit mortal, beauty. She ordered her son Cupid to fire one of his arrows that would cause Psyche to fall in love with an ugly man. Instead, Cupid fell in love with her on sight, and abducted her, only to later abandon her. Psyche subsequently tries to drown herself and is rescued by the god Pan, the subject of the picture shown here. This is one of two similar pictures executed at the same time, differing only in background, this one redolent of a Claude Lorraine (*c.* 1600–82) landscape based on a similar theme.

CREATED

Probably London

MEDIUM

Oil on canvas

RELATED WORK

Landscape with the Death of Procris by Claude Lorraine, *c.* 1647

Sir Edward Coley Burne-Jones *Born* 1833 Birmingham, England

Died 1898

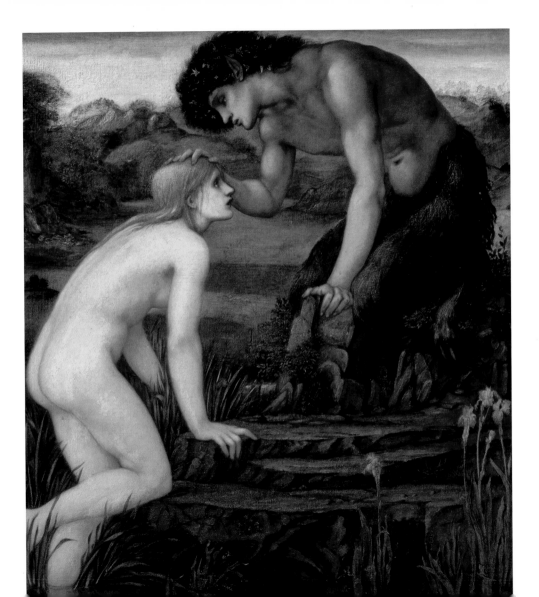

Burne-Jones, Sir Edward Coley
The Beguiling of Merlin (detail), 1874

Frederick Leyland was a wealthy nineteenth-century shipowner and art collector, who famously had the Peacock Room designed for his London house with contributions from Whistler. Although he collected Renaissance art, he was particularly fond of the Aestheticism of Whistler, Albert Moore (1841–93) and of course Burne-Jones. The appeal of Burne-Jones to Leyand was the artist's credo that a painting should be 'a decorated surface'. Leyland commissioned the painting shown here in 1869, although the artist did not begin the work until 1873, completing it the following year. The resigned look on the face of Merlin concerning his fate at the hands of the sorceress Nimue was modelled by a friend of Rossetti's, an American William J. Stillman. At this time, Burne-Jones was suffering from a lack of confidence in his work, and it was Rossetti who was most supportive and persuaded him to exhibit this and other works at the newly opened Grosvenor Gallery in 1877. It was this action that turned Burne-Jones's fortunes around, receiving tremendous accolades for his work in the press. One such commentator was Henry James, who praised the 'fertility of his invention'.

CREATED

Probably London

MEDIUM

Oil on canvas

RELATED WORK

La Princesse du pay de la Porcelaine (the focal painting for The Peacock Room) by James McNeill Whistler, 1864

Sir Edward Coley Burne-Jones *Born* 1833 Birmingham, England

Died 1898

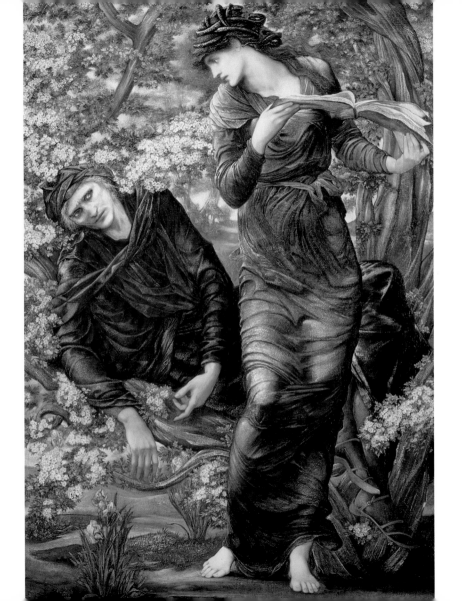

Burne-Jones, Sir Edward Coley
The Wheel of Fortune, 1875–83

© Musée d'Orsay, Paris, France, Lauros/Giraudon/The Bridgeman Art Library

The goddess of Fortune is shown here turning her wheel, attached to which are three mortal men, a slave at the top, a king in the middle and a poet below. Burne-Jones, suggesting its allegorical purpose, wrote, 'My Fortune's Wheel is a true image and we take our turn at it and are broken upon it'.

The painting shows for the first time Burne-Jones's interest in Michelangelo and his attention to the anatomy of the human form, his figures emulating the Mannerist poses and imposing torsos of the master. Similarly, the figure of Fortune bears a resemblance to that of Michelangelo's 'Delphica Sybil' at the Sistine Chapel. Burne-Jones considered Michelangelo's work 'immeasurable', and had copies of his sculptures in the drawing room of his house.

The Wheel of Fortune was exhibited at the Grosvenor Gallery in 1883 after a very long period of execution, after which the artist suffered from exhaustion for several weeks. It was bought by Arthur Balfour the future Prime Minister and patron of the artist, who later commissioned him to paint the 'Perseus' series of pictures.

CREATED

Probably London

MEDIUM

Oil on canvas

RELATED WORK

Delphica Sybil by Michelangelo Buonarroti, 1508–11

Sir Edward Coley Burne-Jones *Born* 1833 Birmingham, England

Died 1898

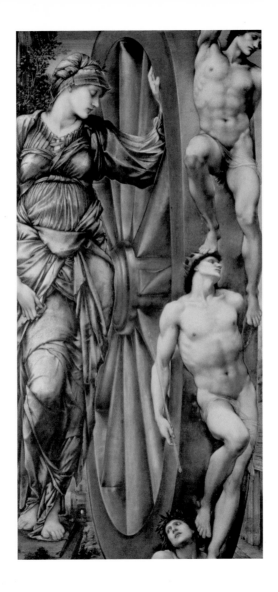

Burne-Jones, Sir Edward Coley

Mermaid with her Offspring, c. 1885

Although they have their antecedents in the water nymphs and sirens of Greek mythology, mermaids seem to have begun as a phenomenon of the nineteenth century, most notably in *The Little Mermaid* by Hans Christian Anderson (1805–75) published in 1872. The theme would have appealed to Burne-Jones for its basis in myth and legend and because of the mermaid's sometime depiction as a *femme fatale*, provoking or at least foretelling of disaster at sea.

At the time this painting was executed, Burne-Jones was an established artist, having gained critical acclaim for his pictures shown at the Grosvenor Gallery, and receiving two honorary titles from different colleges at Oxford including a doctorate. His fame was not confined just to Britain, however. In 1878 he showed paintings including *The Beguiling of Merlin* at the *Exposition Universalle* in Paris where they were much admired. He showed again at the *Exposition Universalle* in 1889 where he was awarded the cross of the *Légion d'honneur* when he exhibited *King Cophetua and the Beggar Maid*. These paintings contributed not only to Burne-Jones's reputation but also to the Symbolist aesthetic in European art.

CREATED

Probably London

MEDIUM

Oil on canvas

RELATED WORK

A Mermaid by John William Waterhouse, 1901

Sir Edward Coley Burne-Jones *Born* 1833 Birmingham, England

Died 1898

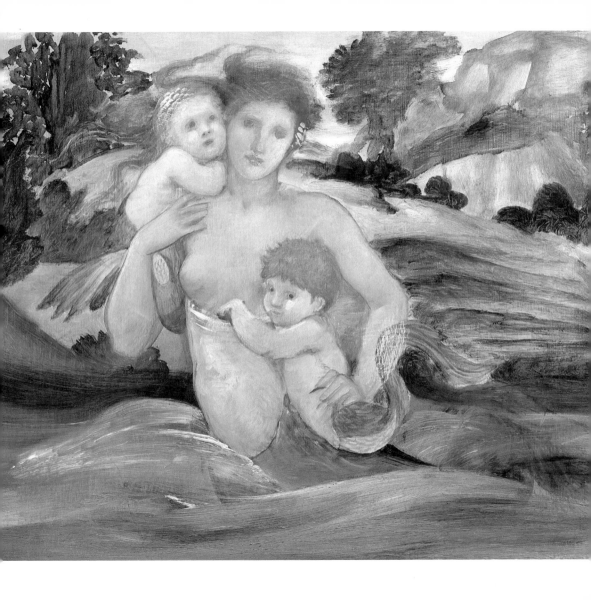

Burne-Jones, Sir Edward Coley
The Mirror of Venus, 1870–76

The Mirror of Venus was another of the paintings to be shown at the *Exposition Universalle* in Paris in 1878. Unlike the others, however, this painting lacks much of the dynamism of say *The Beguiling of Merlin*. It is a more contemplative picture that was commissioned by Frederick Leyland. The work much resembles Botticelli in the style of landscape and in the depiction of Venus. However, her handmaidens are Pre-Raphaelite in style, particularly in the vibrancy of the colours used. The immediacy of the colour caused Ruskin to mistake the painting for a watercolour. The work is frieze-like in nature, with a lyricism found predominantly in Botticelli's stylization and the later Neoclassical traditions of the eighteenth century. The painting as a whole has all the qualities of a decorative panel, and, although its provenance is unknown, was probably intended as such for a large house.

The subject of the painting is explicitly non-narrative and strives for the essence of the ideal beauty, a notion that anticipates Aestheticism, the dominant style in late Victorian visual and decorative art.

CREATED

Probably London

MEDIUM

Oil on canvas

RELATED WORK

La Primavera by Sandro Botticelli, 1478

Sir Edward Coley Burne-Jones *Born* 1833 Birmingham, England

Died 1898

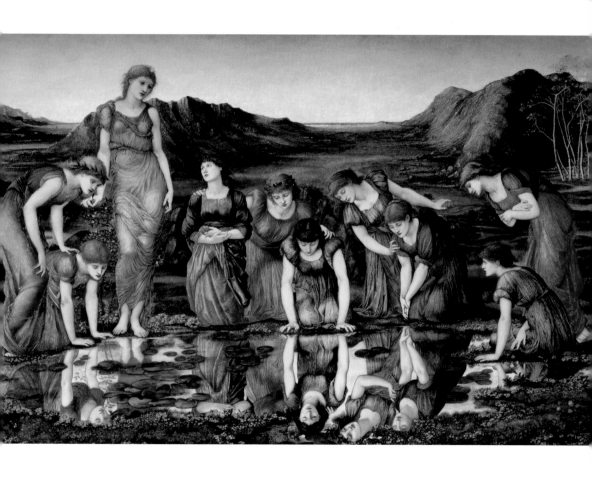

Siddal, Elizabeth Eleanor

Lady Affixing a Pennant to a Knight's Spear, c. 1856

Lizzy Siddal's first exposure to Pre-Raphaelitism was as a model for Hunt's picture *A Converted British Family* in 1850. Her appeal to Hunt and the other artists was her luxuriant red hair and small mouth, noticeable features of many Pre-Raphaelite women from then on. After about 1852, she was only sitting for Rossetti, who agreed to teach her drawing. The link between the two can be seen in this work and Rossetti's *Before the Battle*, which are both scenes of a lady fixing her colours to a knight's lance before going into a battle.

Siddal's painting gives an indication of the weakness of her draughtsmanship, but also the strength of her design capabilities. The circular shape of the couple kneeling serves as a perfect foil to the very rectilinear forms of the background, so that the viewer is immediately drawn to the figures. Siddal used the full length of the spear to create a diagonal across the picture plane. The triangular pennant counterbalances the top half of the diagonal so that again the viewer is only focusing on the couple's faces.

CREATED

Probably London

MEDIUM

Watercolour on paper

RELATED WORK

Before the Battle by Dante Gabriel Rossetti, 1858

Elizabeth Eleanor Siddal *Born* 1829 London, England

Died 1862

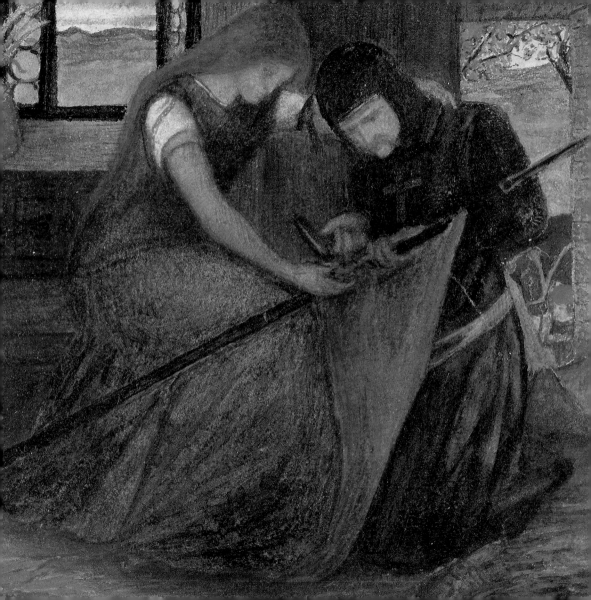

Sandys, Anthony Frederick
The Old Chartist, 1862

The young Anthony Frederick Sandys came to prominence in 1860 with the publication of a satirical drawing that was based on and mocked Millais' painting *Sir Isumbras*. Such notoriety led a number of magazines and journals to employ the services of such a superb draughtsman, the first being the editor of *The Cornhill*, William Makepeace Thackeray, himself a satirist, who commissioned Sandys to produce a drawing of 'A Portent', to illustrate a story by George MacDonald (1824–1905). For this work he was paid the not insubstantial sum of 40 guineas. The work shown here was commissioned by the magazine *Once a Week* to illustrate a poem by Sandys' friend George Meredith. The subject is conducive to the 'political' agenda of the Pre-Raphaelites, using art to create awareness and thus emphasize the need for social change as articulated by Ruskin.

Chartism began in 1838 with 'The People's Charter' drawn up by the disaffected working classes following their exclusion from the 1832 Reform Bill. Despite petitions to the government that contained two million signatures and a mass rally in 1848, Chartism petered out soon after due to a lack of cohesion and indecision.

CREATED

Chelsea, London

MEDIUM

Engraving

RELATED WORK

The Stonebreaker by Henry Wallis, 1857–58

Anthony Frederick Sandys *Born* 1829 Norwich, England

Died 1904

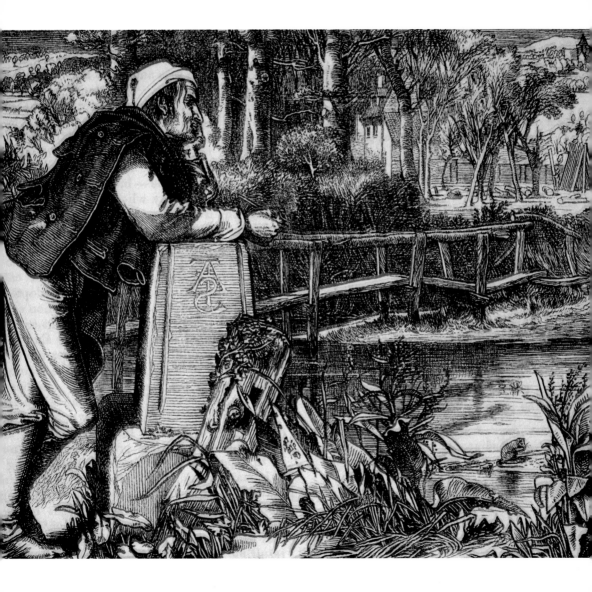

Sandys, Anthony Frederick

Medea, 1866–68

According to Greek mythology, Medea was the daughter of King Aeetes, who was the owner of the Golden Fleece, a prize that was sought by Jason. When he arrived to claim it, Aeetes set Jason a series of near-impossible tasks. Medea, however, had fallen in love with him, and agreed to help in his quest. Having gained the fleece, Jason and Medea fled to his homeland. Jason subsequently betrayed Medea, though she had borne him three sons, and she went on the rampage in a killing spree that included her own children and Jason's new lover. Medea was a sorceress and in this work she is depicted as the *femme fatale* preparing a poisoned vessel for one of her many victims.

The notion of the *femme fatale* figure in legend proliferated around Rossetti's Pre-Raphaelite circle at the time this picture was painted, a time when Sandys was living with Rossetti in Cheyne Walk. On submission to the Royal Academy in 1868 the painting was rejected, precipitating a lengthy correspondence in *The Times* and, with support from Rossetti and others, it gained entry to the exhibition the following year.

CREATED

Chelsea, London

MEDIUM

Oil on panel

RELATED WORK

Jason et Médée by Gustave Moreau, 1865

Anthony Frederick Sandys *Born* 1829 Norwich, England

Died 1904

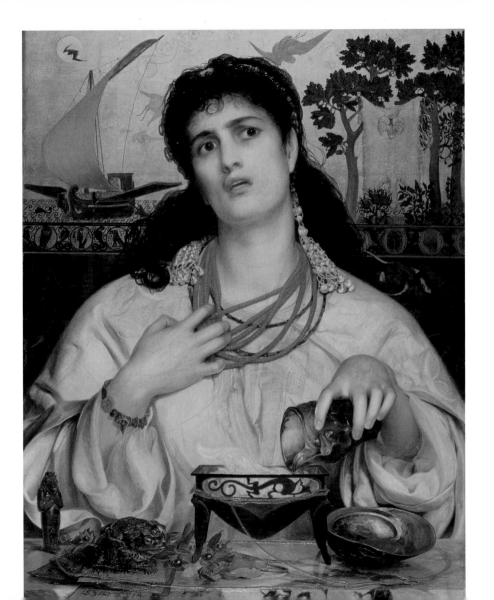

Solomon, Simeon

Dante's First Meeting with Beatrice, 1859–63

As part of Rossetti's circle of Pre-Raphaelites in the 1860s, Simeon Solomon would naturally be influenced by his motifs including Dante and his literature. The drawing shown here is one of Solomon's first using pen and ink, but already shows a delicacy and subtlety of handling that surpasses Rossetti's in this medium. The scene is from *Vita Nuova*, when Dante meets his ideal love Beatrice 'at the beginning of her ninth year almost, and I saw her at the end of my ninth year'. The number nine, which was also the hour that Beatrice died, held a particular, almost fanatical, significance for Rossetti, one that the young impressionable Solomon seems to have latched on to in this work which coincidentally depicts nine characters. The high quality of his draughtsmanship was eagerly sought for book illustrations, which Solomon executed until his career was cut short by scandal.

The depiction of Dante's characters was not unique to the Pre-Raphaelites. In the 1860s, a number of other artists such as Leighton produced several paintings on the theme, making Dante and his literature a topical subject for High Victorians.

CREATED

Probably London

MEDIUM

Pen and ink on paper

RELATED WORK

Paolo and Francesca by Frederic, Lord Leighton, 1861

Simeon Solomon *Born* 1840 London, England

Died 1905

Author Biographies

Michael Robinson (author)

Michael Robinson is a freelance lecturer and writer on British art and design history. Originally an art dealer with his own provincial gallery in Sussex, he gained a first-class honours degree at Kingston University, Middlesex. He is currently working on his doctorate, a study of early Modernist-period British dealers. He continues to lecture on British and French art of the Modern period.

Yvonna Januszewska (foreword)

Yvonna Januszewska is a masters graduate of Kingston University, Middlesex. She is currently working at Christie's auction house looking after all the major European art markets. She is also the consultant for Christie's Poland, and has recently contributed to their *Guide to the International Art Markets*. With a keen interest in photography, she recently held her own one-woman exhibition in a London gallery.

Picture Credits: Prelims and Introductory Matter

Pages 1 & 3: Sir John Everett Millais, *Mariana*, © The Makins Collection/The Bridgeman Art Library

Page 4: William Holman Hunt, *Our English Coasts*, © Tate, London 2007

Page 5 (l to r top): Dante Gabriel Rossetti, *The Girlhood of Mary Virgin*, © Tate, London 2007; Sir John Everett Millais, *The Vale of Rest*, © Tate, London 2007; Sir Edward Coley Burne-Jones, *The Mill* (detail), © Victoria & Albert Museum, London, UK/The Bridgeman Art Library

Page 5 (l to r bottom): Arthur Hughes, *The Long Engagement* (detail), © Birmingham Museums and Art Gallery/The Bridgeman Art Library; Sir John Everett Millais, *The Black Brunswicker* (detail), © Lady Lever Art Gallery, National Museums Liverpool/The Bridgeman Art Library; Dante Gabriel Rossetti, *Found* (detail), © Delaware Art Museum, Wilmington, USA, Samuel and Mary R. Bancroft Memorial/The Bridgeman Art Library

Page 6 (l to r top): William Holman Hunt, *The Scapegoat*, © Lady Lever Art Gallery, National Museums Liverpool/The Bridgeman Art Library; Frederic George Stephens, *The Proposal (The Marquis and Griselda)* (detail), © Tate, London 2007; Ford Madox Brown, *The Hayfield*, © Tate, London 2007

Page 6 (l to r bottom): Fra Angelico, *The Martyrdom of St Cosmas and St Damian*, © Louvre, Paris, France, Giraudon/The Bridgeman Art Library; Sir Joshua Reynolds, *Self Portrait* (detail), © Galleria degli Uffizi, Florence, Italy, Giraudon/The Bridgeman Art Library; Odilon Redon, *The Black Pegasus*, © Christie's Images Ltd, 2007

Page 7 (l to r): Sir John Everett Millais, *The Boyhood of Raleigh*, © Tate, London 2007; Dante Gabriel Rossetti, *Dantis Amor* (detail), © Tate, London 2007; Sir Edward Coley Burne-Jones, *Sidonia von Bork, 1560* (detail), © Tate, London 2007

Page 12: Arthur Hughes, *Home from the Sea*, © Ashmolean Museum, University of Oxford, UK/The Bridgeman Art Library

Page 15: Sir Edward Coley Burne-Jones, *Mermaid with her Offspring*, © Private Collection/The Bridgeman Art Library

Page 16: Frederic George Stephens, *Morte d'Arthur*, © Tate, London 2007

Page 17: Charles Alston Collins, *Convent Thoughts* (detail), © Ashmolean Museum, University of Oxford, UK/The Bridgeman Art Library

Page 18–19: Sir Edward Coley Burne-Jones, *The Sleeping Beauty* (detail), © Faringdon Collection, Buscot, Oxon, UK/The Bridgeman Art Library

Further Reading

Ash, R., *Sir Edward Burne-Jones*, H.N. Abrams, 1993

Barlow, P., *Time Present and Time Past: The Art of John Everett Millais*, Ashgate, 2005

Barnes, R., *The Pre-Raphaelites and Their World*, Tate Gallery Publishing, 1998

Barringer, T., *Men at Work*, Yale University Press, 2005

Barringer, T., *Reading the Pre-Raphaelites*, Yale University Press, 1998

Bendiner, K., *The Art of Ford Madox Brown*, Pennsylvania State University Press, 1998

Cruise, C. (ed.), *Love Revealed: Simeon Solomon and the Pre-Raphaelites*, Merrell, 2005

Elzea, B., *Frederick Sandys (1829–1904): A Catalogue Raisonné*, Antique Collectors' Club, 2001

Fleming, G.H., *John Everett Millais: A Biography*, Constable, 1998

Funnell, P., *Millais: Portraits*, National Portrait Gallery, 1999

Gissing, A.C., *William Holman Hunt: A Biography*, Duckworth, 1936

Harding, E. (ed.), *Re-framing the Pre-Raphaelites: Historical and Theoretical Essays*, Scolar, 1996

Hilton, T., *The Pre-Raphaelites*, Thames and Hudson, 1970

Kestner, J.A., *Masculinities in Victorian Painting*, Scolar, 1995

Mancoff, D. (ed.), *John Everett Millais: Beyond the Pre-Raphaelite Brotherhood*, Yale University Press, 2001

Marsh, J., *Dante Gabriel Rossetti: Painter and Poet*, Weidenfeld and Nicolson, 1999

Millais, J.G., *The Life and Letters of Sir John Everett Millais*, Methuen, 1899

Nunn, P.G., *Problem Pictures: Women and Men in Victorian Painting*, Scolar, 1995

Parris, L. (ed), *The Pre-Raphaelites*, Tate Gallery Publications, 1984

Peters-Corbett, D., *Edward Burne-Jones*, Tate, 2004

Prettejohn, E., *Rossetti and his Circle*, Tate Gallery Publishing, 1997

Prettejohn, E., *The Art of the Pre-Raphaelites*, Princeton University Press, 2000

Read, B. and Barnes J., *Pre-Raphaelite Sculpture*, Lund Humphries, 1991

Roberts, L. and Wildman S., *Arthur Hughes: The Last Pre-Raphaelite*, Antique Collectors' Club, 1998

Rose, A. (ed.), *The Germ: The Literary Magazine of the Pre-Raphaelites*, Ashmolean Museum and Birmingham Museums & Art Gallery, 1979

Rossetti, W.M., *The Pre-Raphaelites and Their World: A Personal View*, Folio Society, 1995

Stansky, P., *William Morris*, Oxford University Press, 1983

Surtees, V., *The Paintings and Drawings of Dante Gabriel Rossetti (1828–1882): A Catalogue Raisonné*, Clarendon Press, 1991

The Pre-Raphaelites, exhibition catalogue, Tate Gallery Publishing in association with Allen Lane and Penguin, 1984

Treuherz, J., Prettejohn E. and Becker E., *Dante Gabriel Rossetti*, Thames and Hudson, 2003

Van der Post, L., *William Morris and Morris and Co.*, V&A Publications, 2003

Wilton, A. and Upstone R., *The Age of Rossetti, Burne-Jones and Watts: Symbolism in Britain, 1860–1910*, Tate Gallery Publishing, 1997

Index by Work

General Index